TREASURING THE TRADITION

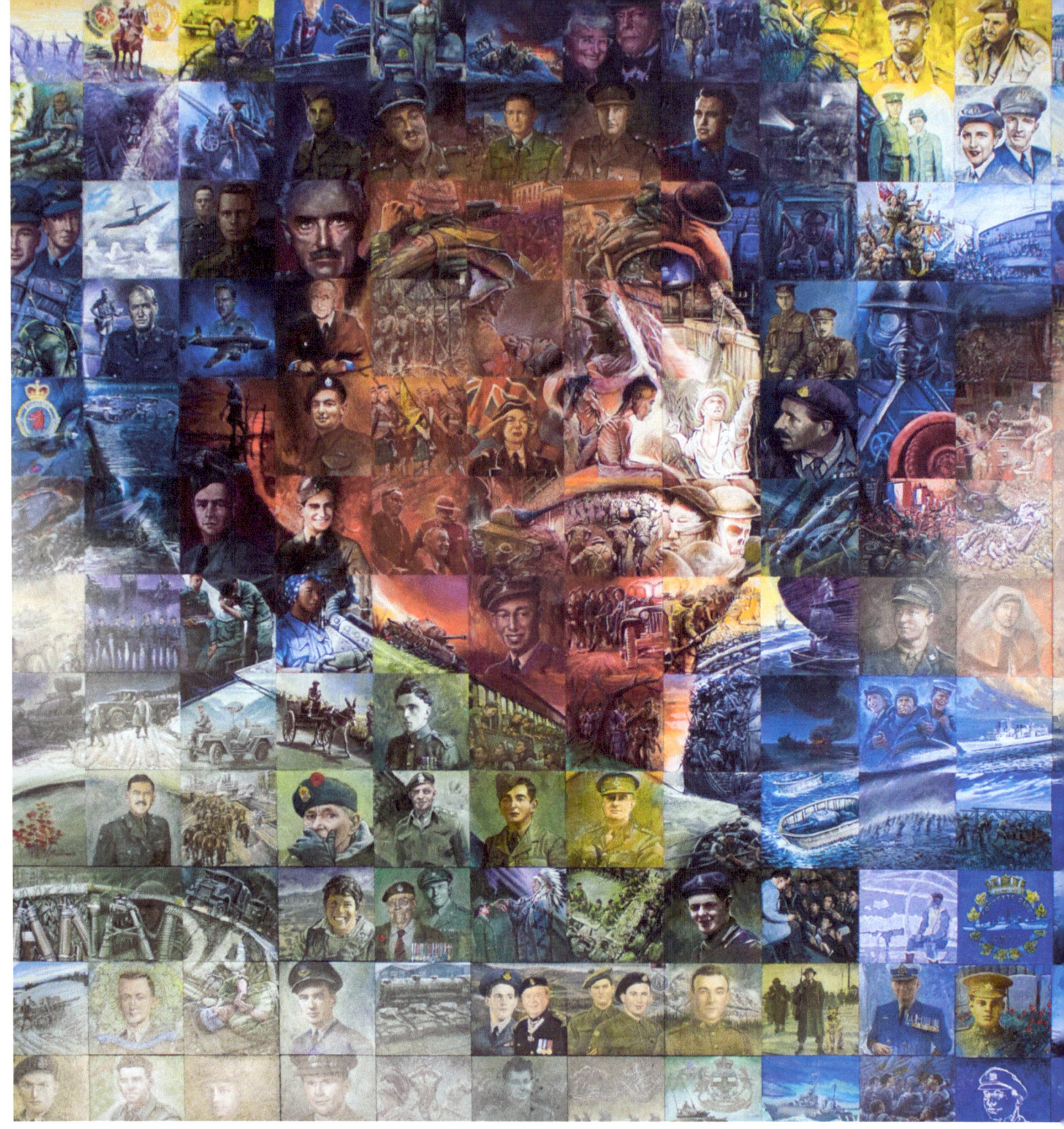

Treasuring *the* Tradition

THE STORY OF THE MILITARY MUSEUMS

Jeff Keshen and David Bercuson

A SPECIAL PUBLICATION OF

© 2020 The Military Museums Foundation

University of Calgary Press
2500 University Drive NW
Calgary, Alberta
Canada T2N 1N4
press.ucalgary.ca

This book is available as an ebook which is licensed under a Creative Commons license. The publisher should be contacted for any commercial use which falls outside the terms of that license.

Library and Archives Canada Cataloguing in Publication

Title: Treasuring the tradition : the story of the Military Museums / Jeff Keshen and David Bercuson.
Names: Keshen, Jeff, 1962– author. | Bercuson, David Jay, author.
Identifiers: Canadiana (print) 20190057793 | Canadiana (ebook) 20190057858 | ISBN 9781773850580 (softcover) | ISBN 9781773850597 (Open Access PDF) | ISBN 9781773850603 (PDF) | ISBN 9781773850610 (EPUB) | ISBN 9781773850627 (Kindle)
Subjects: LCSH: Military Museums (Calgary, Alta.)—History. | LCSH: Military museums—Alberta—Calgary—History.
Classification: LCC U13.C32 C35 2019 | DDC 355.0074/712338—dc23

The University of Calgary Press acknowledges the support of the Government of Alberta through the Alberta Media Fund for our publications. We acknowledge the financial support of the Government of Canada. We acknowledge the financial support of the Canada Council for the Arts for our publishing program.

This book has been published with generous support from The Military Museums Foundation, Mount Royal University Faculty of Arts, University of Calgary Faculty of Arts, the Naval Museum of Alberta Society, Princess Patricia's Canadian Light Infantry Regimental Museum & Archives, Valour Canada, King's Own Calgary Regiment (RCAC) Regimental Museum & Archives, and Naval Museum of Alberta.

The authors would like to thank Terry Thompson for providing information in an early unpublished manuscript and Rory Cory for his invaluable help with captions, photographs, and coordination on behalf of The Military Museums.

Copyediting by Francine Michaud
Cover image Louis Lavoie, *Mural of Honour*, The Military Museums, Calgary https://themilitarymuseums.ca/visit/mural-of-honour.
Cover design by Melina Cusano
Page design and typesetting by zijn digital

CONTENTS

Introduction
vii

1
A Military
Community
1

2
A Museum for
the Regiments
27

3
The Naval Museum—
Beginnings
43

4
Operating the Museum
of the Regiments
59

5
Coming Together
73

6
Canada's Military History
on Display
97

7
Remember, Preserve,
Educate
119

INTRODUCTION

Friday, 6 June 2009, the 65th anniversary of D-Day, started miserably in Calgary with a mixture of rain and hail. Still, a growing crowd gathered outside the city's new Military Museums, including federal and provincial politicians and the mayor. They awaited Her Royal Highness The Countess of Wessex, who was to preside at the opening of the new $26.4 million facility. Three years earlier, also in June, she had turned the sod to announce officially the museum's expansion, which more than doubled its size to 107,000 square feet compared to when Queen Elizabeth II first opened it in June 1990 as the Museum of the Regiments.

Numerous veterans were among the hundreds gathered around the eternal flame by the main entrance. They included Elly Raskin, then eighty-nine years old, who fought at Dieppe and had pulled shrapnel from his left leg when wounded at Ortona, Italy, in December 1943. Also present was Master Corporal Paul Franklin, a casualty of Canada's latest conflict, having lost both his legs in a suicide bombing attack in Kandahar, Afghanistan, in 2006.

As the ceremony got underway, the press reported "slivers of sunlight split the dark clouds." Referring to the new facility as a "magnificent achievement," the Countess said that it would be a "focal point to remind us" of the tremendous sacrifices endured by Canadians in war, and the military's impact in shaping both the local and national experience. Bruce McDonald, chair of the Calgary Military Museums Society, the organization that spearheaded the campaign to create the new facility, declared that it would ensure "future generations get a balanced

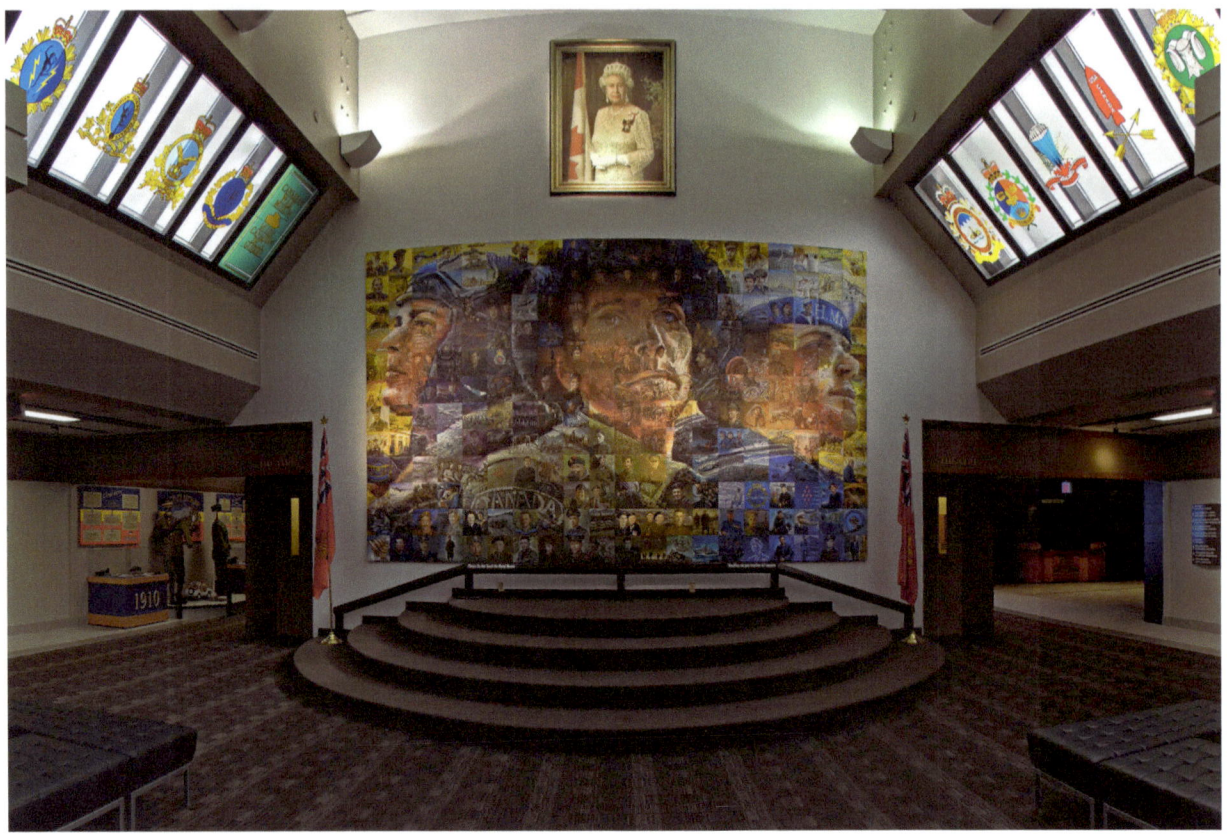

The *Mural of Honour* by Louis Lavoie with a portrait of the Queen above it and windows of regiments and organizations which contributed to the completion of the museum. The front entrance is to the rear of the photographer's viewpoint.

perspective as to what sacrifices their forefathers made ... because freedom does come with a price."

The weekend that followed continued the celebration with a royal tea for six hundred soldiers and veterans, and a D-Day Dance at the Hyatt Regency. The opening of the museum was the culmination of a drive that transpired over a quarter century. This was the dream of several societal leaders—a majority of whom had military backgrounds—all familiar with Calgary's rich military heritage, which they saw neglected for far too long. They drew together support from prominent figures in business, education, politics, the military, as well as citizens in general, to raise millions from both governments and private sources.

Initially christened in 1990 as the Museum of the Regiments, it brought together the substantial collections of the city's main historic regiments: the Lord Strathcona's Horse (Royal Canadians), the King's Own Calgary Regiment (KOCR), Princess Patricia's Canadian Light Infantry (PPCLI), and the Calgary Highlanders. In its present, expanded form as The Military Museums, its ground floor contains one of Canada's largest collections of naval artifacts. A substantial Air Force museum on the main gallery leads to an impressive two-storey library and archives. Two flexible-walled structures erected near the parking lot contain a Canadair Sabre fighter jet, a Lockheed CF-104, and a CF-188 (most often referred to as a CF-18),

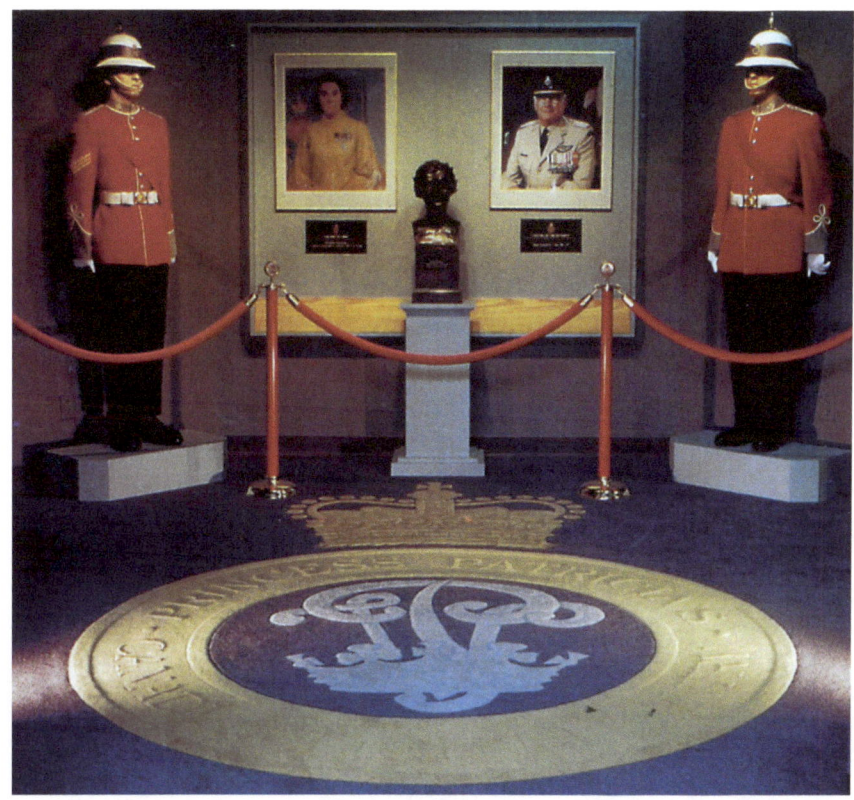

Original entrance to the Princess Patricia's Canadian Light Infantry Museum prior to 2013 renovations.

INTRODUCTION

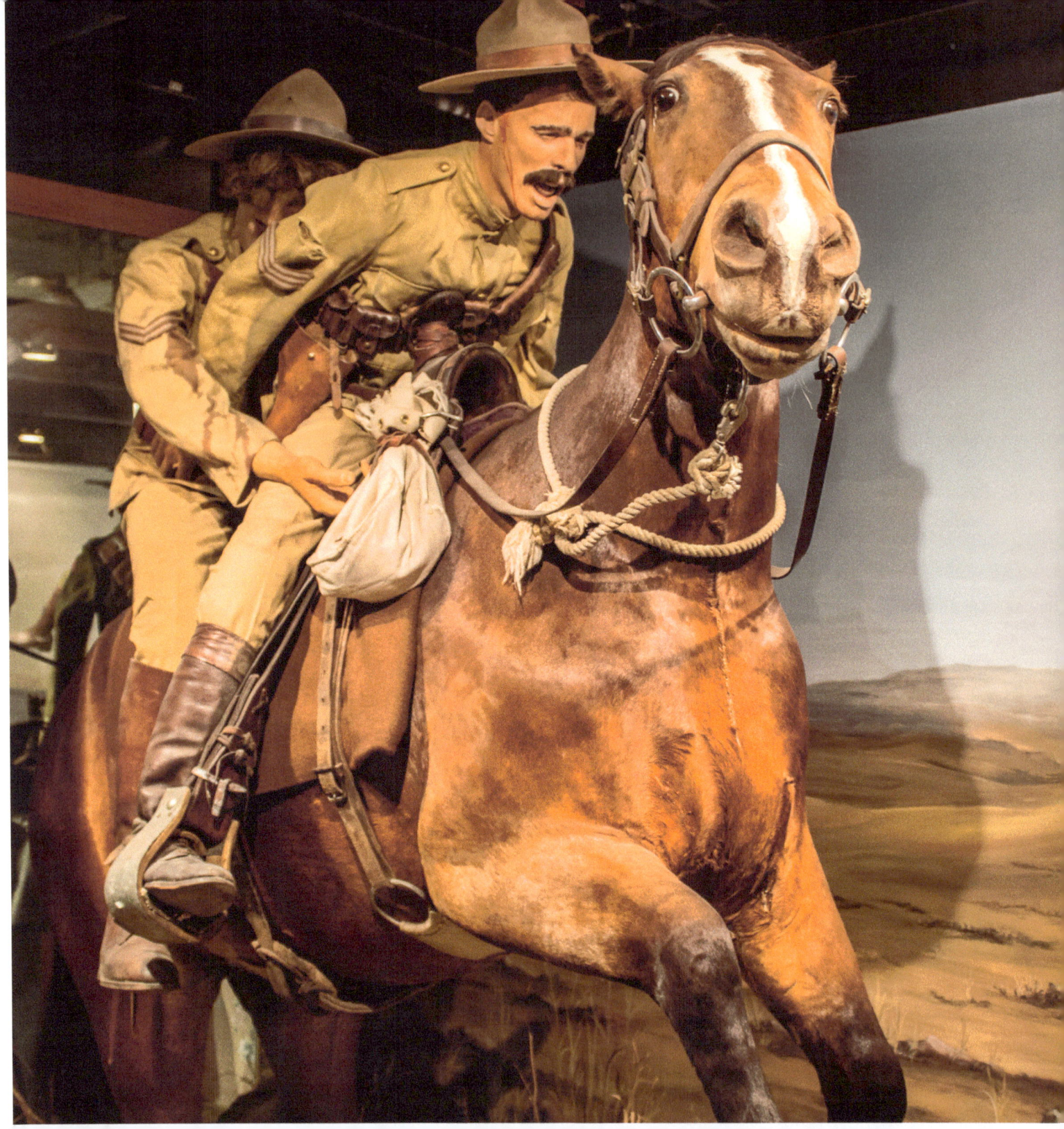

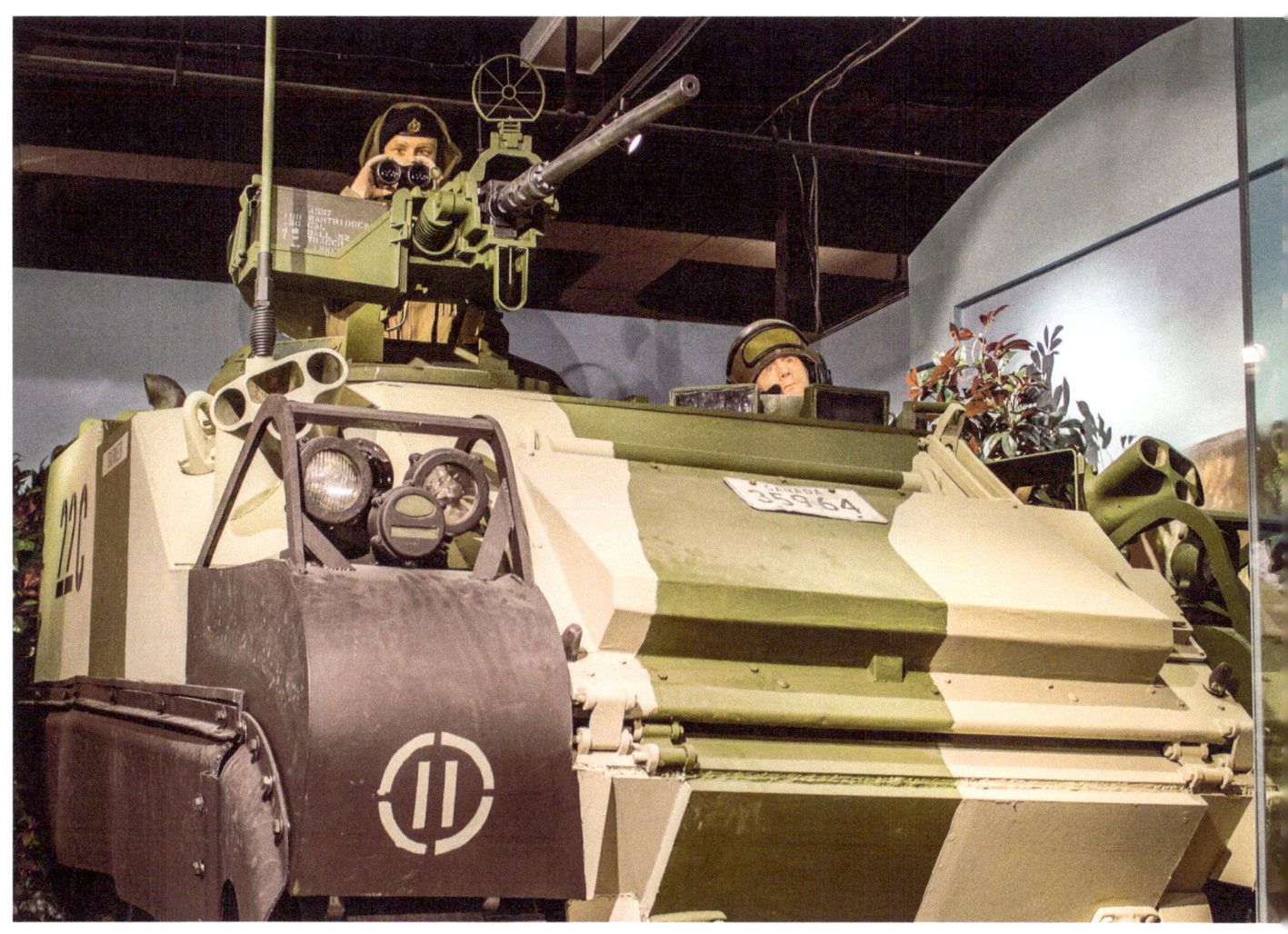

(OPPOSITE)
A diorama depicts Sergeant A.H.L. Richardson saving Corporal MacArthur of Lord Strathcona's Horse during the Battle of Wolve Spruit, 5 July 1900, in the South African War. For this action, he was awarded the Victoria Cross.

(ABOVE)
Another diorama in the Lord Strathcona's Horse (Royal Canadians) gallery depicts a Lynx reconnaissance vehicle. It was used by the Canadian Forces from 1968 until it was phased out in the early 1990s.

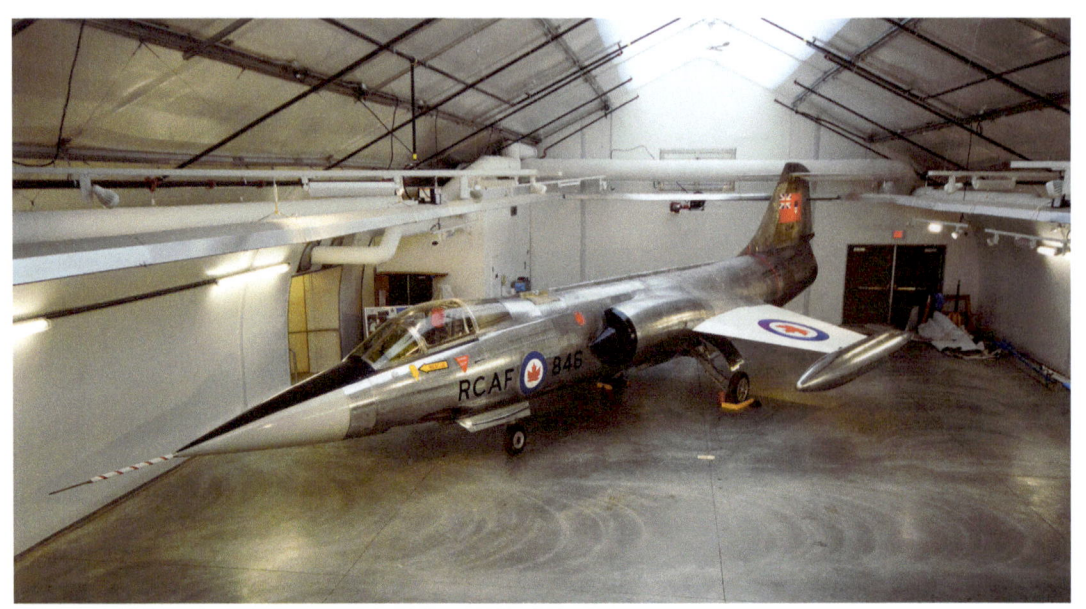

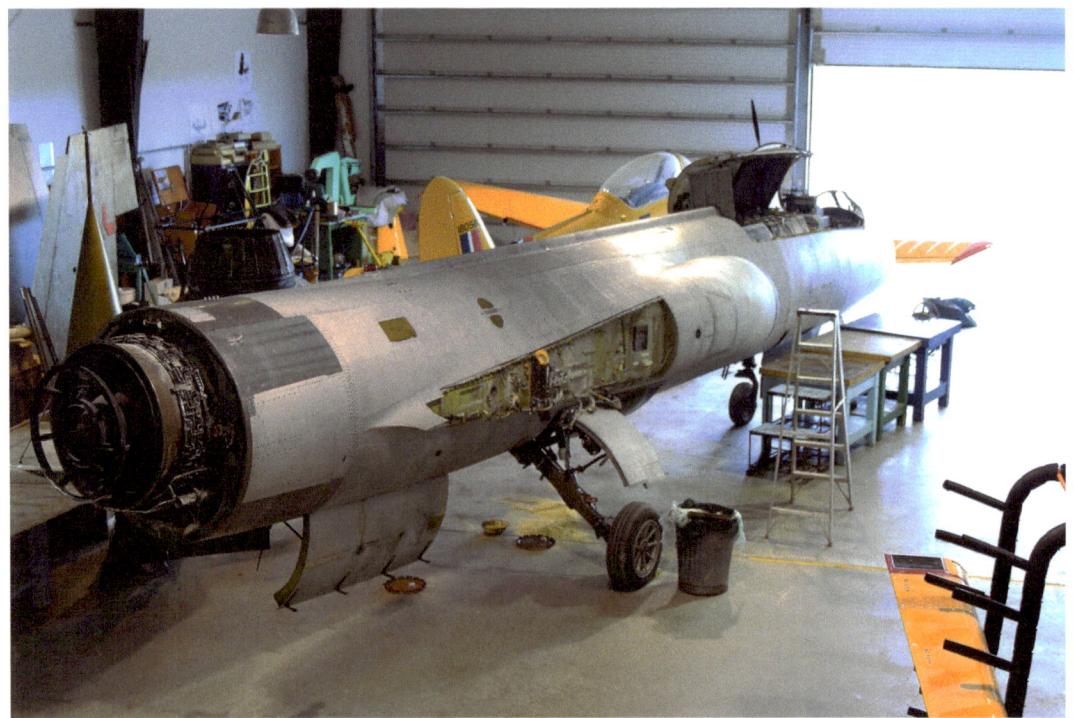

all in RCAF livery with the CF-18 painted to represent the 100th year of flight in Canada.

The Military Museums is the second largest military museum in Canada; only the Canadian War Museum in Ottawa is bigger. Although managed by civilian museum professionals, it remains part of Canada's Armed Forces, and the most significant of some seventy museum collections the Department of National Defence operates across the country. Its mission statement is to "Remember, Preserve and Educate." It accomplishes this through multiple means: artifact displays, lectures, community outreach, and by hosting groups of Calgary students. It provides a venue for major art exhibits, displays artifacts spanning the scope of Canada's military experience, and draws researchers worldwide to its extensive library and archival collection. It also serves as Calgary's chief gathering place for Remembrance Day ceremonies that now attract more than ten thousand people. In just a generation, the Museum has become a world class facility and one of Calgary's principal cultural, educational, and tourist sites.

(OPPOSITE, ABOVE)
CF-104 846 located in the west hangar of the Cold War Exhibit in 2015 prior to opening.

(OPPOSITE, BELOW)
Canadair CF-104 846 halfway through restoration in a hangar at Springbank Airport. The restoration work was spearheaded by Gary Watson, Jim Kulak, and Vic Lukawitski.

(ABOVE)
The Military Museums logo. It was based on the much earlier Museum of the Regiments logo which replicated the original front entrance to the museum.

(BELOW)
Original logo for the Founders' Gallery designed by Calgary illustrator Brad Yeo in 2009. It represents both the art and heritage exhibits featured in the gallery.

THE REGIMENTS

(RIGHT)
Modern cap badge of Princess Patricia's Canadian Light Infantry. "VP" stands for "Victoria Patricia," after the Regiment's first Colonel-in-Chief, Princess Patricia.

(FAR RIGHT)
Badge of the Lord Strathcona's Horse (Royal Canadians) Regiment. It is based on the personal coat of arms of Donald Alexander Smith, 1st Baron Strathcona and Mount Royal.

(FAR LEFT)
This Calgary Highlanders regimental cap badge/museum logo evolved from a First World War badge which featured the beaver with maple leaves surmounted by the Crown. The new badge added the cross of St. Andrew among other elements.

(LEFT)
Badge of the King's Own Calgary Regiment. The crown represents service to the sovereign. The badge incorporates the shield, horse, steer, roses, thistles and shamrocks, as adopted by the City of Calgary in 1902.

(ABOVE, LEFT) The Army Museum of Alberta logo. The central crest is the provincial shield of Alberta. The crossed swords represent the crest of the Canadian Army.

(ABOVE, RIGHT) The badge of the Naval Museum of Alberta features a Supermarine Seafire and anchor. The White Ensign behind the anchor was flown on ships from 1910–64.

(BELOW) The Air Force Museum of Alberta logo reflects the crest of the Royal Canadian Air Force. *Per Ardua ad Astra* means "Through Adversity to the Stars."

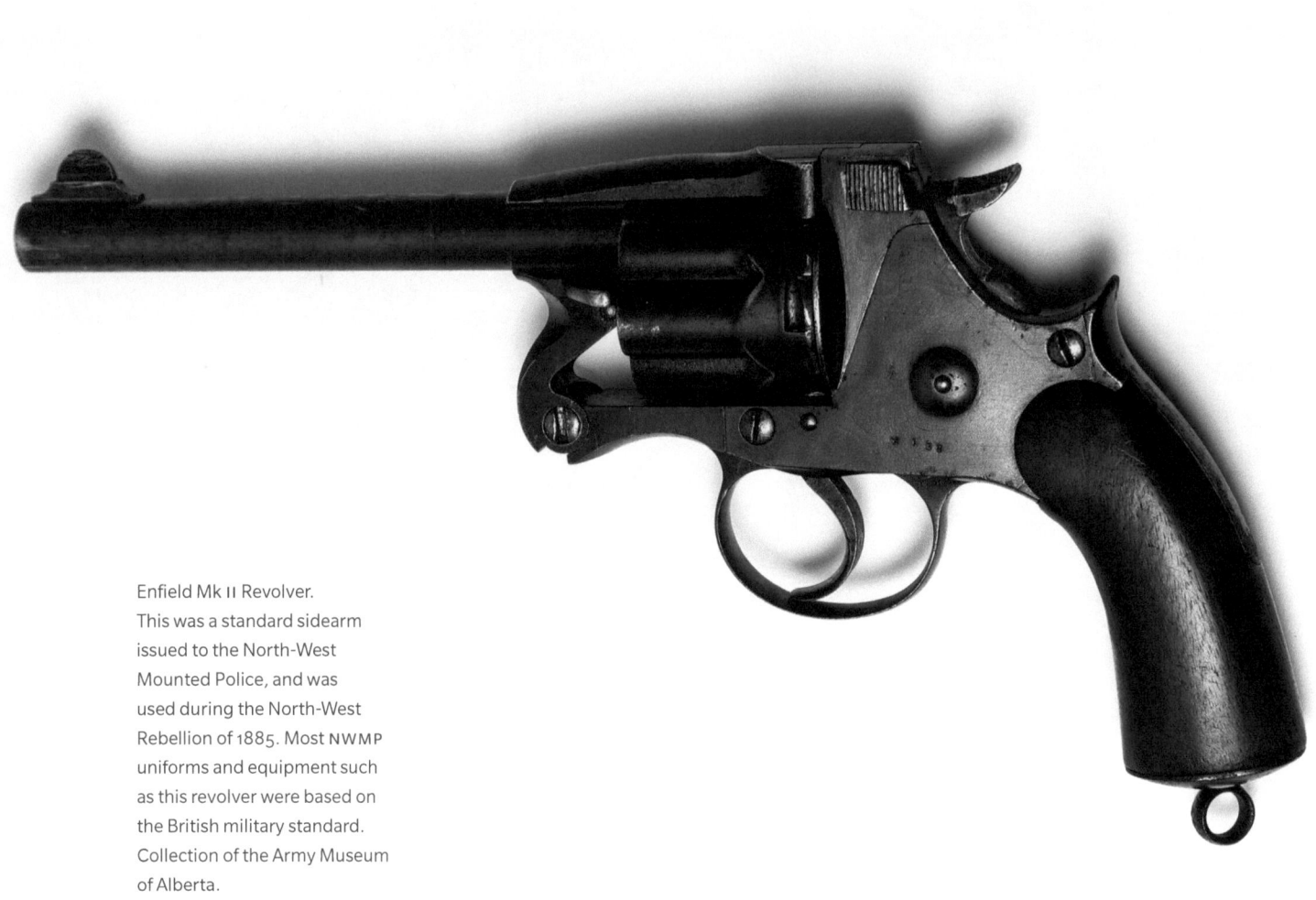

Enfield Mk II Revolver. This was a standard sidearm issued to the North-West Mounted Police, and was used during the North-West Rebellion of 1885. Most NWMP uniforms and equipment such as this revolver were based on the British military standard. Collection of the Army Museum of Alberta.

PHOTO: JULIE VINCENT PHOTOGRAPHY

1

A MILITARY COMMUNITY

The museum certainly fitted well with Calgary's past where the military has long had a strong presence. Initially situated in what was called the North West Territories—stretching across the Prairies—in 1873 Calgary became subject to the authority of the newly-formed North-West Mounted Police, a paramilitary organization. The Mounties had been sent west by the government of John A. Macdonald to establish posts along the boundary with the United States and to represent the government of Canada to First Nations inhabiting the area. One year later the Mounties established Fort Macleod, near present-day Lethbridge. In 1875, they built Fort Calgary at the juncture of the Bow and Elbow rivers, naming it after Calgary Bay on the Isle of Mull in Scotland. The frontier outpost grew substantially with the arrival of the Canadian Pacific Railway in 1883. Within a year, Calgary was incorporated as a town with 506 people, and a decade later, with a population of 3,900, was officially named as a city.

In 1899, Canada's High Commissioner to Britain Donald Alexander Smith—the 1st Baron of Strathcona and Mount Royal who had driven in the last spike of the Canadian Pacific Railway in British Columbia in 1885—donated funds to the federal government to establish Strathcona's Horse to fight in the South African War (known as the Boer War). The gift of a horse regiment as part of the second wave of volunteers was widely praised as a patriotic act; it was also a timely one as the federal government's initial response to fund the recruitment and transport of a battalion to support British forces in South Africa divided Canadians, since Francophones

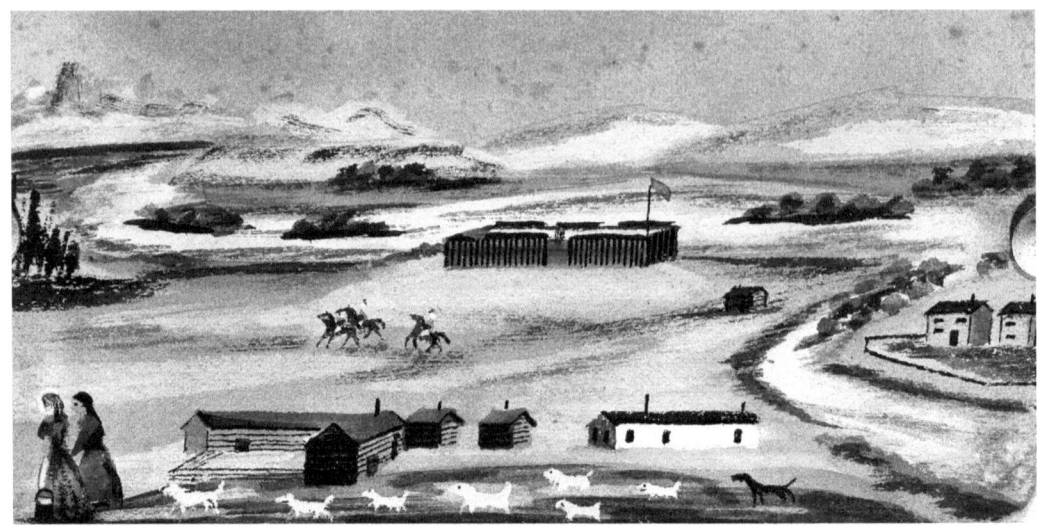

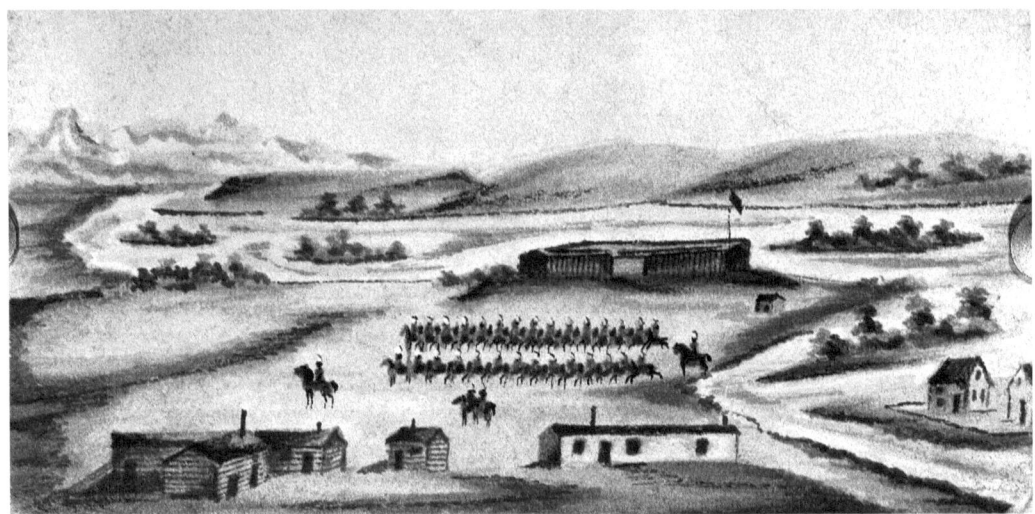

(ABOVE)
"View of Fort Calgary, Alberta, looking north," ca. 1876, by William Winder.

(BELOW)
"View of Fort Calgary, Alberta, with parade of North-West Mounted Police," ca. 1876, by William Winder.

Both images courtesy of Glenbow Archives, Glenbow Library and Archives, University of Calgary.

"Officers of Lord Strathcona's Horse enroute to South African War," 1900. Courtesy of Glenbow Archives, Glenbow Library and Archives, University of Calgary.

(LEFT)
"Sergeant A.H.L. Richardson, Lord Strathcona's Horse," ca. 1900–01, by S.J. Jarvis.

(CENTRE)
"Colonel Samuel B. Steele, Lord Strathcona's Horse," 1901, by William Notman & Sons.

(RIGHT)
"James Walker, Calgary, Alberta," ca. 1910.

were overwhelmingly opposed to involvement in this war. A large number of the initial recruits for Strathcona's Horse came from Western Canada. Being a cavalry unit, the Regiment sought to attract skilled horsemen. Many were drawn from the ranks of the North-West Mounted Police; others were cowboys and frontiersmen. Their uniform even included a Stetson.

Command of the Regiment was given to Sam Steele, then Superintendent of the North-West Mounted Police. Numerous awards for bravery were bestowed upon these first Strathcona's, including Sgt. Arthur Richardson who received the Victoria Cross for rescuing a wounded soldier under a hail of gunfire.

Edward VII presented The King's Colours to the Regiment at the end of their service period of one year. Disbanded soon after arriving back in Canada, the Strathcona's was reformed again in 1909 from the ranks of the Canadian Mounted Rifles.

Three years later, it was renamed the Strathcona's Horse (Royal Canadians), and soon after, with the addition of the word "Lord," arrived at its current nomenclature.

In 1901, Canada's federal government authorized in the District of Alberta—which became a province four years later—the raising of militia units in Calgary, Fort Macleod, and Medicine Hat. The Calgary-based formation held its first summer training camp in 1903 on James Walker's estate located just outside the town's limits in the present-day district known as Inglewood. That same year, Calgary's first permanent drill hall appeared, and in 1905, Walker became Colonel of the newly-formed 15th Light Horse.

In 1907, Calgary became administrative headquarters for Canada's Military District 13. Colonel Sam Steele was its commander. Although not from Alberta, he was strongly identified with Western Canada. He had participated in the 1870 expedition to suppress the Red River Rebellion and was a founding member of the North-West Mounted Police. He commanded Steele's Scouts in the 1885 Northwest

Images on these two pages courtesy of Glenbow Archives, Glenbow Library and Archives, University of Calgary.

(BELOW)
"First regimental camp of 15th Light Horse, Calgary, Alberta," 1905–08.

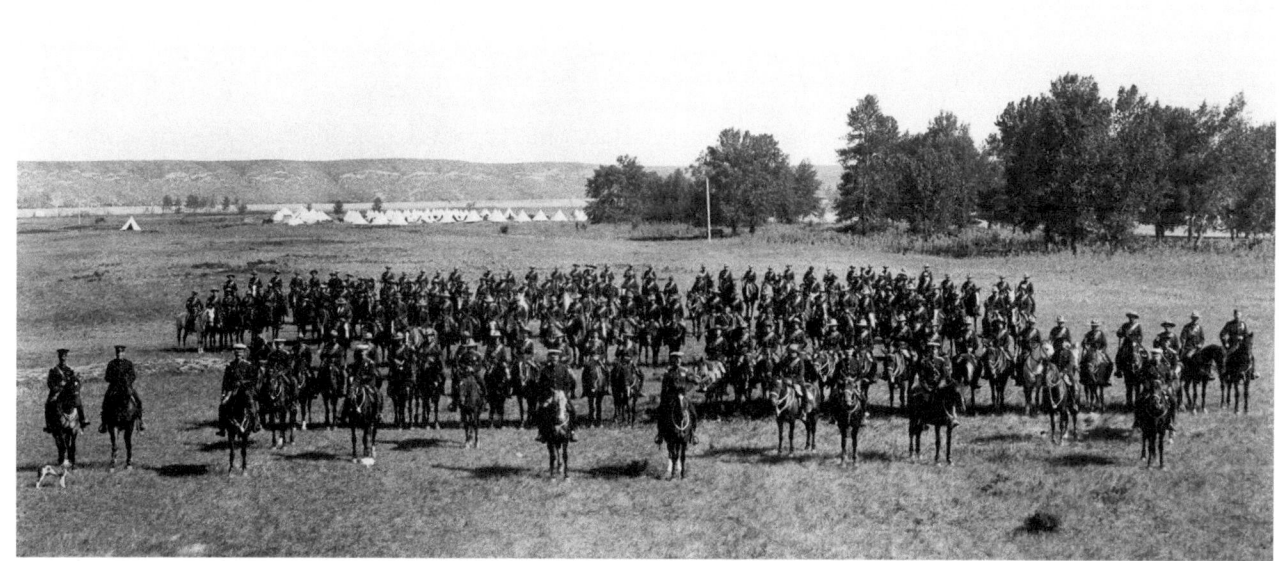

A MILITARY COMMUNITY

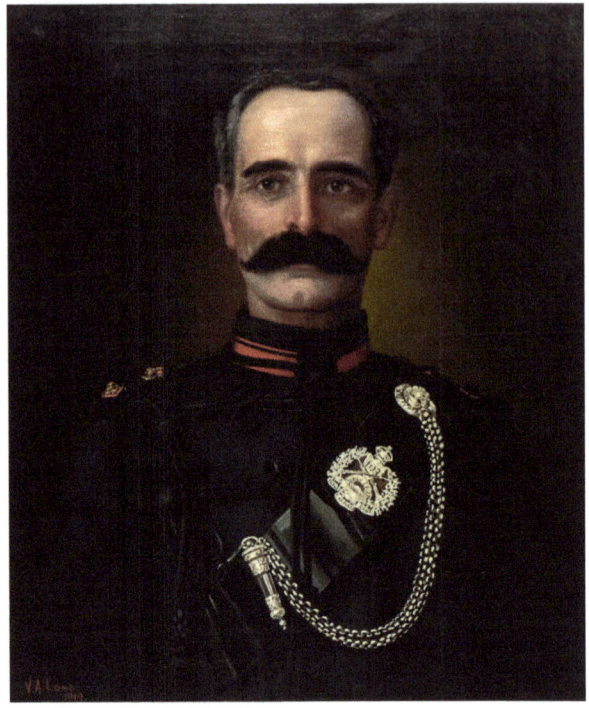

PHOTO: JULIE VINCENT PHOTOGRAPHY

(ABOVE, LEFT)
Regimental dinnerware, 103rd Regiment (Calgary Rifles), ca. 1912. Collection of the Calgary Highlanders Museum and Archives.

campaign, brought law and order to the Yukon during the 1898–99 gold rush, and commanded Lord Strathcona's Horse (Royal Canadians) during the Boer War.

In 1910 the federal government approved the creation of the 103rd Regiment (Calgary Rifles). It was commanded by Lieutenant-Colonel William C.G. Armstrong, who had acquired considerable wealth through land speculation and had served as a city councillor. In 1911, the 103rd joined militia units from across the province at a summer training camp held at Reservoir Park, the future home of Currie Barracks and eventually The Military Museums.

The militia's role at this time was not especially active. The West was being settled, First Peoples had been placed on reserves, and the 1885 North-West Rebellion had been fought a generation earlier. Still, as Canada's permanent military was tiny—only a few thousand strong—the militia was the primary means of responding

(OPPOSITE, RIGHT) Portrait of Lieutenant-Colonel William Charles Gordon Armstrong, founder and first commanding officer of the 103rd Regiment (Calgary Rifles). Both the King's Own Calgary Regiment (RCAC) and the Calgary Highlanders are descended from the 103rd Regiment (Calgary Rifles). V.A. Long, oil on canvas, 1914. Collection of the Calgary Highlanders Museum and Archives.

(BELOW) Medals group of Major General Sir David Watson, commander of the 4th Canadian Division in the First World War. Watson's diaries and photo albums are also in the museum's collections. Collection of the Army Museum of Alberta.

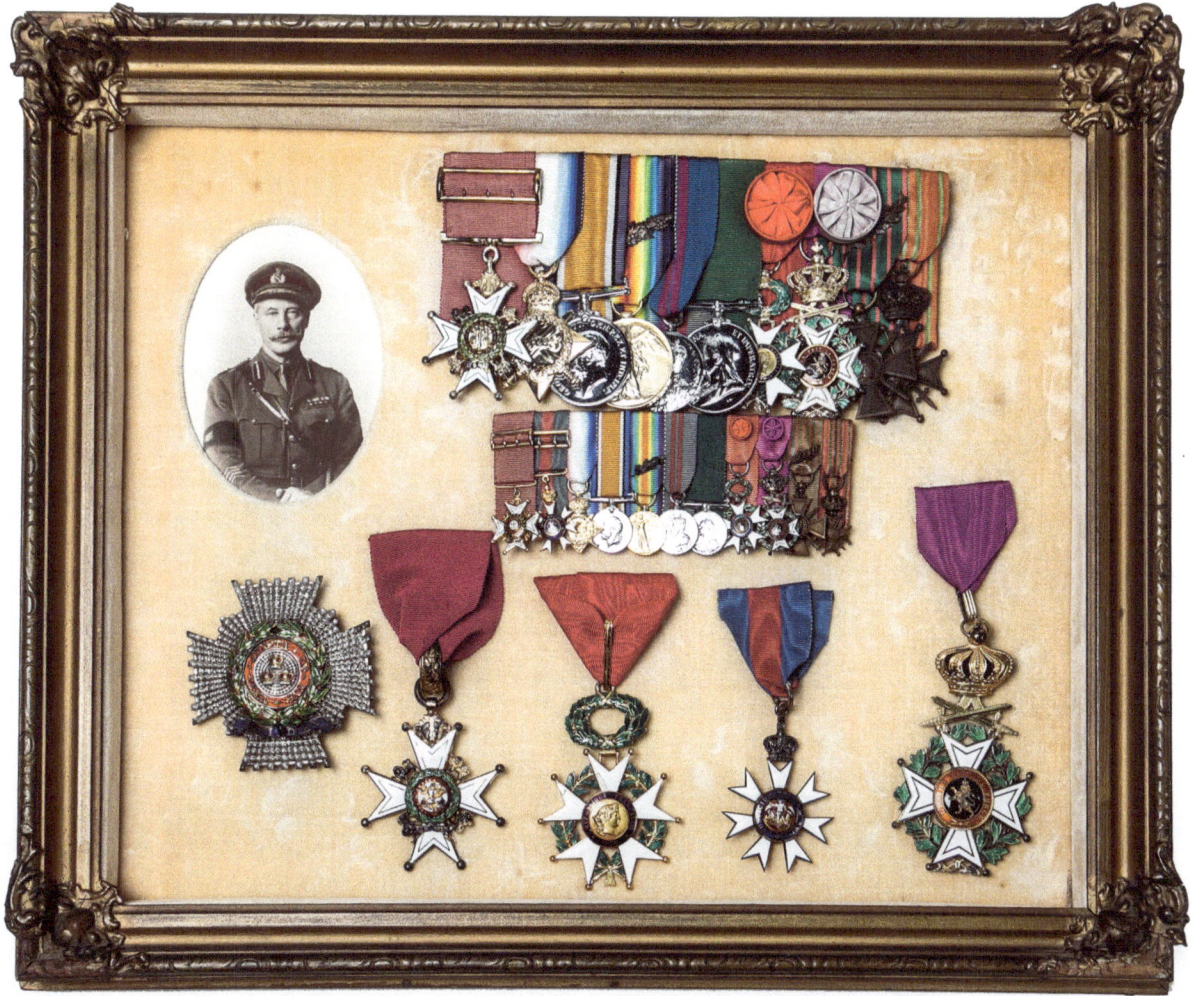

PHOTO: JULIE VINCENT PHOTOGRAPHY

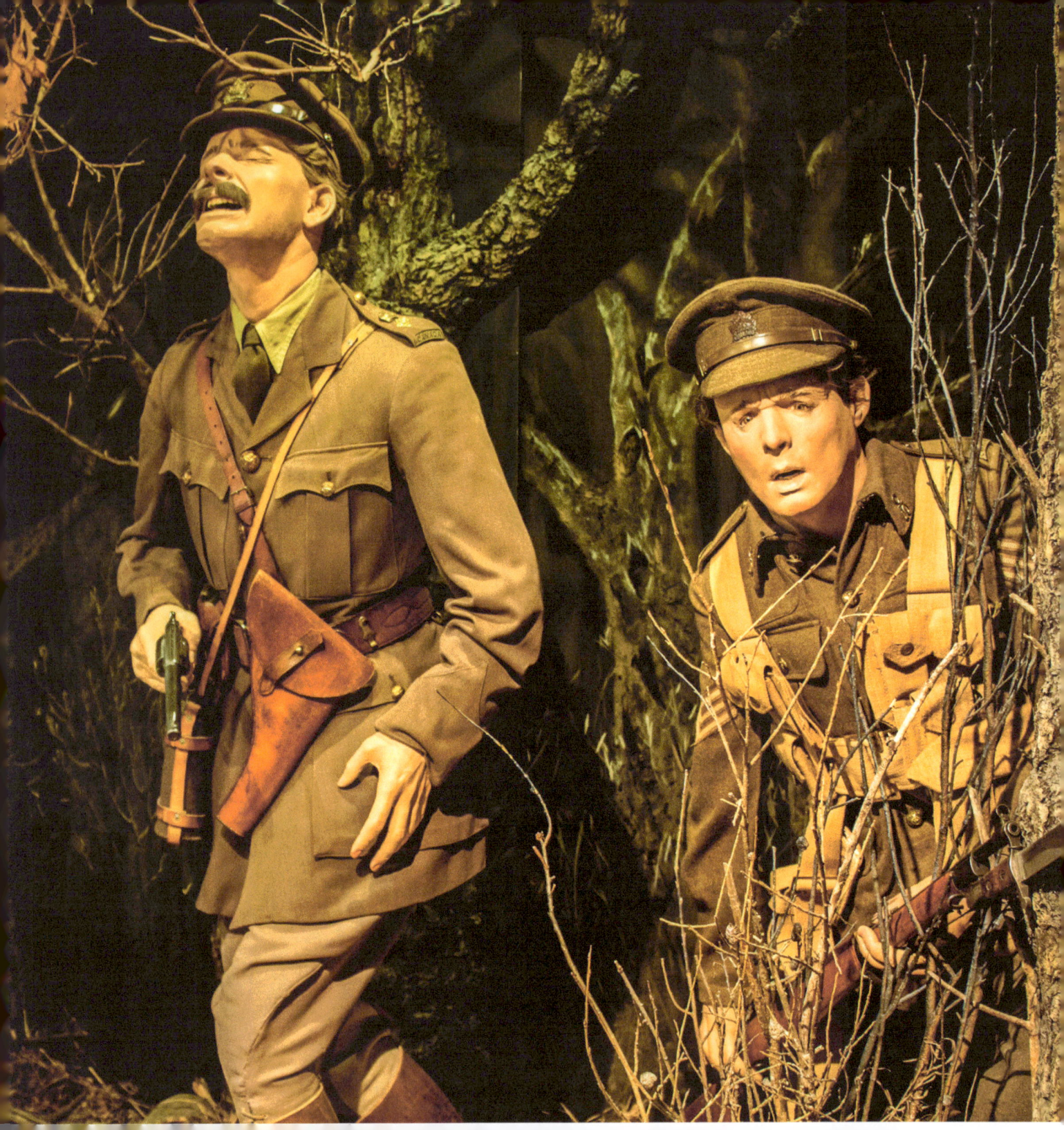

to major threats, such as aiding the civil power to control violent labour disputes. The appeal for those in command was not only patriotism but also enhanced social status. Because militia leaders were typically prominent and wealthy citizens, they were also often obliged to help fund operations and even sometimes to supply uniforms. For those making up the ranks, there was the draw of comradeship and the opportunity to go away, typically during the summer, for training sessions, assuming they could afford the time.

Alberta was only nine years old as a province when the First World War broke out. Its population was approximately four hundred thousand, and its major cities, Edmonton and Calgary, both stood at around sixty thousand. From the six hundred thousand men who served with Canada's military in the First World War, Alberta supplied 45,136, achieving among the highest provincial enlistment rates, with one-third of its eighteen- to forty-five-year-old male population donning a military uniform. Ultimately, Alberta paid dearly for its patriotism: 6,140 were killed in action and some 20,000 were wounded.

The First World War saw the appearance of several Calgary-based units. Among the larger, the 50th Battalion was authorized on 7 November 1914. It was mobilized in Calgary in December 1914 under the command of Lieutenant-Colonel E.G. Mason and trained at Sarcee Camp. Its first draft of five officers and 251 other ranks became replacements for the 10th Canadian Infantry Battalion, which had left with the Canadian Expeditionary Force for England in late 1914. At the Battle of St. Julien in late April 1915, the 10th Battalion had sustained a heart-wrenching 75 per cent casualty rate among its force of eight hundred. Lord Strathcona's Horse arrived in France in 1915 as well, were soon at the front, and endured heavy casualties throughout the Somme campaign.

Back in Calgary, within a year of the war starting, it became necessary to find space for the influx of recruits, many coming from surrounding areas. The solution was land Colonel Steele had identified in 1908 as ideal for a major training centre. Located next to the Sarcee Indian Reserve on the Elbow River Flats, it was relatively close to Calgary's main area of settlement and had access to water, wagon trails, a provincial phone line, and a transmission line of the Kananaskis Power Company. It was also expansive and varied enough to replicate different battlefield terrains.

By spring 1915, Sarcee Camp had become the second largest training facility in Canada, second only to Valcartier in Quebec. It housed as many as 5,000 men

(OPPOSITE) Depiction of 10th Battalion (later the Calgary Highlanders) at St. Julien in 1915.

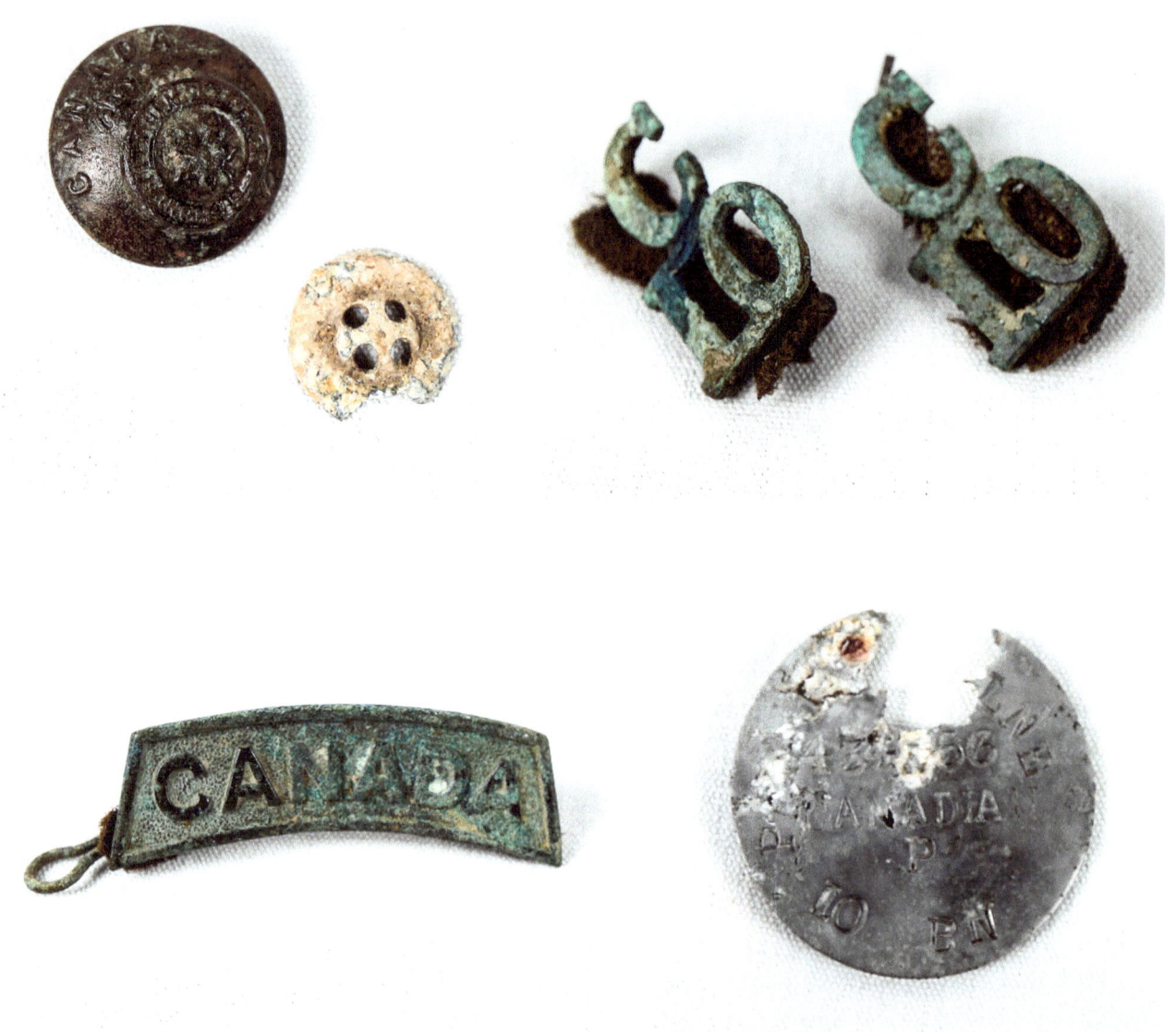

PHOTOS: JULIE VINCENT PHOTOGRAPHY

(OPPOSITE) Items excavated in 2013 at Arleux Loop battlefield, northern France, along with the remains of 10th Batallion sergeant James Alexander Milne. *Clockwise from top left*: buttons, badges, ID disc, and metal 'Canada' shoulder title. Collection of the Calgary Highlanders Museum and Archives.

(THIS PAGE) Sergeant Milne's steel helmet and NCO's whistle. Sergeant Milne's remains were reinterred with military honours by his Calgary Highlanders' brothers-in-arms in August 2017. His effects are now preserved in the Calgary Highlanders Museum. Collection of the Calgary Highlanders Museum and Archives.

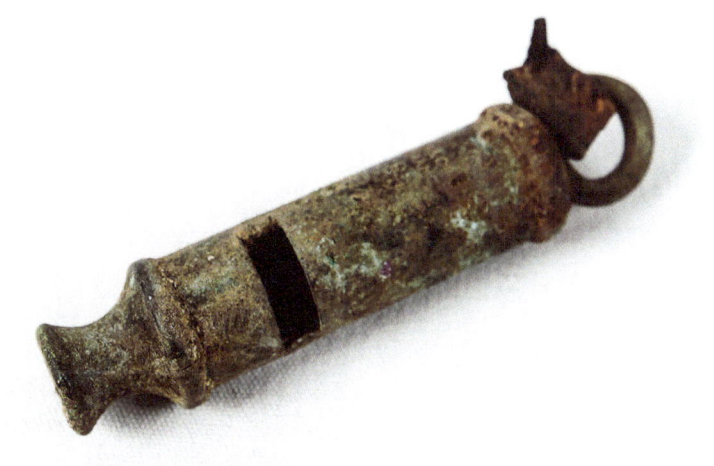

PHOTOS: JULIE VINCENT PHOTOGRAPHY

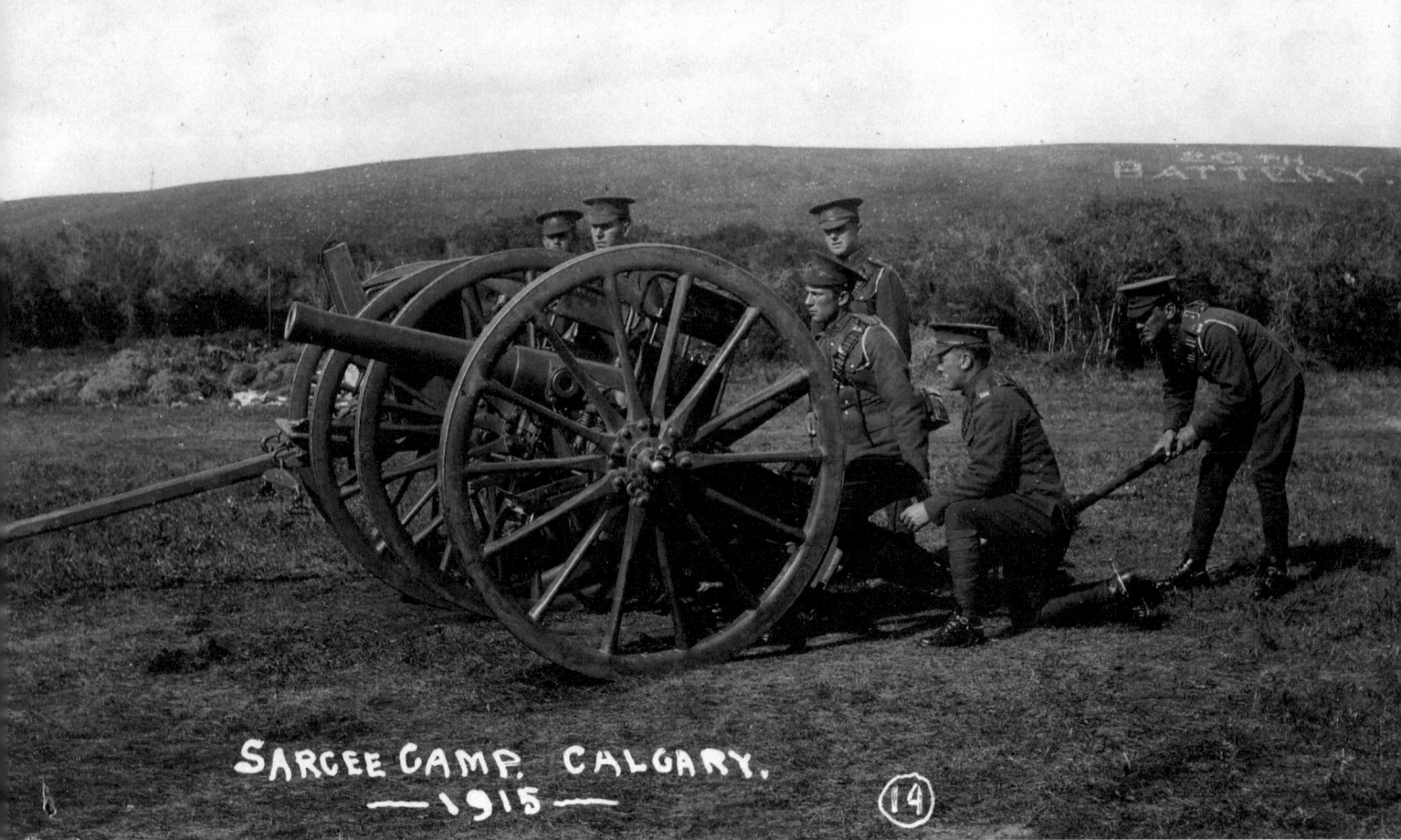

Men of the 20th Battery, Canadian Field Artillery training at Sarcee Camp in 1915. The battery name is laid out in white stones on the hillside in the background. The Military Museums Library and Archives, Robert Horn photo album.

at any one time. Soon, it added property leased from the Sarcee Nation through an annual payment of $225, this being calculated on the basis of $1 for each band member aged twenty-one or older, $10 for the Chief, and $5 for each of the three Sarcee councillors. The lease continued after the war, with the annual payment rising to $930 on property assessed at $235,000. Soon the site was crowded with wooden buildings, tents, rifle ranges, and even a streetcar line from Calgary. From here, thousands of Calgarians started their journey to the battlefields of France and Flanders, participating in nearly all major battles and campaigns that involved the Canadian army.

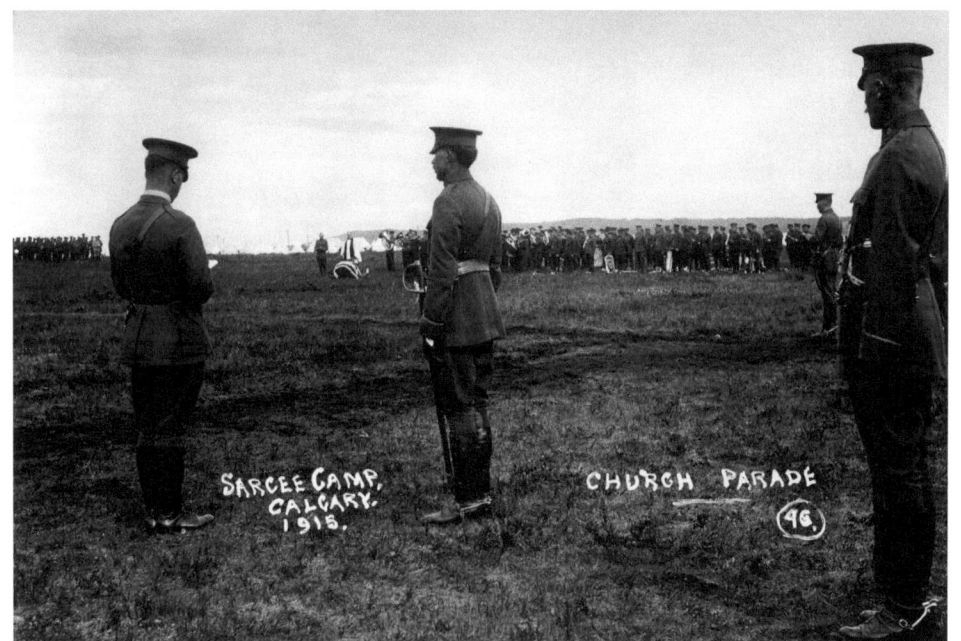

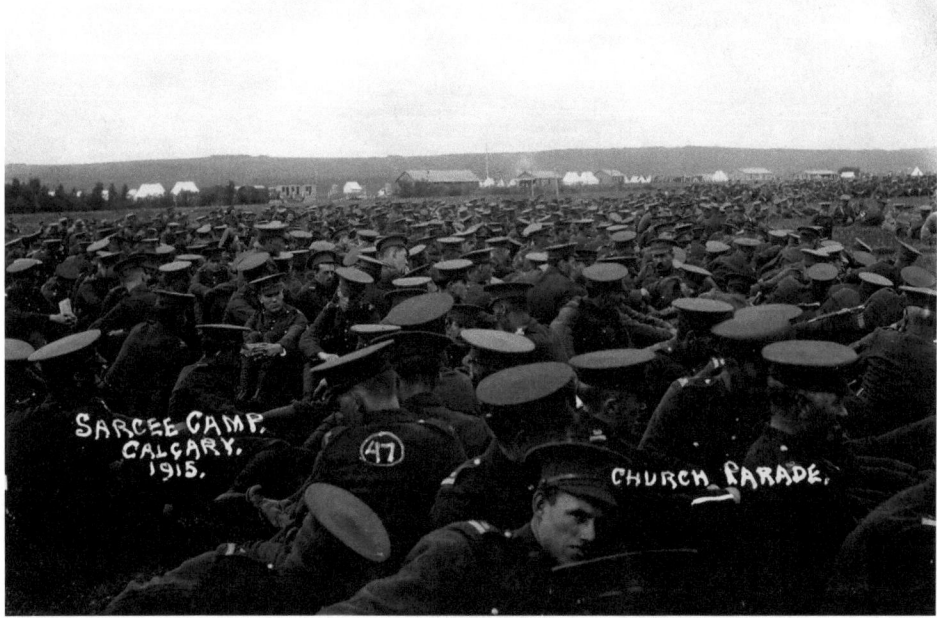

Church parade at Sarcee Camp in 1915. Church services were conducted regularly by military chaplains during training in Canada and England, but not once the men entered the trenches. Nonetheless, chaplains accompanied the men into the front lines to keep their morale up and deliver last rites as necessary. The vast majority of the men passing through Sarcee Camp came from the Church of England (Anglican), but there were Roman Catholic (often from the francophone communities in Alberta) and Jewish soldiers among others. Private Louis Zuidema was one of those Jewish soldiers, later earning the Distinguished Conduct Medal for Bravery. The Military Museums Library and Archives, Robert Horn photo album.

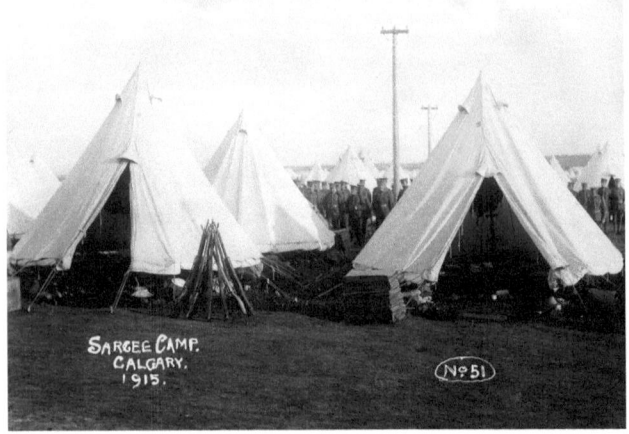

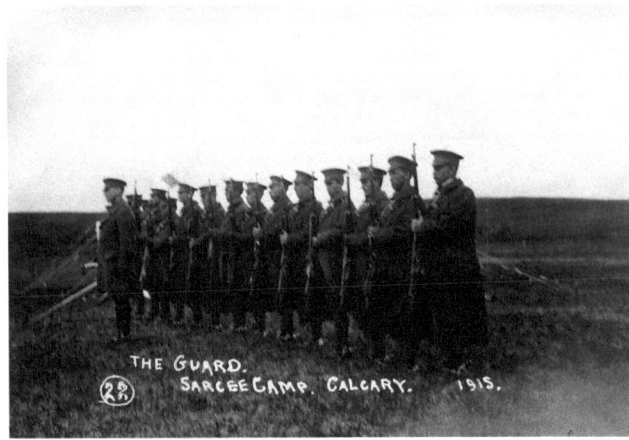

(ABOVE, LEFT)
Bell tents at Sarcee Camp. This style of tent was used for training. They were not used in the front lines. The Military Museums Library and Archives, Robert Horn photo album.

(ABOVE, RIGHT)
Soldiers from Sarcee Camp visit the Cave and Basin in Banff National Park. The men were able to sightsee in their off time, and often came into Calgary. The Military Museums Library and Archives, Robert Horn photo album.

(BELOW, LEFT AND RIGHT)
Mounting guard at Sarcee Camp, 1915. Guard or sentry duty was one of the more common tasks given to the men training at Sarcee Camp. It was an important way to learn diligence and observation, which would keep many of them alive overseas. Other common tasks were marching drill, rifle training, and washing dishes and laundry. The Military Museums Library and Archives, Robert Horn photo album.

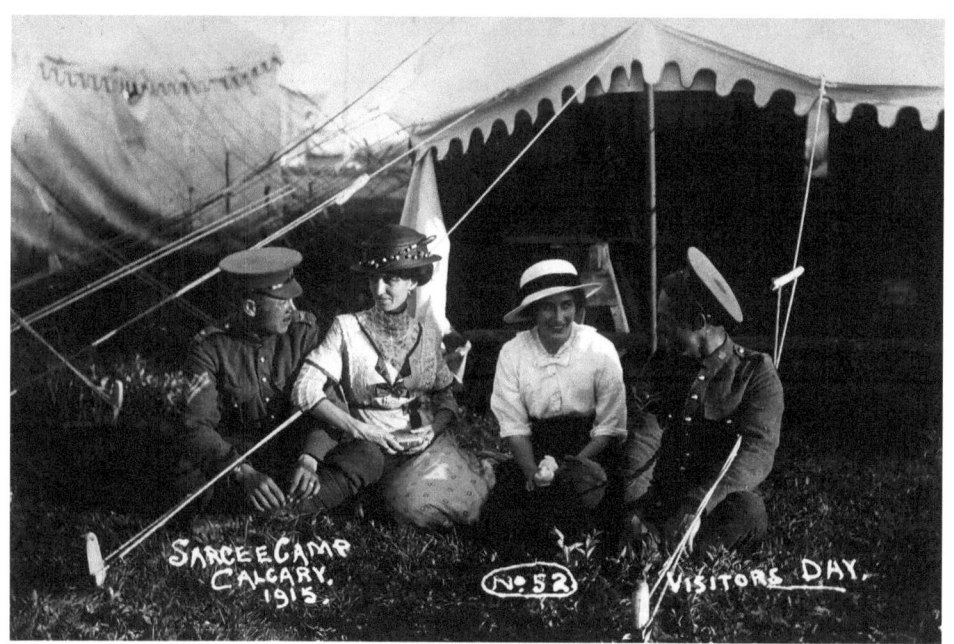

(ABOVE)

Visitors Day, Sarcee Camp 1915. Many of the men at Sarcee Camp were locals, with family or sweethearts in Calgary. Due to the proximity of the camp to Calgary, and the frequent traffic between the two, there was a close relationship between Calgarians and the men in the camp. The Military Museums Library and Archives, Robert Horn photo album.

(BELOW)

Marching drill, Sarcee Camp 1915. Although closed unit battlefield tactics were obsolete by the time of the First World War, they were still important for soldiers to learn to operate as a team, and to take orders. These were some of the very basic concepts taught at Sarcee Camp. The Military Museums Library and Archives, Robert Horn photo album.

"Calgary Highlanders,
'C' Company, 10th Battalion,
Calgary, Alberta, ca. 1914–18.
Courtesy of Glenbow Archives,
Glenbow Library and Archives,
University of Calgary.

Changes followed the end of the war. By 1924, what had been the 103rd Regiment had been reorganized into two separate units: The Calgary Regiment and The Calgary Highlanders. The end of the war also saw completion of the Mewata Armoury, located on the edge of Mewata Park in the city's present-day central southwest. Designed by Department of Public Works architect Thomas W. Fuller, with Calgary architect Leo Dowler as project supervisor, it was an impressive structure for the time, costing over $280,000 (worth $6.3 million in 2019). The Mewata Armoury is a representative example of the third phase of drill hall construction in Canada (1896–1918). In 1920, it became headquarters and provided accommodation for Lord Strathcona's Horse. Some one hundred and sixty men squeezed into the facility; their sixty horses jammed into an inadequate stable at the building's rear.

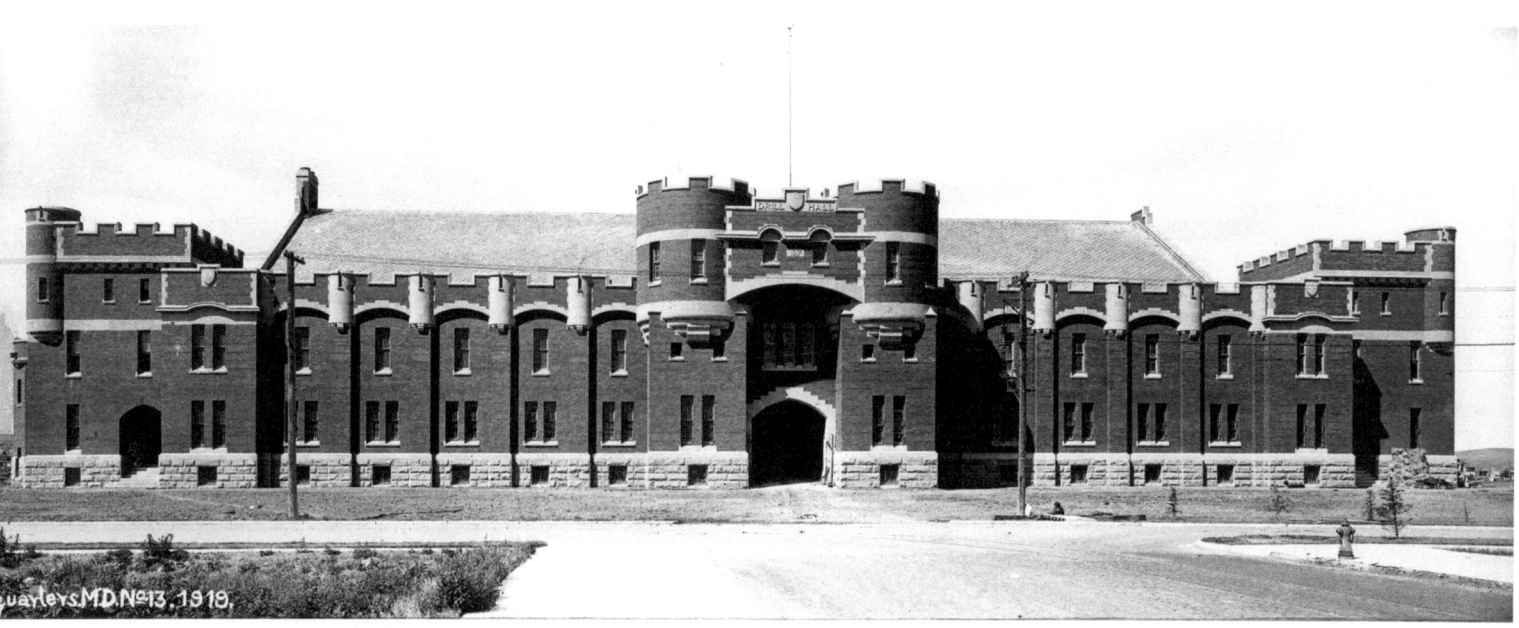

The Mewata Armoury has served as a focus of military training from its completion in 1918 to the present day. [NA-4075-1]. Courtesy of Glenbow Archives, Archives and Special Collections, University of Calgary.

In 1934, the Conservative government of R.B. Bennett, who represented the federal parliamentary seat of Calgary West, authorized under the newly passed Public Works Construction Act a $1.2 million military building project that would include an aerodrome on three hundred acres of land in Reservoir Park. Then located on Calgary's southwestern edge, on a plateau above the south slope of the Bow River valley, the result was Currie Barracks, named for Lieutenant-General Arthur Currie, widely regarded as Canada's most successful military leader, the first Canadian to command the Canadian Corps during the First World War.

On 12 April 1935, Canada's Governor General, the Earl of Bessborough, laid the cornerstone for the new facility. Opened the next year, it housed numerous branches of Canada's army over its lifespan that officially ended in 2001. In 1935, a landing strip was constructed on the base, and in October 1938, with the completion of an aerodrome, No. 1 (Fighter) and No. 3 (Bomber) Squadrons of the Royal

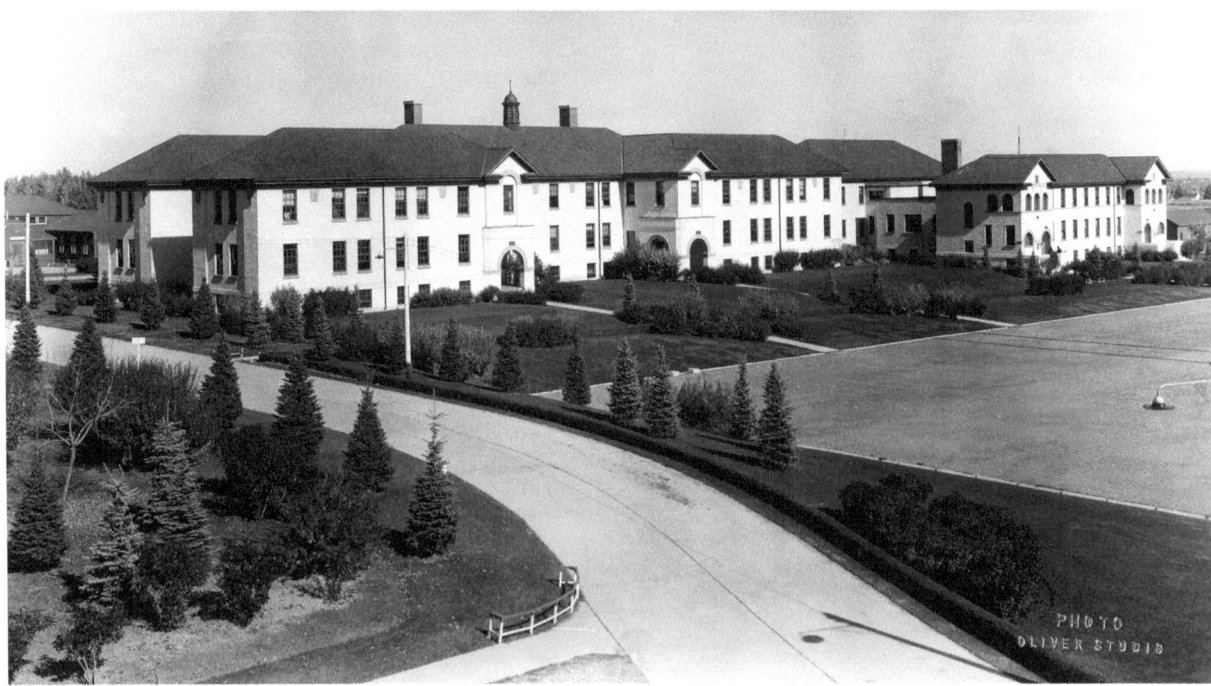

"Currie Barracks, Calgary, Alberta," by W.J. Oliver. Courtesy of Glenbow Archives, Glenbow Library and Archives, University of Calgary.

TREASURING THE TRADITION

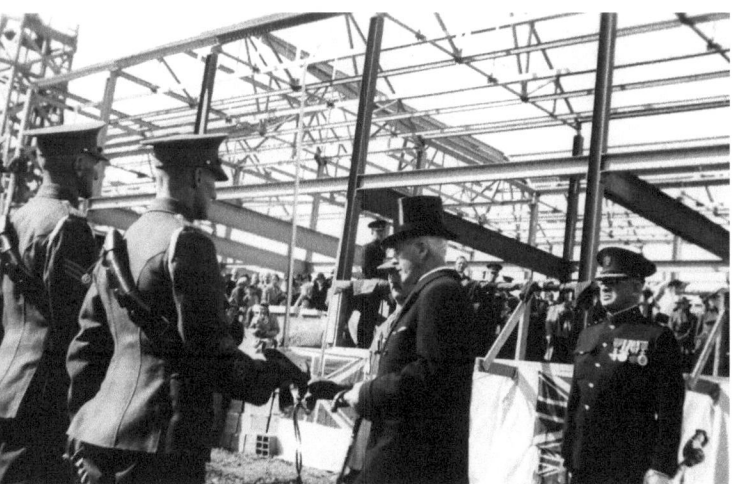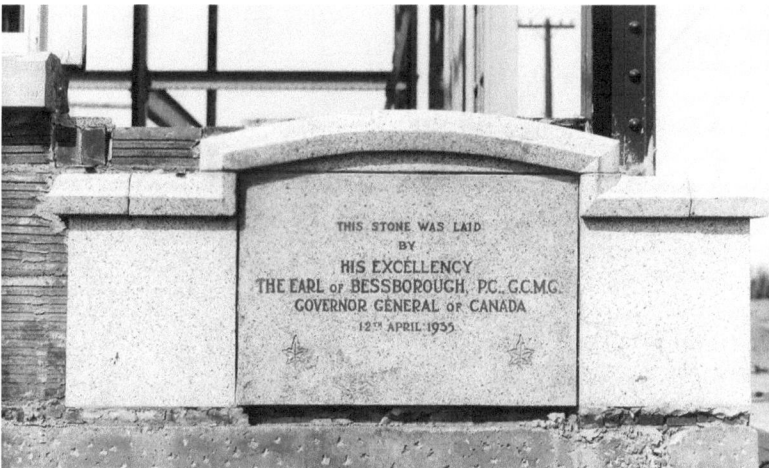

Canadian Air Force began training there. A lavish air show that drew more than fifteen thousand spectators marked this development.

By the outbreak of the Second World War, Calgary's population was approaching ninety thousand. Once again, the city's contribution of recruits was impressive. Currie Barracks housed as many as two thousand trainees. The 14th Army Tank Battalion (The Calgary Regiment (Tank)) mobilized in February 1941. In August 1942, providing support in Churchill tanks, it joined the ill-fated raid on Dieppe. Of the 181 who managed to get ashore, only five made it back to England—many of the rest being included in the almost two thousand Canadian prisoners taken in the battle. Reconstituted with fresh recruits, the next year the 14th participated in the invasions of Sicily and Italy, remaining in the Mediterranean campaign until December 1944, after which it participated in the liberation of the Netherlands. Lord Strathcona's Horse, having been transformed from a mounted regiment into a mechanized one, were equipped primarily with tanks later in the war. They saw action in Italy through to late 1944, after which they joined the North West Europe campaign in February 1945.

With vast expanses of wide open, relatively treeless, and flat land, southern Alberta became home to many British Commonwealth Air Training Plan (BCATP)

(LEFT)
The Earl of Bessborough, Governor General of Canada, preparing to lay first stone at Barracks Block 2 (later Bessborough Hall), 12 April 1935. Canada Lands Corporation Historical Photo Collection.

(RIGHT)
Cornerstone laid on southeast corner of Barracks Block 2 during the construction of Currie Barracks. After the closure of the base, the building became Clear Water Academy, a private school. The Military Museums Library and Archives.

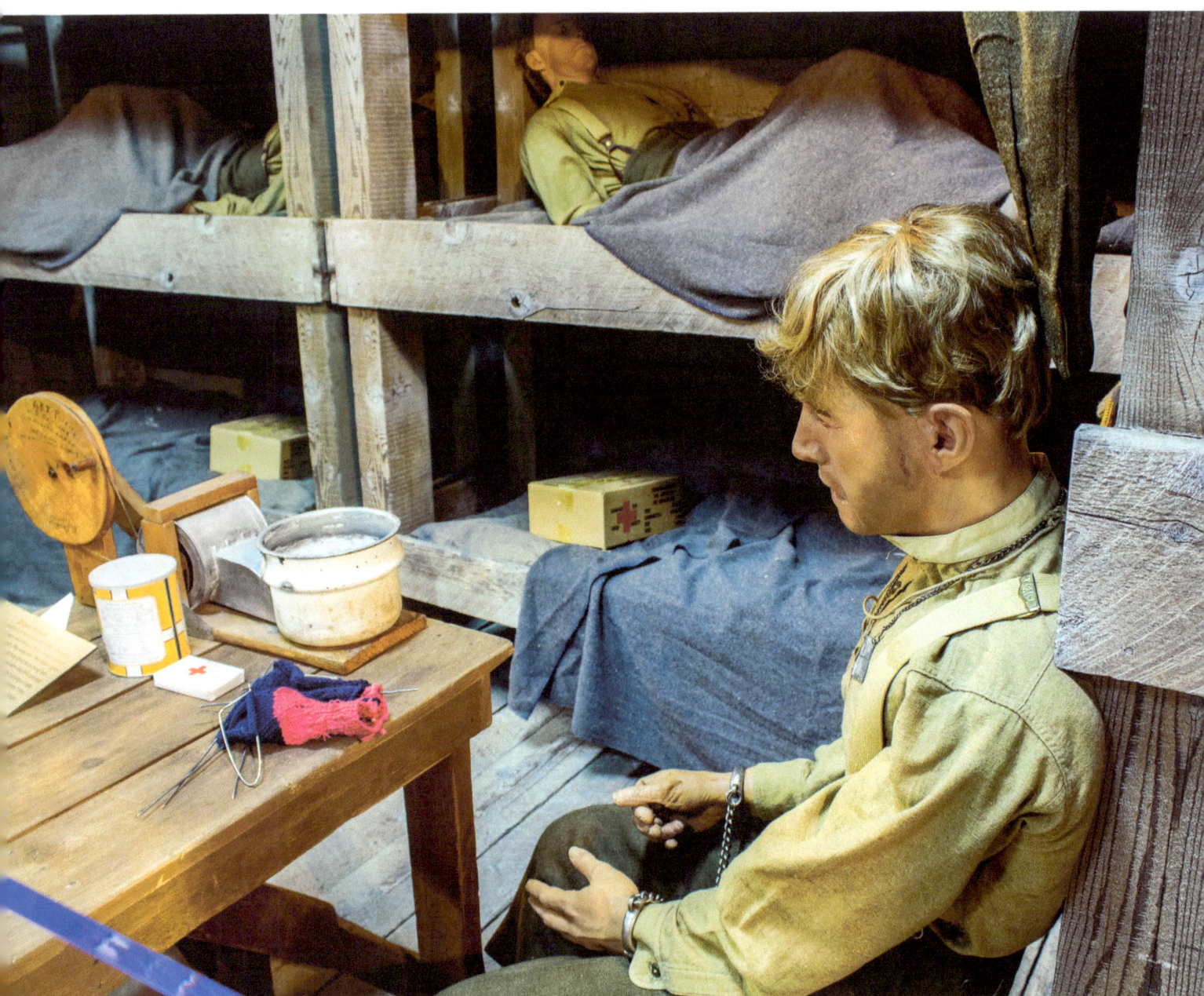

TREASURING THE TRADITION

(OPPOSITE)
Exhibit depicting Calgary Regiment Dieppe prisoners of war in the King's Own Calgary Regiment gallery. This exhibit was originally designed and built by Calgary Regiment Dieppe veterans.

(BELOW, LEFT)
14th Canadian Armoured Regiment (Calgary Regiment) cap badge, handmade by a Calgary Regiment Dieppe POW. The cap badge is fabricated from scrap metal and tin foil. Collection of the King's Own Calgary Regiment (RCAC) Museum.

(BELOW, RIGHT)
Exhibit in the King's Own Calgary Regiment gallery showing a ⅔ replica model of the Churchill tank "Calgary" disembarking from a Landing Craft Tank during the Dieppe Raid, 19 August 1942.

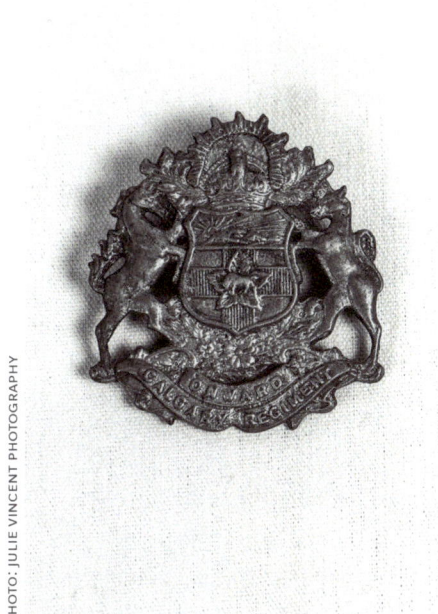

PHOTO: JULIE VINCENT PHOTOGRAPHY

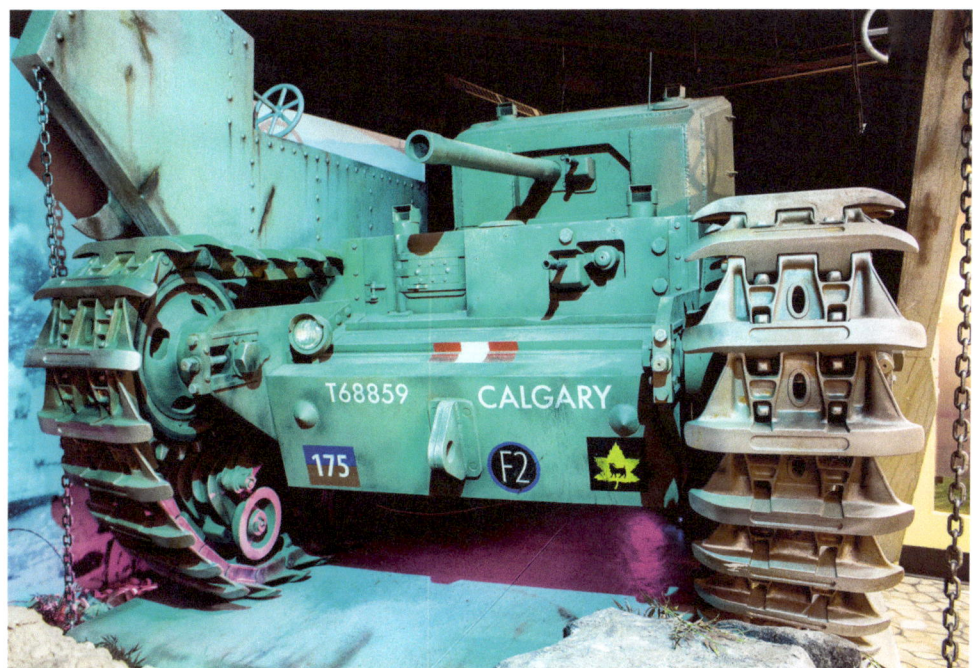

A MILITARY COMMUNITY

No. 3 Service Flying Training School, Lincoln Park, Calgary, Alberta, ca. 1939–45. Courtesy of Glenbow Archives, Glenbow Library and Archives, University of Calgary. Modifications to this image include cropping.

bases that during the war prepared some one hundred and thirty-one thousand air crew personnel, nearly seventy-three thousand being Canadian. This included several facilities in Calgary. The No. 3 Service Flying Training School operated out of Currie Barracks, in an area where Mount Royal University is currently located. McCall Field, which is presently the south end of Calgary's International Airport, housed the No. 37 Service Flying Training School. The No. 2 Wireless Training School was located in a space that now houses the Southern Alberta Institute of Technology. Calgary was also home to the No. 4 Air Training Command, the No. 10 Repair Depot, and the No. 11 Equipment Depot. One trainee who arrived from Moose Jaw recalled Calgary as a "mecca for airmen" and the city's Palliser Hotel as their unofficial social club.

In October 1950, Currie Barracks became known as the Calgary Garrison through which numerous army formations cycled. This included Princess Patricia's Canadian Light Infantry, which in June 1946 relocated its headquarters from

Winnipeg to Calgary. The Air Force, in a section of the facility now known as Lincoln Park, continued its presence with a repair depot and as a fighter pilot training centre, though in 1958 that changed to preparing air transport personnel.

With Calgary's population growing and spreading geographically after the Second World War, the garrison became increasingly surrounded by residential settlement. The base itself became reflective of this trend. Temporary accommodation was demolished and replaced by married living quarters. Protestant and Roman Catholic chapels appeared, as did an elementary school for the children of military personnel.

The RCAF discontinued flights at Lincoln Park in 1964. Some of the land used for this purpose went to the Army. Other parts were sold to the city government, which used it to expand residential and commercial activity, to support the relocation of Mount Royal College, and to establish the ATCO Industrial Park. Land remaining with the Army became known as Canadian Forces Base (CFB) Calgary, which was inaugurated on 14 March 1966. The renaming reflected the unification of the Canadian Forces. Minister of National Defence Paul Hellyer proposed this to the House of Commons on 26 March 1964 and it was officially enacted on 1 February 1968; the Canadian Army became known as Mobile Command. By the 1970s, the Calgary International Raceway was using the former north-south air landing strip for drag racing. In September 1981, forty-eight hundred hectares of land was returned to the Sarcee Nation, which had become known as the Tsuu T'ina Nation.

By the mid-1980s, Calgary was home to two thriving military bases and a number of reserve formations. Each of the city's four main regiments—Lord Strathcona's Horse (Royal Canadians), the King's Own Calgary Regiment (Royal Canadian Armoured Corps), Princess Patricia's Canadian Light Infantry, and the Calgary Highlanders—attempted to preserve their history and heritage. The Canadian regimental system, patterned after Britain's, permitted individual regiments to develop distinctive qualities, such as the look of their uniform. The purpose was to instill a sense of identity, mutual loyalty, and esprit de corps. Regimental histories and traditions were preserved through historical records, books, and artifacts. The Calgary regiments had all these, but due primarily to lack of room or space, they were stored in as many nooks and crannies as possible in buildings on the bases and in the Glenbow Museum in downtown Calgary.

The collection of the King's Own Calgary Regiment was housed in two small rooms in the Mewata Armoury, and was accessible only by appointment. Older uniforms were placed in dry-cleaning bags, and uncatalogued and unprotected archival documents were piled on shelves. Calgary's Glenbow Museum, whose mandate was to collect material relating to western Canadian history, stored the Calgary Highlanders' collection. The collection related to Princess Patricia's Canadian Light Infantry enjoyed more storage space in a building at Currie Barracks with a rather expansive display on its main floor. Three military personnel managed it, and it attracted up to five thousand visitors annually. However, the space lacked suitable security, temperature and humidity controls, and lighting. Lord Strathcona's Horse Regimental Museum and Archives was also housed at Currie Barracks. Although a small number of non-commissioned members worked at keeping the collection organized, the job was almost impossible due to restricted space, which also largely precluded its display for visitors.

Starting in the mid-1980s, discussions began between the four regiments, along with a number of well-connected private citizens with a high interest in military matters, about pooling resources to create a new facility that could properly store and exhibit all of Calgary's army heritage. Surveys concluded that such a place would have wide public appeal. For instance, annual attendance at the Glenbow, which was used as a model, topped 130,000.

But where? The Calgary Board of Education had been operating a school named for Sir Sam Steele at Currie Barracks since 1964. By 1987, it was slated for closure and to be handed back to the Department of National Defence for a nominal sum. It was a likely site, but much reconstruction was necessary for it to become a museum.

The backers of the museum project quickly realized that some sort of legal entity would be required to raise funds for the new facility and to pay for its staff and upkeep. Thus the Calgary Military Museums Society (CMMS) was incorporated in March 1987 as a charitable organization to pursue those goals. Its bylaws stated that its Board of Directors had to include the commanding officer—or delegate—from each of the four regiments, the deputy commander of CFB Calgary, and ten associate members. It was an impressive and influential group, largely comprised of former military leaders, most of whom were generals.

By 1988, the CMMS had seized the opportunity to pursue redevelopment of the school. Engineers judged the building to be in good physical shape. An independent study done with the aid of the Provincial Museum and Archives in Edmonton favourably assessed its potential to house and display the regimental collections. Adequate space was also identified in a remodeled structure for visiting exhibits, storage, a cafeteria, an archives, a library, and administrative offices. Its location was considered an advantage, being highly visible along Crowchild Trail where some fifty thousand vehicles passed daily.

The estimated cost of converting the school into a museum was $6.5 million. The plan was to have one permanent exhibit dedicated to each of the four regiments. A fifth exhibit hall would cover major aspects of Southern Alberta's military experience on land, such as relating to Indigenous communities and the North-West Mounted Police, the Alberta Field Force and its role in the Riel Rebellion, early militia and life at Sarcee Camp, and local involvement in battles and peacekeeping operations. A small gallery would be used for temporary or travelling exhibits.

The job of turning the former school into a museum would take money, and the Department of National Defence had precious little of that to invest in such a project. The next phase required massive fundraising from local individuals and businesses, and all levels of government.

THE KING'S OWN CALGARY REGIMENT (RCAC) MUSEUM & ARCHIVES

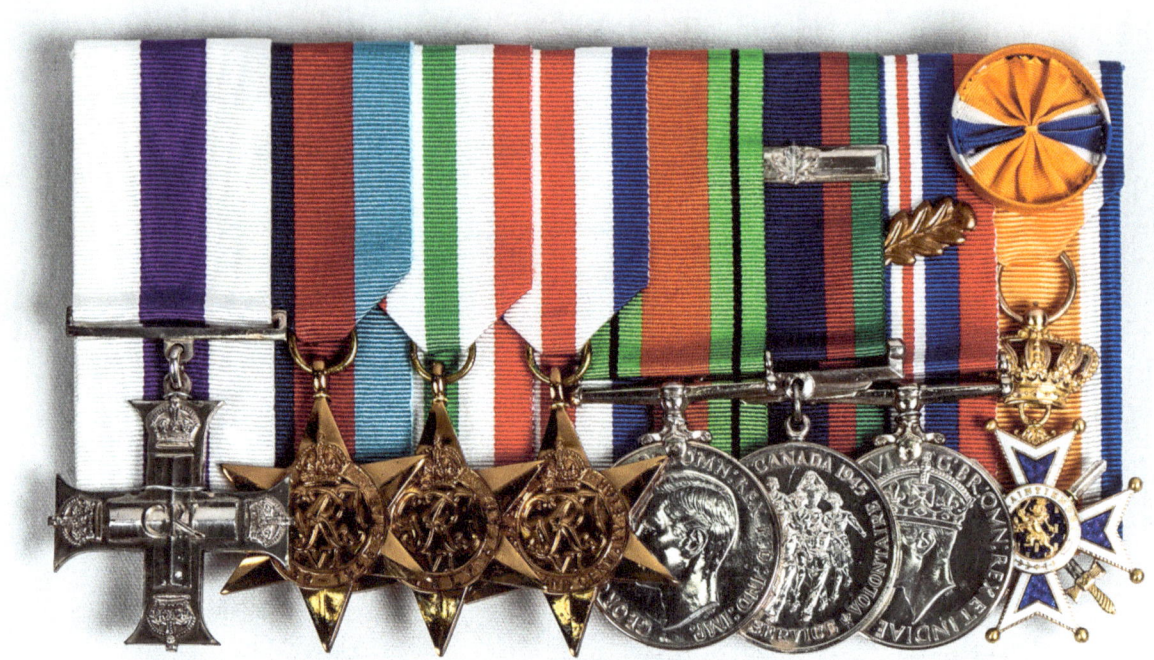

PHOTO: JULIE VINCENT PHOTOGRAPHY

Medals group of Major Fred Ritchie, MC, 14th Canadian Armoured Regiment (The Calgary Regiment). From left to right: Military Cross, 1939–1945 Star, the Italy Star, the France and Germany Star, the Defence Medal, Canadian Volunteer Service Medal (with bar), War Medal, with Mention in Dispatches Oak Leaf, and Bronze Cross (Netherlands award). Collection of the King's Own Calgary Regiment (RCAC) Museum.

(ABOVE)
Ceremonial riding troop cap, King's Own Calgary Regiment (RCAC). Although the ceremonial riding troop for Lord Strathcona's Horse (RC) continues into the 21st century, the King's Own Calgary Regiment troop only lasted three years in the 1950s. As such, this is a very rare object. The riding troops for both units hearken back to earlier days, before the advent of mechanized warfare—both units are now armoured regiments. Collection of The King's Own Calgary Regiment (RCAC) Regimental Museum & Archives.

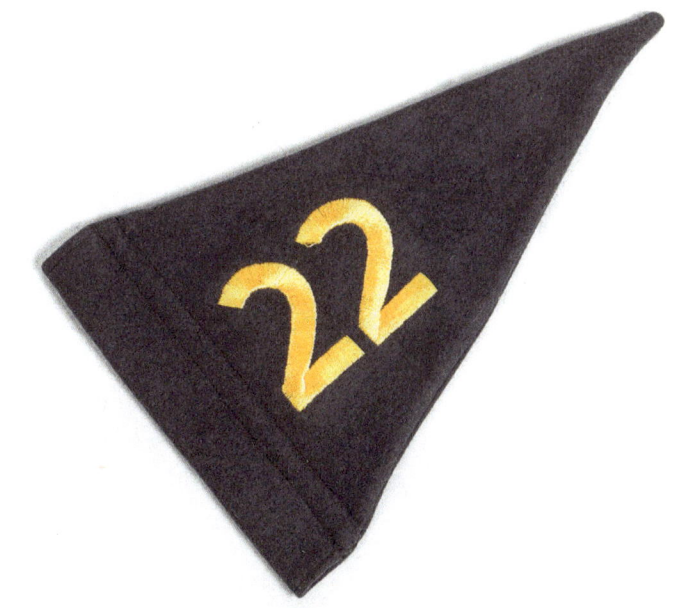

(BELOW)
Pennant, 22nd Militia Group. This pennant was used by W. A. Howard when he was Colonel Commandant. Howard was a prominent Calgary lawyer and retired as a Major General. The library at The Military Museums is named for him. Collection of The King's Own Calgary Regiment (RCAC) Regimental Museum & Archives.

PHOTOS: JULIE VINCENT PHOTOGRAPHY

LORD STRATHCONA'S HORSE (ROYAL CANADIANS) MUSEUM & ARCHIVES

(LEFT)
First World War field service cap, Lord Strathcona's Horse (Royal Canadians). Worn by Johnson Lionel Cox, who was wounded at the battle of Moreuil Wood, 30 March 1918—one of the last Canadian cavalry charges in history. Collection of Lord Strathcona's Horse (RC) Museum & Archives.

(BELOW, LEFT)
Strathcona hat/cap badge (left) and collar dog (right) authorized for wear in 1912. It was no longer commonly worn as of the 1920s. Collection of Lord Strathcona's Horse (Royal Canadians) Regimental Museum.

(BELOW, RIGHT)
Souvenir tour ring from Cyprus, 18-carat rose gold, featuring a Strathcona badge with United Nations and Cyprus imagery. Owned by Warrant Officer Clement. Collection of Lord Strathcona's Horse (Royal Canadians) Regimental Museum.

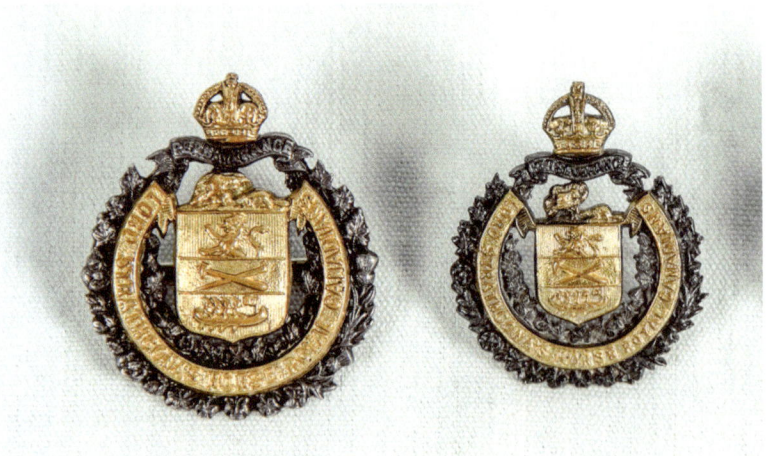

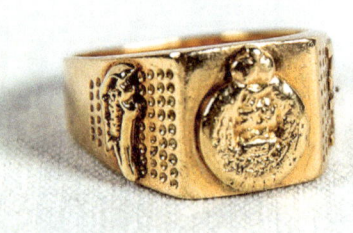

PHOTOS: JULIE VINCENT PHOTOGRAPHY

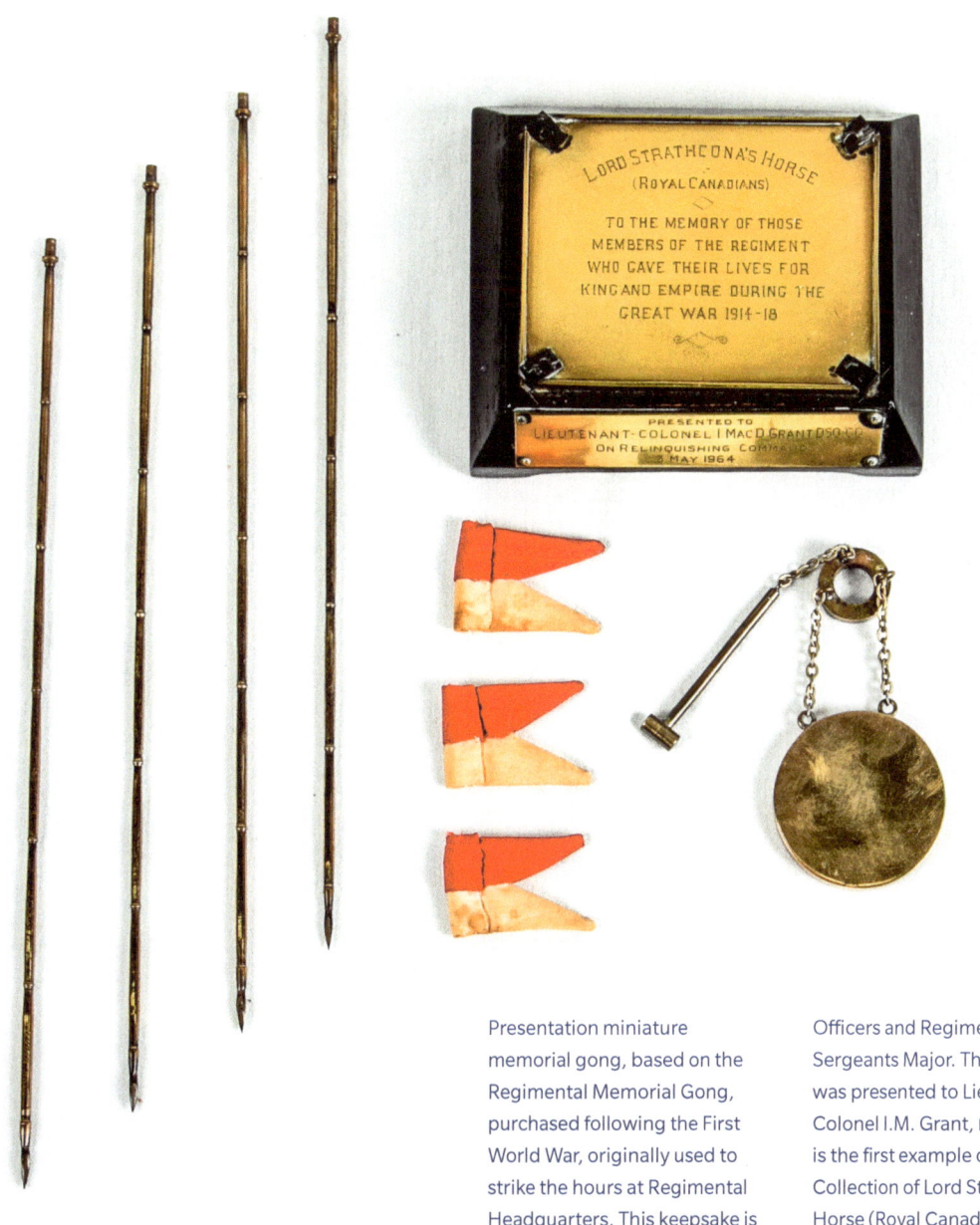

Presentation miniature memorial gong, based on the Regimental Memorial Gong, purchased following the First World War, originally used to strike the hours at Regimental Headquarters. This keepsake is given to outgoing Commanding Officers and Regimental Sergeants Major. This example was presented to Lieutenant-Colonel I.M. Grant, DSO, and is the first example of its kind. Collection of Lord Strathcona's Horse (Royal Canadians) Regimental Museum.

PHOTO: JULIE VINCENT PHOTOGRAPHY

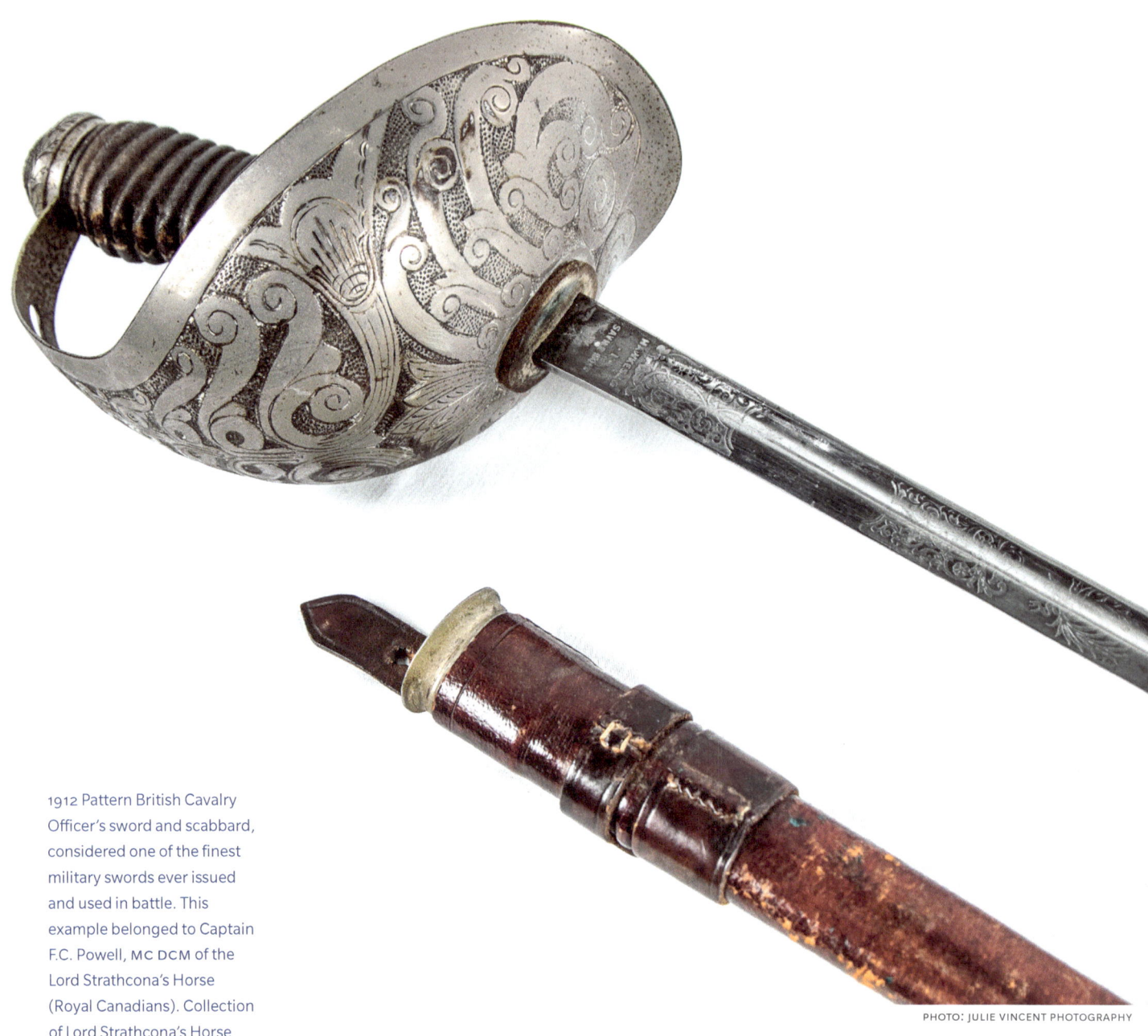

1912 Pattern British Cavalry Officer's sword and scabbard, considered one of the finest military swords ever issued and used in battle. This example belonged to Captain F.C. Powell, MC DCM of the Lord Strathcona's Horse (Royal Canadians). Collection of Lord Strathcona's Horse (Royal Canadians) Regimental Museum.

PHOTO: JULIE VINCENT PHOTOGRAPHY

2

A MUSEUM FOR THE REGIMENTS

By 1988, CMMS had an old empty school building in the middle of the Currie Barracks family quarters with no infrastructure, no exhibits, and no managing staff. More importantly, it had no money. Plans were laid to remedy all these problems. First came the money. Calgary had a long military history and housed two large bases. Many retired personnel stayed in the city after leaving the military and a sizeable number found their way into Calgary's burgeoning oil and gas business. Several large corporations were headquartered in the city and other companies had major branch offices there. These companies were targeted for fundraising as were wealthy individuals with military ties or military backgrounds. For some time, Lord Strathcona's Horse had put on "Businessmen's Lunches," known as BMLs, one Friday every month where local business leaders and members of the Calgary Garrison met and mingled over food and drinks. These BMLs drew in even more potential donors. The CMMS also sought to raise $2.5 million from the federal government and the Department of National Defence, $1.5 million from the provincial government, and $800,000 from the municipal government. Calgary was just recovering from another one of its boom/bust cycles in the late 1980s, so fundraising was somewhat slow at first, but then the money started rolling in.

At the beginning of the campaign, the effort was headed by a committee of wealthy notables and military representatives chaired by Stan Waters, the former Commander of Force Mobile Command. The committee would meet every two weeks for a 7:00 a.m. breakfast at the Petroleum Club. Stan kept a "to do" list in his

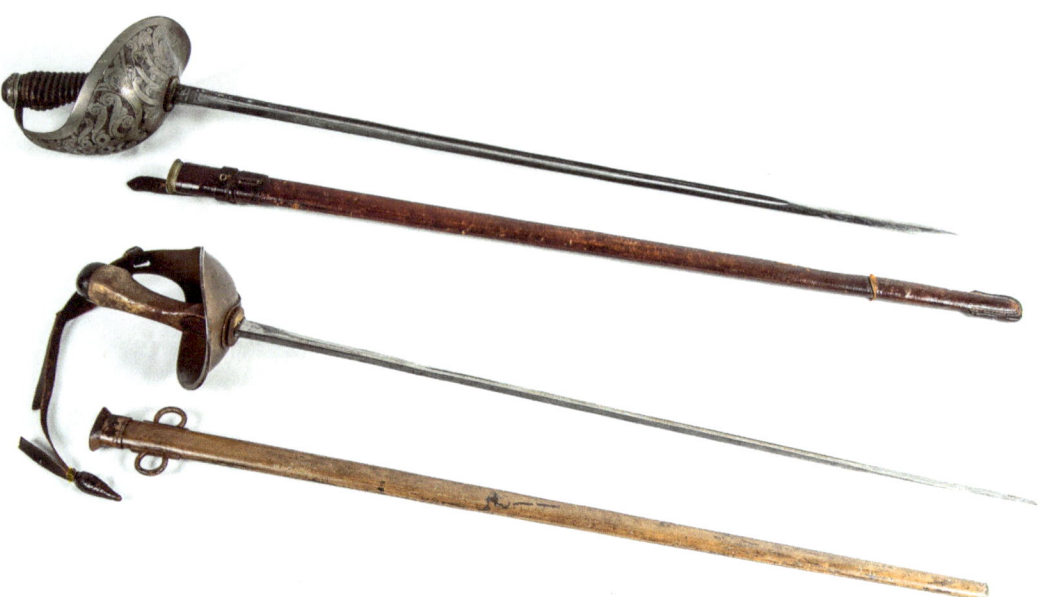

(ABOVE)
1912 Pattern British Cavalry Officer's sword and scabbard.

(BELOW)
1908 Pattern Cavalry Trooper's sword and scabbard. This belonged to Trooper James Elvin Cox, Lord Strathcona's Horse (Royal Canadians). Cox was wounded at the battle of Moreuil Wood, one of the last great cavalry charges of the First World War. Very similar to the 1912 Pattern, the 1908 was less ornate and designed to be purely functional. Collection of Lord Strathcona's Horse (Royal Canadians) Regimental Museum.

head. At one such meeting he questioned a prominent oilman who had pledged to raise a million dollars. The oilman had just started to eat a forkful of scrambled eggs when Waters asked him where the million dollars was. The oilman said that he had collected $700,000; Waters brusquely asked him where the other $300,000 was—retired Lieutenant-General Waters was not afraid to confront any members of the committee.

The plan to operate the museum was to have a museum director set overall strategy, assisted by a managing curator and supported by a mix of civilian employees and military personnel. The four regiments would coordinate with the director, but still manage their own personnel—namely regimental members and volunteers—and individual collections.

For several years while fundraising was going on, different people tried to manage the museum as a single unit within the Department of National Defence. It was a difficult job, like trying to herd cats, and it did not work. Then Ian Barnes was hired as the museum's first paid director. Barnes began to cajole and convince

the regiments to work together on planning the museum infrastructure and prospective general programing, while independently operating their own facilities within the future building.

The changes and upgrades needed to transform the former school into a museum were substantial: flooring, lighting, ventilation, window coverage, security, fire protection, and the provision of proper storage and display facilities.

The museum was promoted for its ability to educate people, especially the young, about the centrality of military history to Calgary's, Alberta's, and Canada's past. It would also provide another major tourist attraction, taking advantage of the fact that in 1986 some 6.9 million people visited Calgary, a 17 per cent increase over 1985. Future growth was projected with the city slated to host the 1988 Winter Olympics.

Numerous groups expressed support for a new museum, including school boards, the Calgary Police Service, the RCMP, the Canadian Armed Forces, museum associations, management of the Calgary Stampede, and the city's Chamber of Commerce. Publicity and fundraising campaigns launched under the motto, "Treasure the Tradition." A mobile display of military artifacts travelled to schools and various public venues across Calgary to raise awareness and support. The campaign linked itself to what was cast as the entrepreneurial, optimistic, can-do attitude typifying the region, as promotional literature declared: "It took grit and determination to settle the west, co-operation to civilize it, perseverance to help it grow and prosper, and courage to help keep it free. We treasure traditions that reflect them in our collective consciousness. Our military heritage is integral to our Western heritage as is our pioneer tradition in which we take such pride."

The federal government initially provided money for an architectural assessment. CMMS leaders pressured for core funding, emphasizing that contributions from other levels of government would not come unless Ottawa provided its share. It took a year, but a $945,000 grant from the federal Department of Communications got the ball rolling, convincing other public sources to pitch in according to the goals the CMMS established.

Numerous companies delivered large donations, many well into the five figures, including Shell, Husky, Trans Canada Pipelines, and Amoco Petroleum. Bingo games and benefit concerts, including a military tattoo, raised well over $100,000. In October 1988, the CMMS borrowed $78,000 to purchase a Mercedes Benz 560

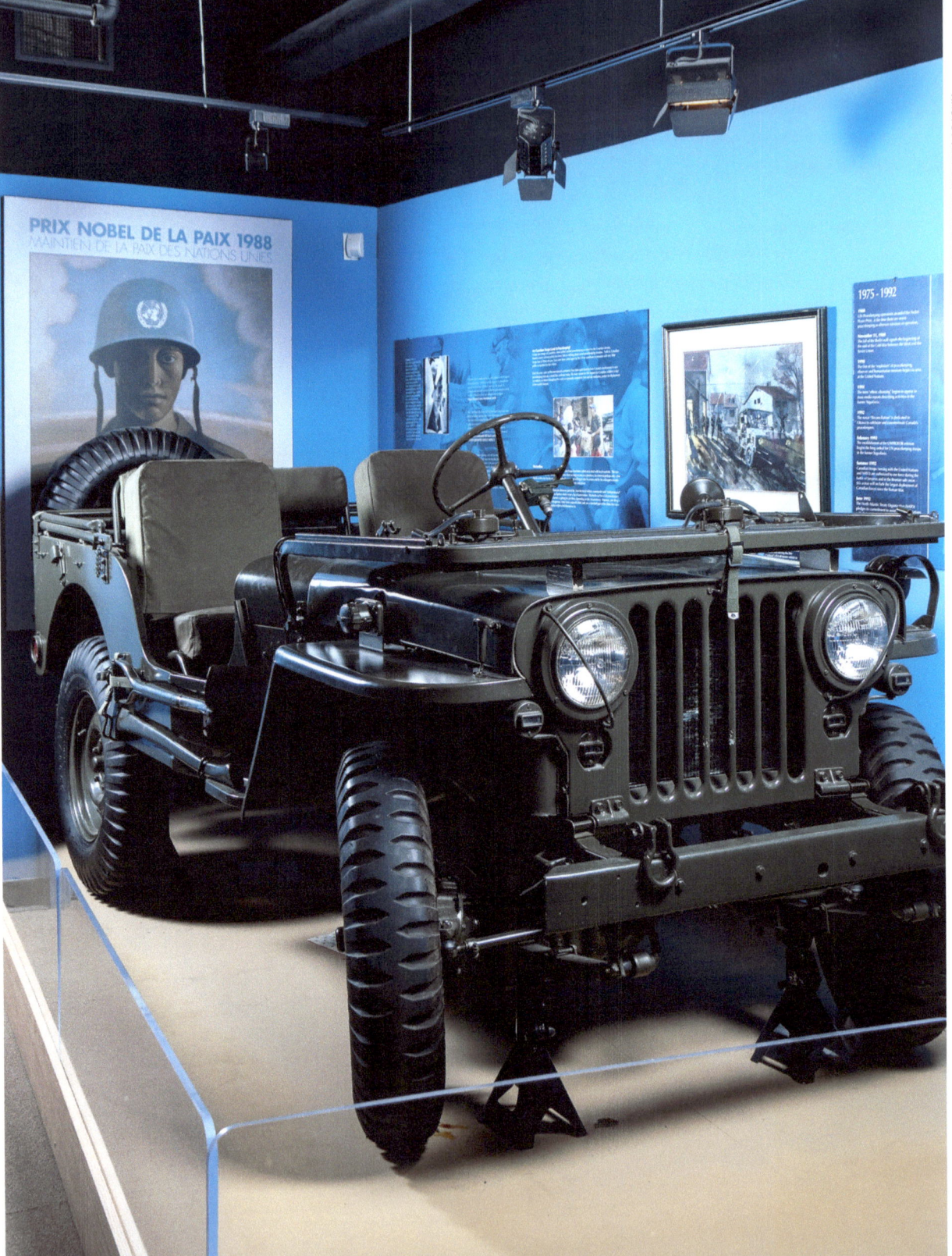

Coupe Roadster, a top end sports luxury car, which it raffled off for tickets costing $100 each, making another $100,000 in profit.

Those running the fundraising campaign emphasized the intent to create a dynamic institution, not a stuffy, staid, temple to the past. As the collections grew out of regimental activities, the preponderance of artifacts were strictly military in nature: weapons, uniforms, medals, maps, photos, and larger items such as artillery, motorcycles, jeeps, and even tanks. Many items were tied to individuals, like the Victoria Cross, on loan to the museum, posthumously awarded to Strathcona Lieutenant Gordon Muriel Flowerdew, who was mortally wounded while leading one of the last cavalry charges of the First World War at the Battle of Moreuil Wood in March 1918.

The goal of every exhibit was to immerse visitors in the stories being told, having them interact with military history whenever possible, such as by walking through a trench, rather than only viewing items in locked cabinets. The museum would pay homage to past sacrifice, but not indulge in nostalgia. "We seek no glorification of war," went one CMMS report, "but rather an attractive and tasteful museum where its means and consequences, military, economic and social, may be viewed and reflected upon by people of all ages."

The Queen was anticipated to visit in 1990 to present colours to the Calgary Highlanders and review her other regiment, the King's Own Calgary Regiment. Fred Mannix, the honorary colonel of the Highlanders, had long been interested and involved in military affairs. He was also a driving force behind the fundraising for the museum. As honorary colonel, it was his privilege to visit the Queen once a year to report on the progress of the regiment. He was anxious to see her in 1987 to also explain the museum project and issue a personal invitation for her to officially open the new museum while she was in Calgary in 1990. Fully decked out in his dress uniform complete with sword, dirk, and honours, he attended her at Buckingham Palace in 1987 and was surprised by her considerable knowledge of the Calgary Highlanders. Mannix was supposed to spend the customary seven minutes allotted to the Queen's visitors, but the conversation ran on for three-quarters of an hour. Mannix showed her the regimental book the Highlanders were preparing and reported that they were commissioning official histories of the regiment in both World Wars. He also explained the museum project, which she was interested to hear about, noting they were having trouble getting money from the

(OPPOSITE)

M38 CDN Jeep manufactured in 1952 by the Ford Motor Company of Canada Ltd., as seen on display in the Army Museum of Alberta. This particular jeep served in the Korean conflict. It was very useful on the poor roads in Korea. Collection of the Army Museum of Alberta, donated by the Estate of Randall Anderson.

three levels of government and the private sector. At this point, the Queen said she would open the museum when she was in Calgary, and then all levels of government would put in money—and that he should make sure to ask for enough. When they were done, the Queen took Honorary Colonel Mannix by the elbow to walk him out of the room. He knew that he was supposed to remain two paces behind her; he struggled with his sword (which he had not worn before) and did his best to keep up. When they exited the room, a royal page told Her Majesty that she was quite late; she placed her face close to his and with hands on her hips declared, "We are never late."

Now fundraising and construction of the museum had to proceed as quickly as possible. Indeed, those driving the project used the upcoming June 1990 visit to lobby governments for more money to speed things along. To some controversy, the municipal government contributed an additional $400,000 to get the building to a state where the Queen could visit and dedicate the site, as initially the plan was to open it on Remembrance Day. When the Queen and Prince Philip arrived, their tour was confined to the main foyer since it was actually not until September 1991 that the interior of the building was finished.

With the Museum's opening, a major addition had been made to Calgary's cultural landscape. In its first year of operations, attendance at the new museum far

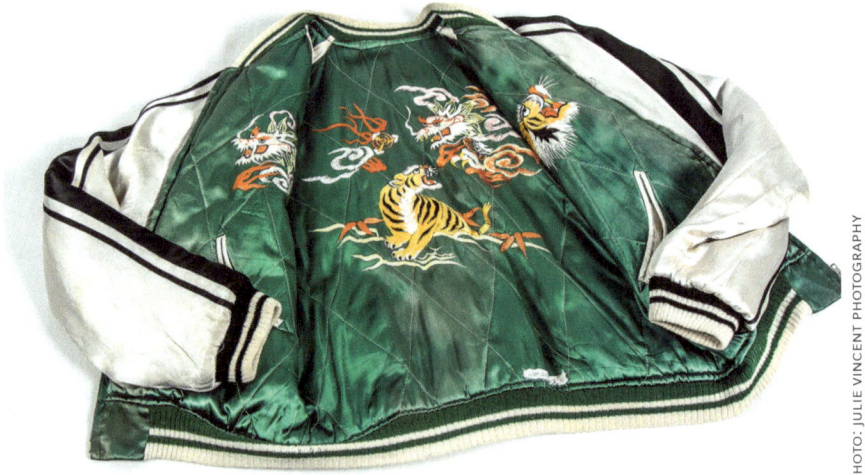

Korean "Souvenir" style Jacket. This silk embroidered jacket was made for an unknown soldier of Lord Strathcona's Horse (Royal Canadians) while serving overseas in the Korean War. Collection of Lord Strathcona's Horse (Royal Canadians) Regimental Museum.

PHOTO: JULIE VINCENT PHOTOGRAPHY

exceeded the number of combined visitors to the previous four separate regimental facilities.

Each of the four regimental collections had common aspects; indeed, a theme running through all was to get visitors to appreciate the "concept of 'the regiment,'" namely as an entity to which its members felt "loyalty, honour, comradery, identity, family, [and] interdependence." The four regimental collections followed a chronological approach spanning from their origins to peacekeeping operations, with the greatest focus being on the World Wars. However, there were many distinct aspects reflecting the fact that they each had different core functions: Lord Strathcona's Horse (Royal Canadians) was primarily a tank regiment; Princess Patricia's Canadian Light Infantry was a regular force infantry regiment; the King's Own Calgary Regiment (Royal Canadian Armoured Corps) was an armoured regiment; and the Calgary Highlanders was a militia infantry regiment.

Each exhibit hall contained numerous unique pieces. Princess Patricia's Canadian Light Infantry's hall included the Ric-A-Dam-Doo, its initial colour designed and hand sewn by Princess Patricia. Lord Strathcona's Horse displayed large road signs brought back from peacekeeping operations in Bosnia-Herzegovina and a small Canadian flag Prime Minister Jean Chrétien autographed when he visited the regiment overseas. Princess Patricia's Canadian Light Infantry focused more than the others on its significant role in the Korean conflict as well as Peacekeeping. The Lord Strathcona's Horse placed more emphasis on its involvement in the Boer War; the King's Own Calgary Regiment on its origins in the 103rd Regiment and its involvement at Dieppe, Sicily, and Italy in the Second World War; and the Calgary Highlanders on perpetuating the 10th

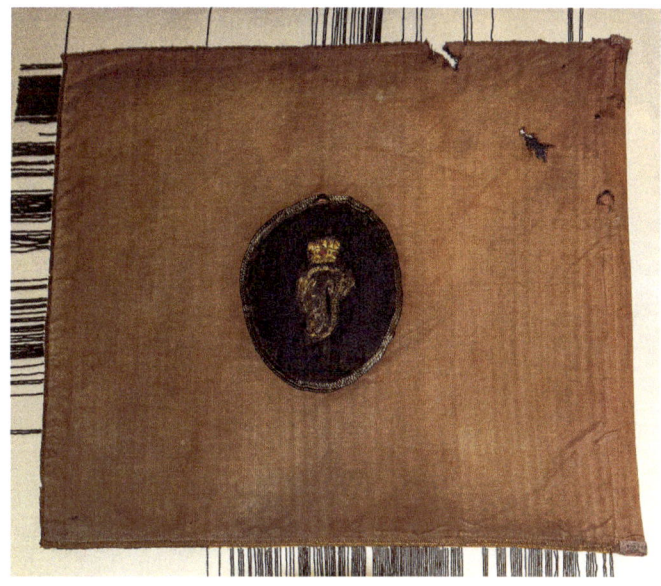

The Ric-A-Dam-Doo was designed and sewn by Princess Patricia and presented to PPCLI on 23 August 1914 to be carried into battle as the Regiment's camp colour. Maroon, blue, and gold, it bears Princess Patricia's cypher "VP". One of the last colours to be carried by infantry into battle, it was officially consecrated on 28 January 1919, and was adorned with the Wreath of Laurel presented by Princess Patricia on 21 February 1919. PPCLI Archives.

A MUSEUM FOR THE REGIMENTS

Battalion (including battle honours) as part of the Canadian Expeditionary Force in the First World War, and as part of the 5th Infantry Brigade, as well as its role in the Battle of the Walcheren Causeway in October 1944.

The museum sought to remain current with academic trends in military history, namely the increasing focus on the social, cultural, and personal impact of war. Its treatment of Indigenous peoples—which expanded over time, both with permanent and temporary exhibits—dealt not only with First Nations participation in the World Wars but also the destructive aspects of interaction with European and Canadian colonizers, such as through the spread of the whiskey trade, the appropriation of Reserve land for military training, and unequal treatment in accessing veterans' programs. In covering the North-West Mounted Police, the museum

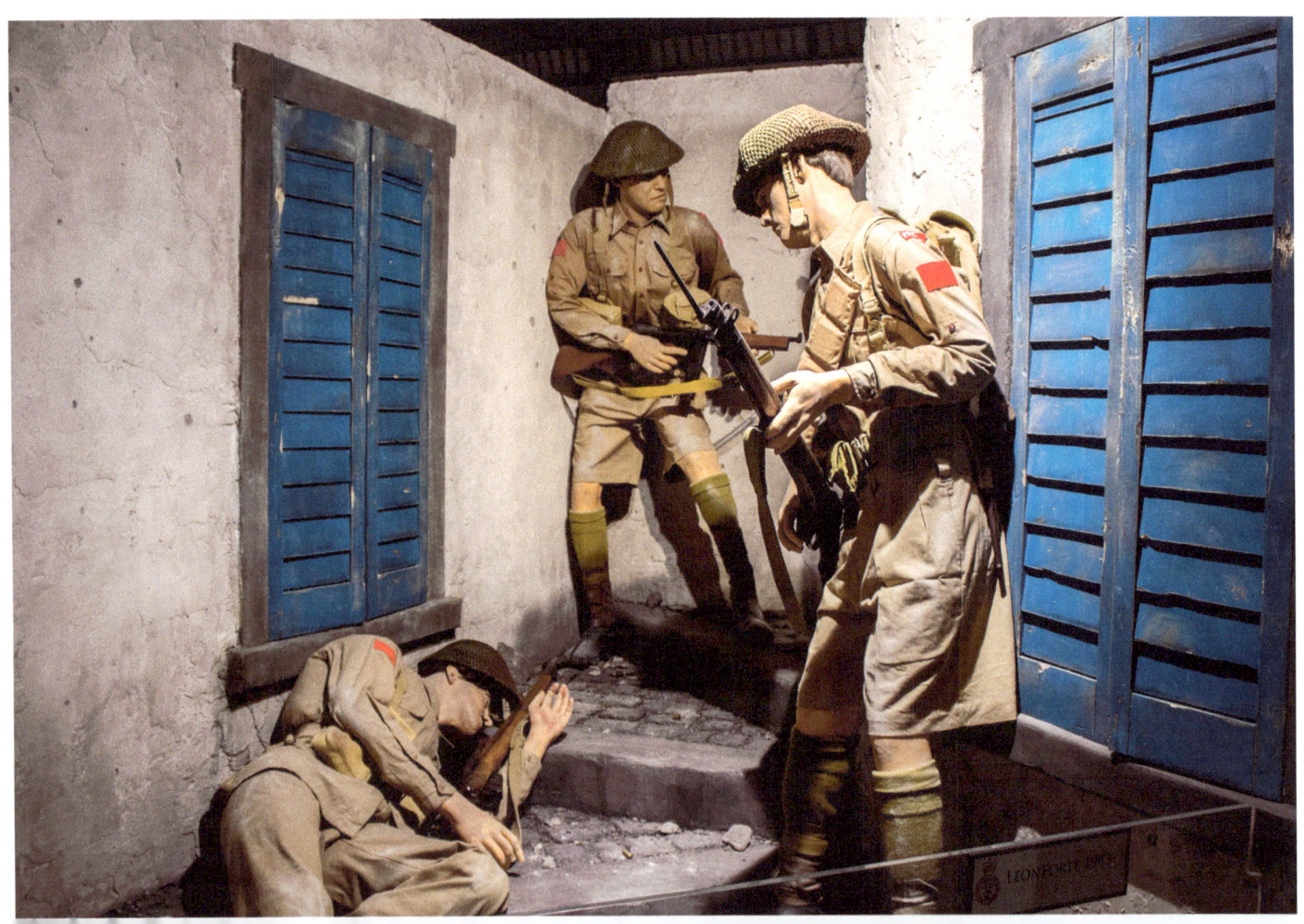

A display in the PPCLI gallery depicts Princess Patricia's in Sicily during the Italian Campaign in the summer of 1943.

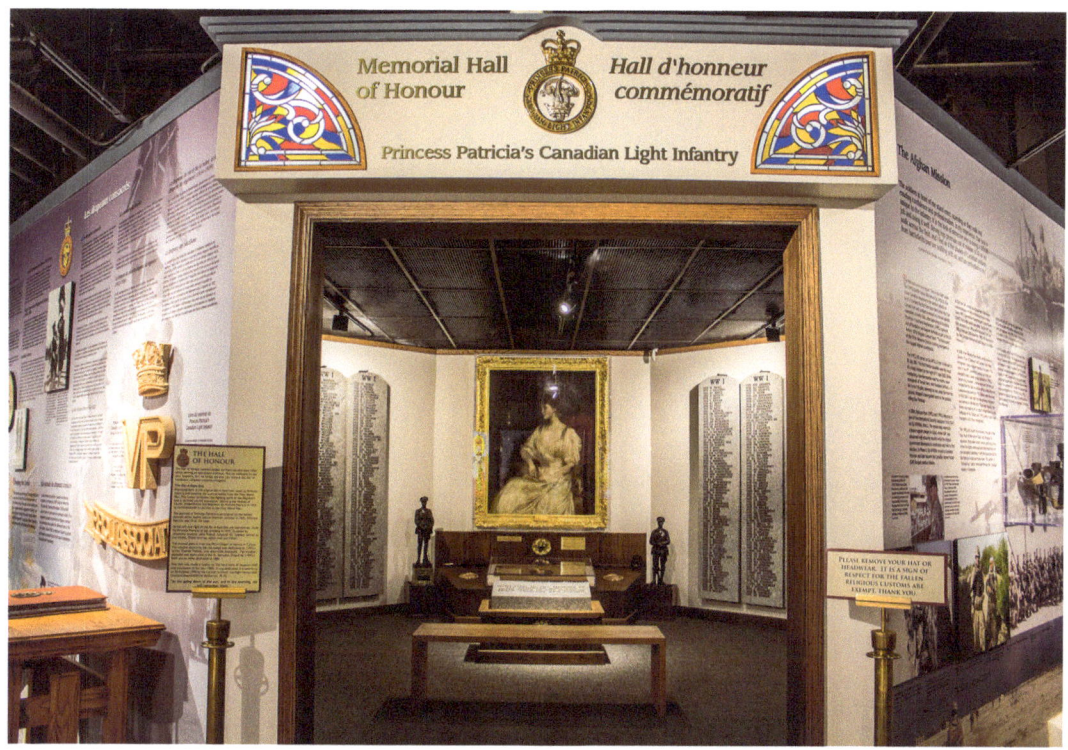

exhibit showed that the NWMP not only brought law and order to the frontier, but also performed numerous other essential services including volunteer fire fighting, delivering mail, patrolling the international border, acting as customs agents, caring for the ill, while their posts served as community social centres. A re-creation of the Sarcee training camp allowed museum visitors to peer into army tents and to climb on board a replica of the streetcar that travelled between the city and the training facility. And when it came to the representation of Currie Barracks and Lincoln Park, it was thought that visitors, particularly children, would be attracted by the opportunity to enter a cockpit of an Anson Mark II, the standard aircraft used for preparing those seeking to qualify as pilots under the British Commonwealth Air Training Plan.

The Patricia's Memorial Hall of Honour at the museum, where the names of all of the Regiment's Fallen are stoically engraved in stone.

PRINCESS PATRICIA'S CANADIAN LIGHT INFANTRY IN THE FIRST WORLD WAR

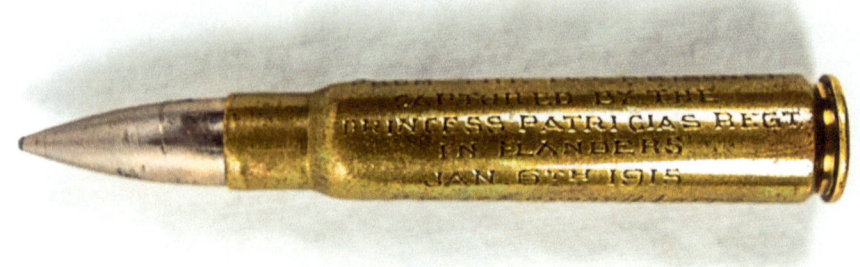

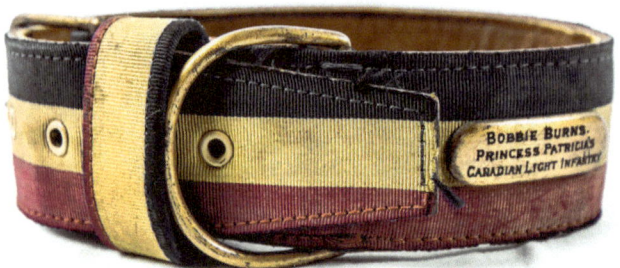

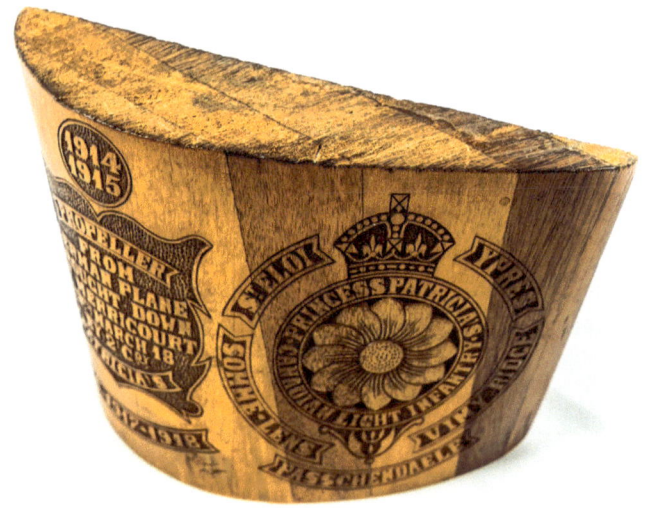

(ABOVE) Cartridge engraved with "taken from the 1st prisoner captured by the Princess Patricia's Reg't in Flanders January 6, 1915 by 1st Sgt H. Lofts."

(LEFT, ABOVE) Collar belonging to PPCLI's first mascot, collie Bobbie Burns. Burns belonged to a PPCLI original, Lieutenant Jack Munroe; both survived the First World War.

(LEFT, BELOW) Piece of a plane propeller scavenged from German aircraft shot down by PPCLI. The Regiment's original cap badge, the "Marguerite," is carved into the wood.

PHOTOS: JULIE VINCENT PHOTOGRAPHY

First World War tunic and helmet belonging to Andrew Hamilton Gault, who joined Princess Patricia's Canadian Light Infantry in August 1914. Despite being wounded several times and losing a leg, he would remain active with the Regiment throughout and after the war until his death in 1958.

All items from the collection of the Princess Patricia's Canadian Light Infantry (PPCLI) Museum and Archives.

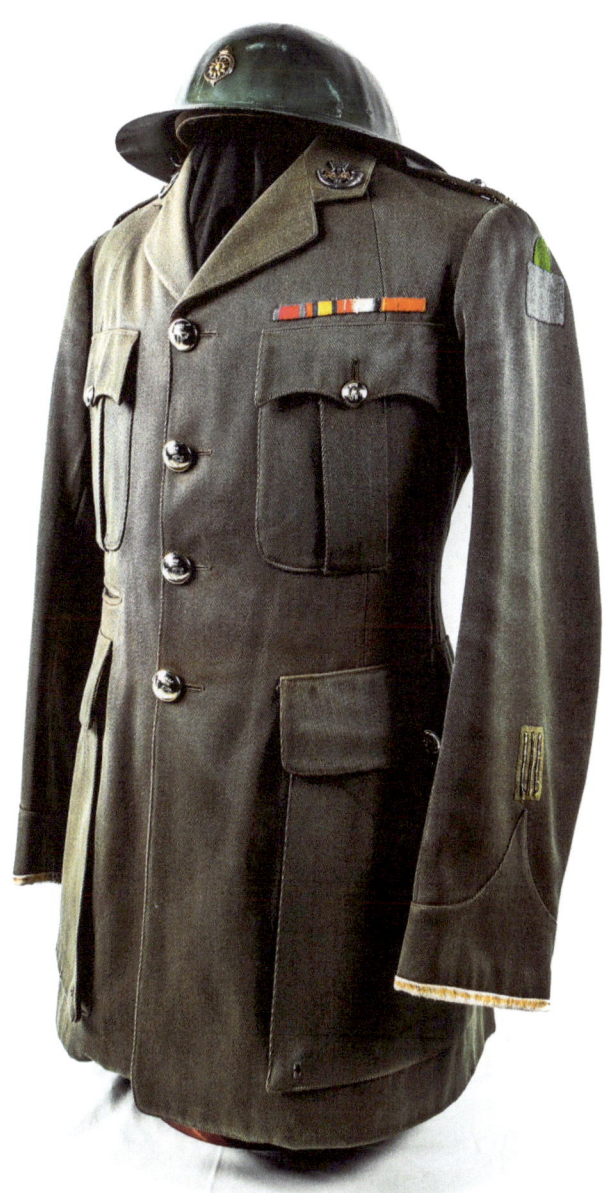

PHOTO: JULIE VINCENT PHOTOGRAPHY

PRINCESS PATRICIA'S CANADIAN LIGHT INFANTRY MUSEUM & ARCHIVES

(RIGHT)
Russian gold pencil case designed by a workmaster to Peter Carl Fabergé. Inscription reads: "H.R.H Princess Patricia from WO's [Warrant Officers], NCO's [Non-Commissioned Officers] & Men, PPCLI, Xmas 1916."

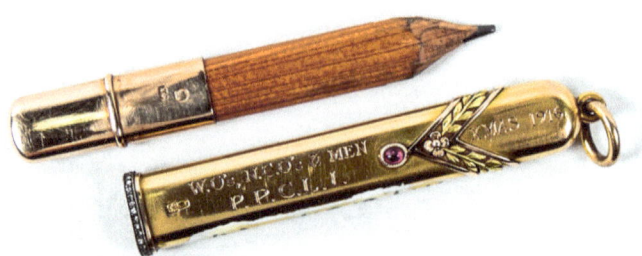

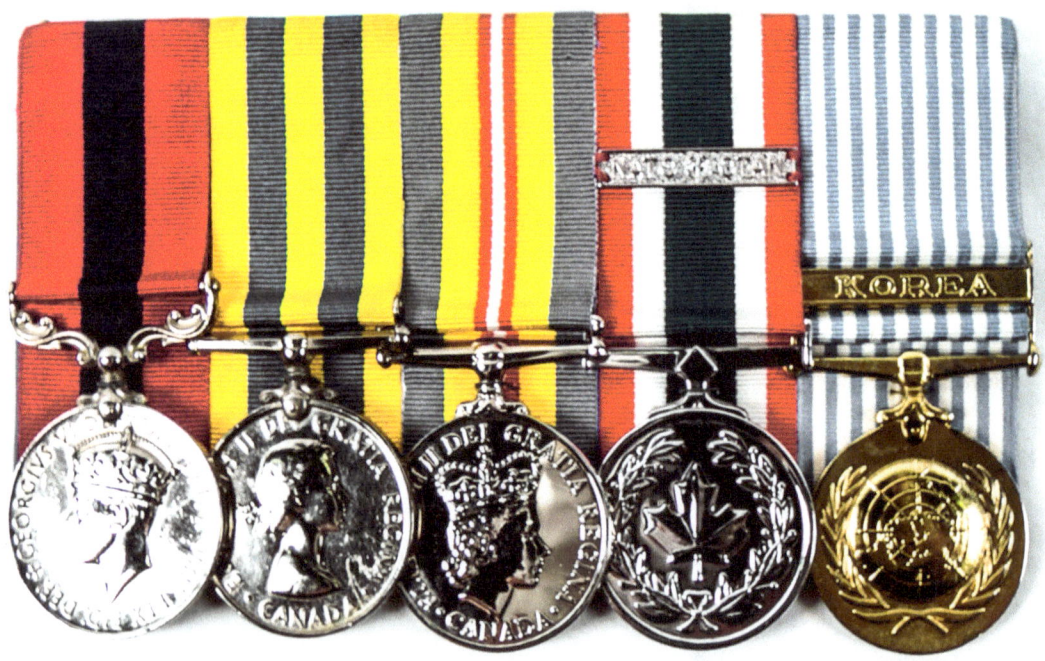

PHOTOS: JULIE VINCENT PHOTOGRAPHY

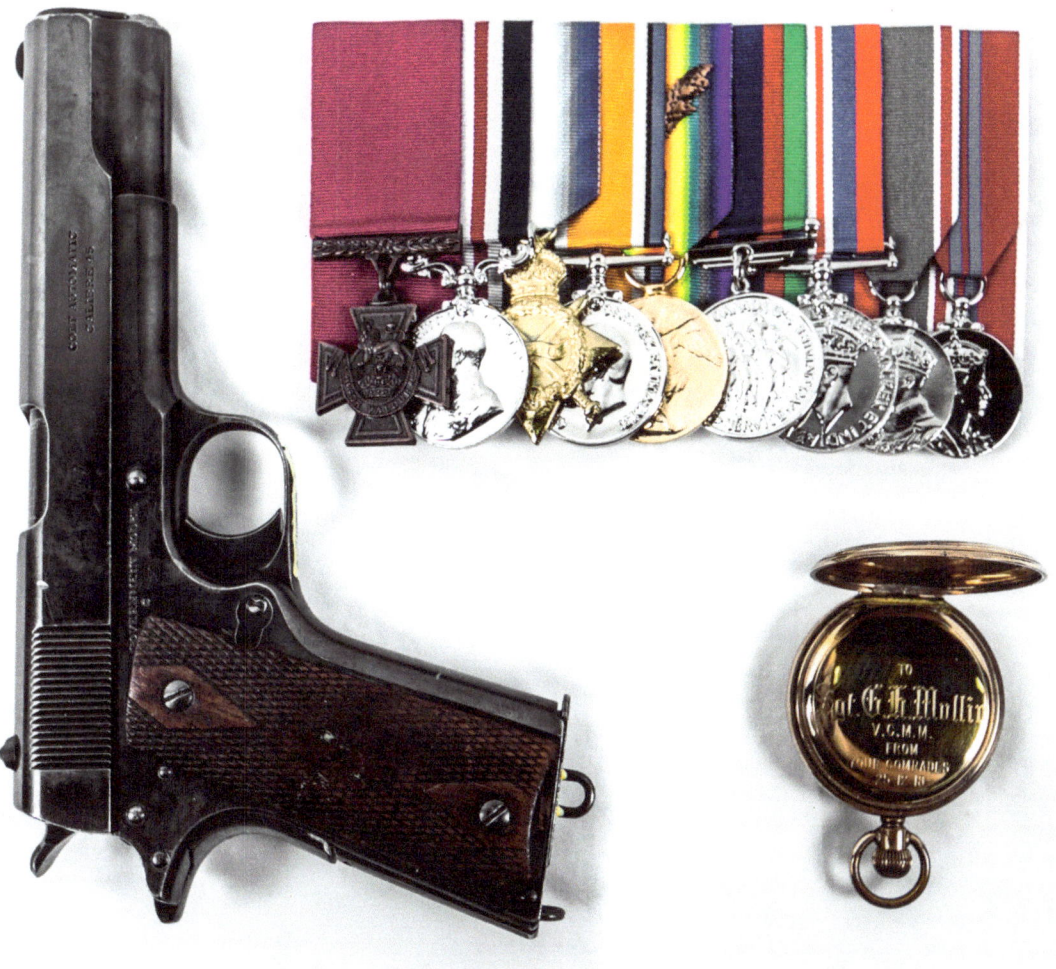

PHOTO: JULIE VINCENT PHOTOGRAPHY

(OPPOSITE)
Medal set of Private Wayne Robert Mitchell. He was awarded the Distinguished Conduct Medal for his actions at the Battle of Kapyong, Korea, 1951. Collection of PPCLI Museum and Archives.

(ABOVE)
At the Battle of Passchendaele on 30 October 1917, Sergeant George Harry Mullin attacked a pillbox, for which he was awarded the Victoria Cross. Fellow Patricia Lieutenant Hugh McKenzie was similarly awarded for directing this assault. Pictured are Sergeant Mullin's pistol, medal set, and engraved pocket watch. Collection of PPCLI Museum and Archives.

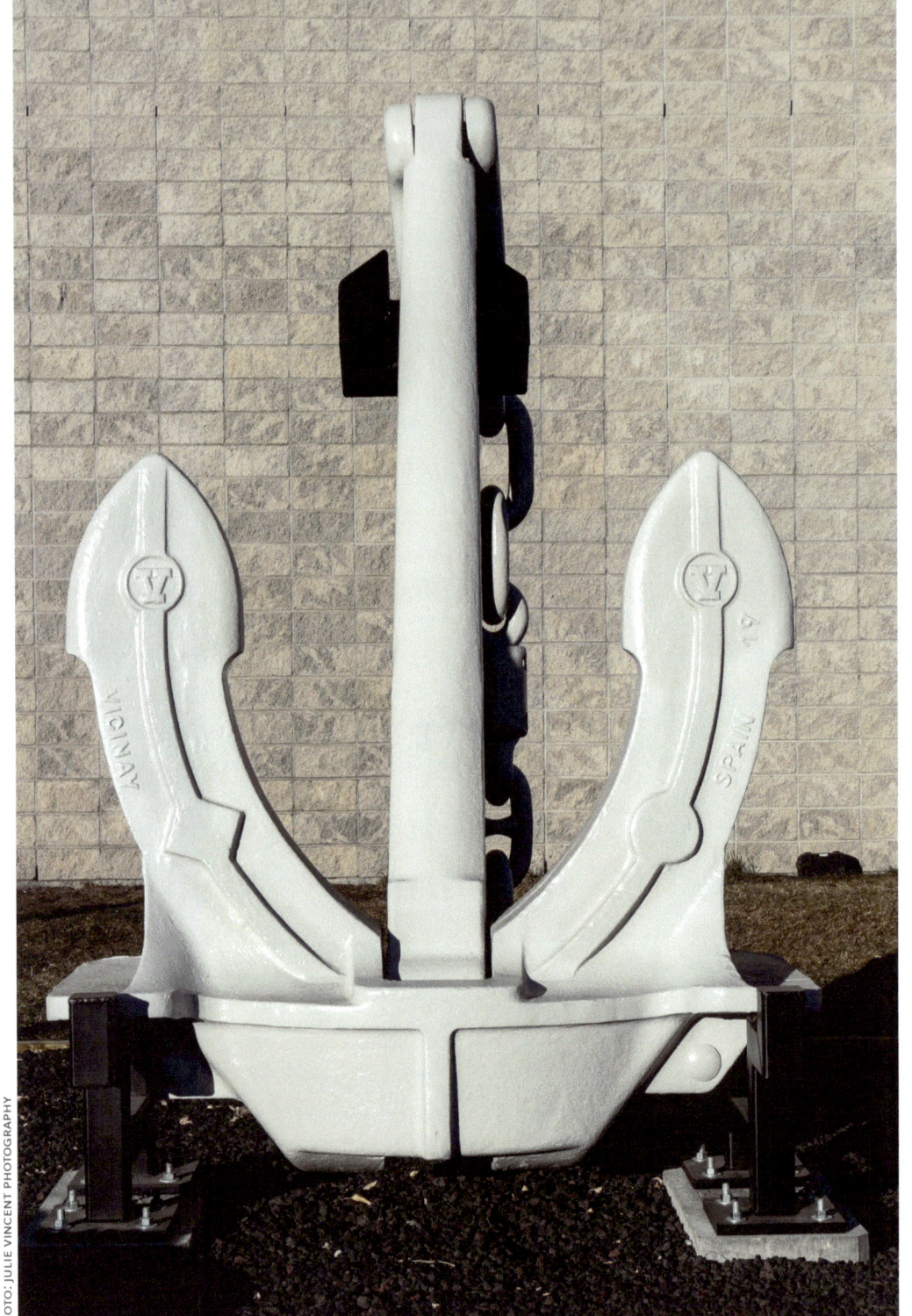

PHOTO: JULIE VINCENT PHOTOGRAPHY

The anchor from HMCS *Protecteur* outside the Naval Museum of Alberta. Collection of the Naval Museum of Alberta.

3

THE NAVAL MUSEUM—BEGINNINGS

Calgary was also the location of another Canadian Armed Forces installation. Her Majesty's Canadian Ship (HMCS) *Tecumseh* (commissioned in 1941) was a recruitment and training centre home to the Naval Reserve. The Royal Canadian Navy (RCN) first used the site in the Second World War, from which some twenty thousand volunteers were sent for advanced combat preparation on both Canada's west and east coasts. Located on the corner of 17th Ave and 24th St SW, just west of Crowchild Trail, the main building of HMCS *Tecumseh* and several of her historical artifacts were destroyed by a fire in the spring of 1981. Fortunately, the Calgary Fire Department was able to save the three navy fighter aircraft—a Supermarine Seafire, Sea Fury, and Banshee—that were exhibited outside the buildings. All three aircraft had flown off of wartime and postwar Canadian aircraft carriers. They had suffered paint blistering and smoke damage in the fire. They had also been deteriorating in Calgary's harsh winters and were in desperate need of restoration and indoor housing.

The fire prompted an outpouring of support for the Navy and its long naval heritage in Calgary. Naval veterans and their families began offering their own personal artifacts to replace those lost in the fire. Many veterans offered to assist, and the need to establish a naval museum was born. The Commanding Officer of HMCS *Tecumseh* was Laraine Orthlieb and she rallied the naval community around the concept of building a naval museum. In 1984, when confirmation came that *Tecumseh* would be rebuilt at the existing site, then Captain (N) Orthlieb founded the Tecumseh Historical Society (THS) to undertake a fundraising campaign to

Royal Canadian Navy Hawker Sea Fury in the Naval Museum of Alberta.

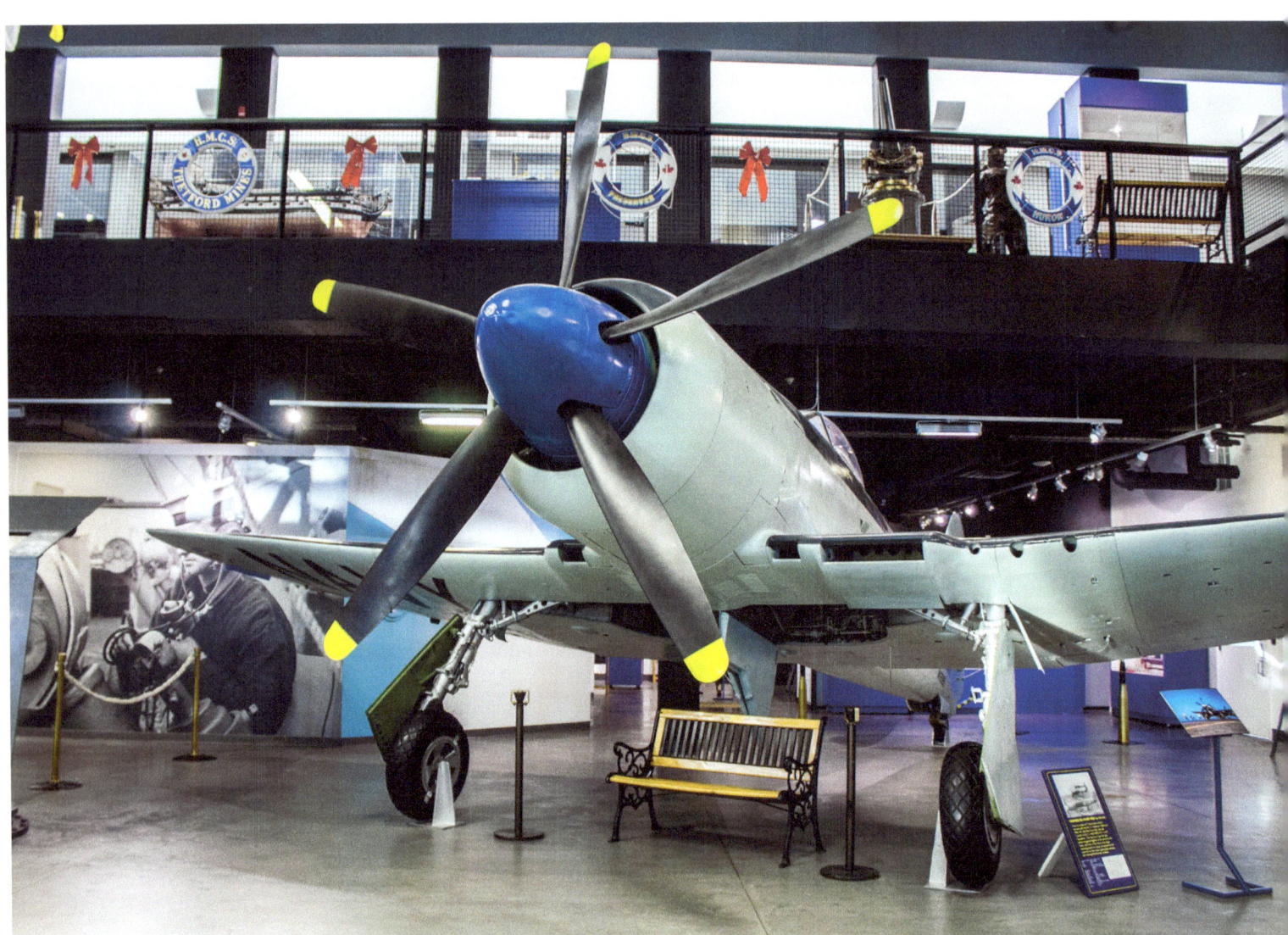

build a separate structure to house the three fighter aircraft and to accommodate donated ship and historical artifacts. Two of the people most instrumental in managing this society were Captain (N) Bill Wilson and Lieutenant-Commander Frank Saies-Jones. The THS secured a lease on a piece of land from Department of National Defence to build a museum within the grounds of HMCS *Tecumseh*. The Naval Museum of Alberta (NMA) was to be a separate building from the HMCS *Tecumseh* re-build.

The THS began a robust fundraising campaign to build their facility and soon reached their target of $300,000. These funds enabled it to construct and open the Naval Museum of Alberta in October 1988. This would house a vast repertoire of artifacts that were restored or donated after the fire. Funds were raised for construction from the naval community, the citizens of Calgary, the Province of Alberta, and the City of Calgary. In 1997, the new NMA building was further expanded to display considerable materiel on the Battle of Atlantic as well as naval guns weighing up to fifteen tons. Though located more than one thousand kilometres from salt water, the "Little Naval Museum on the Prairies" vied with the Naval Museum of Halifax as Canada's largest repository of navy artifacts. This reflected the astonishing fact that, during the Second World War, more than half the members of the RCN came from the landlocked prairies.

The name of the Tecumseh Historical Society was changed officially and registered as the Naval Museum of Alberta Society (NMAS) on 9 May 1996. The NMAS still remains the owner of that first NMA building, but it is now called the NMA Annex. It contains storage space for museum artifacts and a workshop to support the present NMA.

The NMAS consists primarily of members of ten relatively independent organizations of Calgary's Naval Community. These are the HMCS *Tecumseh*, Canadian Naval Veterans Association (CNVA), Naval Officers Association of Canada (NOAC) Calgary Branch, Chief and Petty Officers (CPO) Association, Naval Air Group, Merchant Navy Association, one Navy League Branch, and three Sea Cadet Corps. As a result of the increased visibility created by the new Naval Museum, these numbers increased by the creation of three additional Cadet Corps and two Navy League Branches.

At the NMA, through items that included photographs, uniforms, badges, ship models, and recorded and transcribed testimony, visitors learned of Canada's

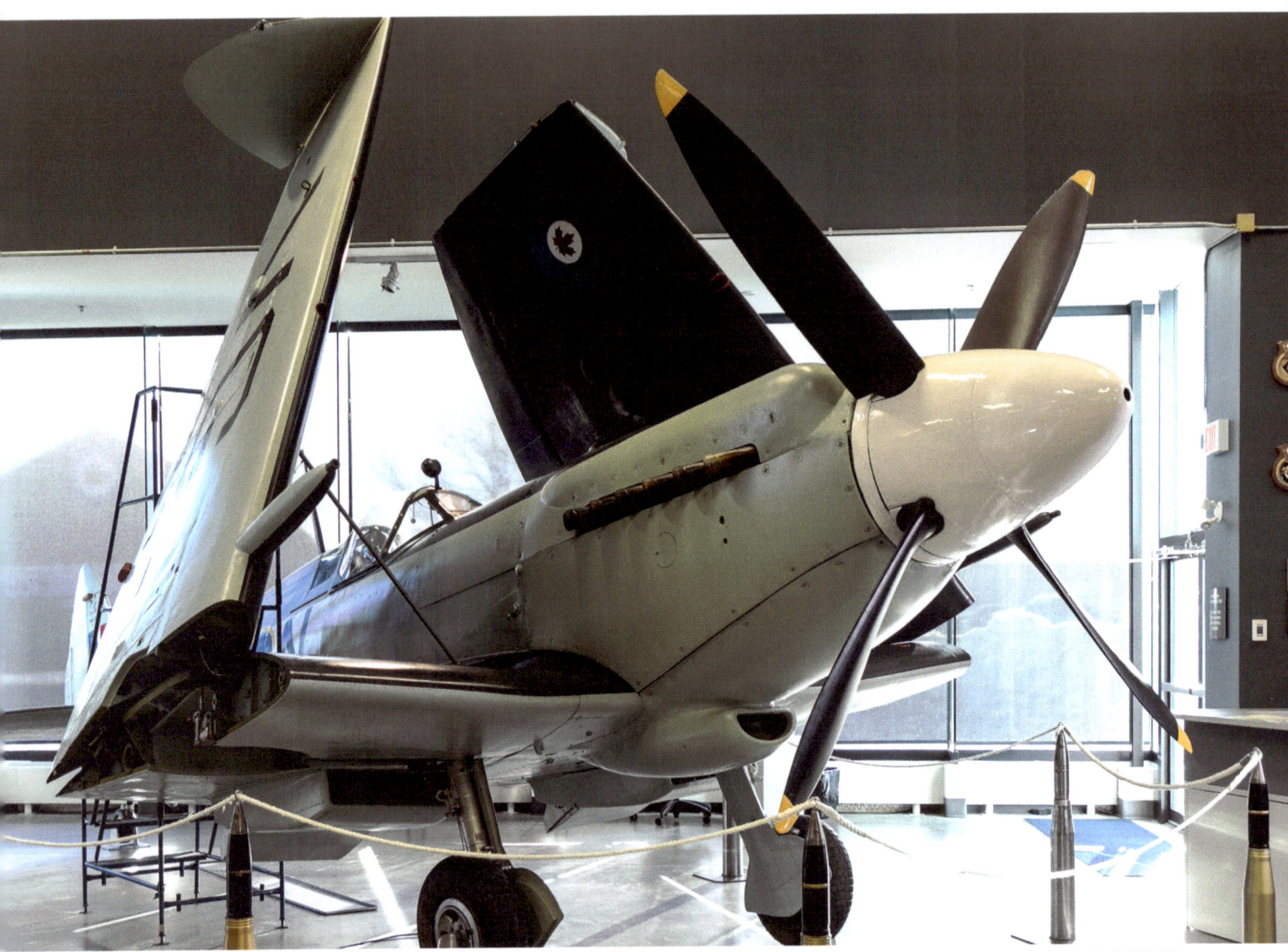

PHOTO: JULIE VINCENT PHOTOGRAPHY

(ABOVE AND OPPOSITE)
Supermarine Seafire in the Naval Museum of Alberta. Collection of the Naval Museum of Alberta.

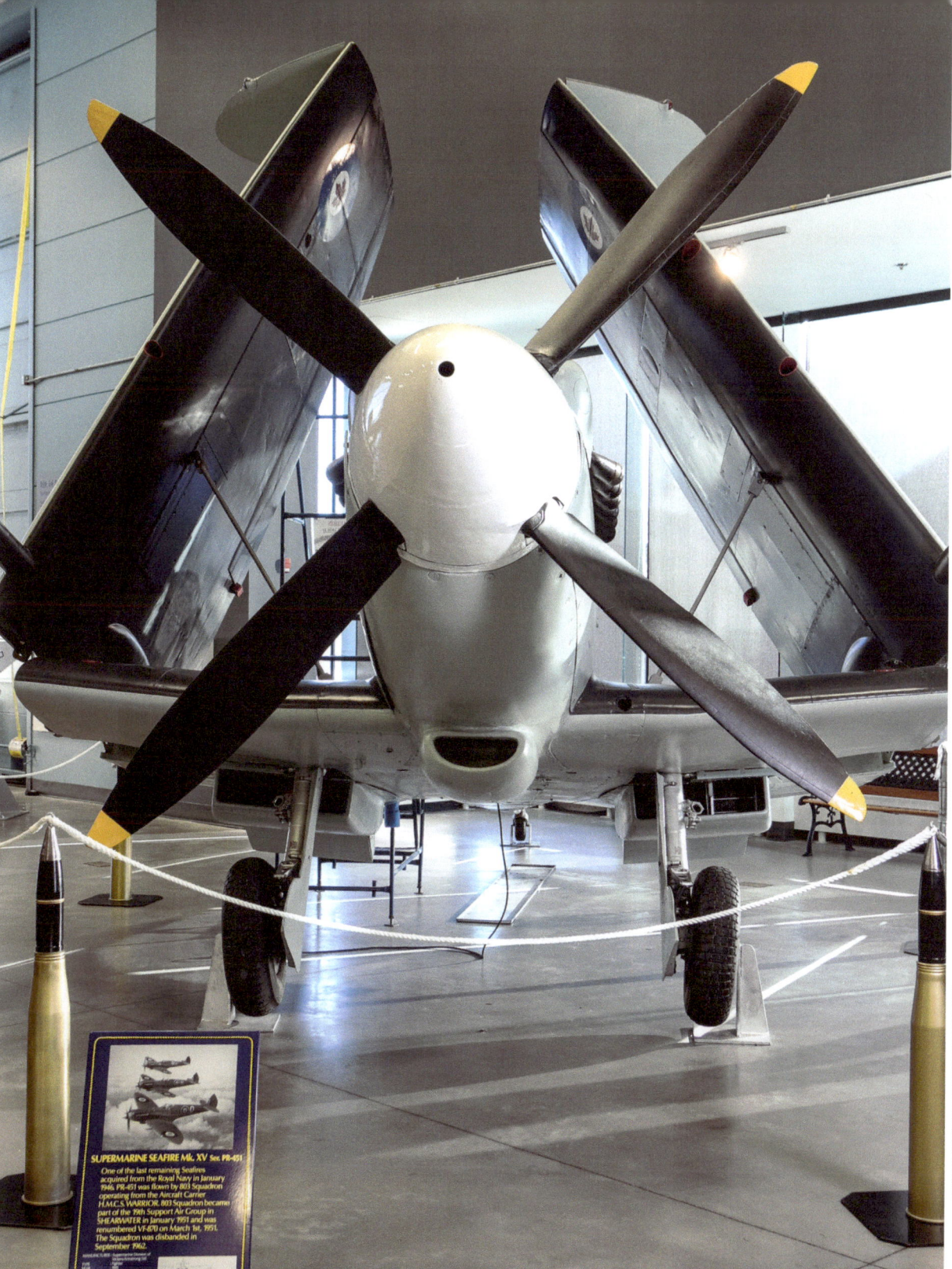

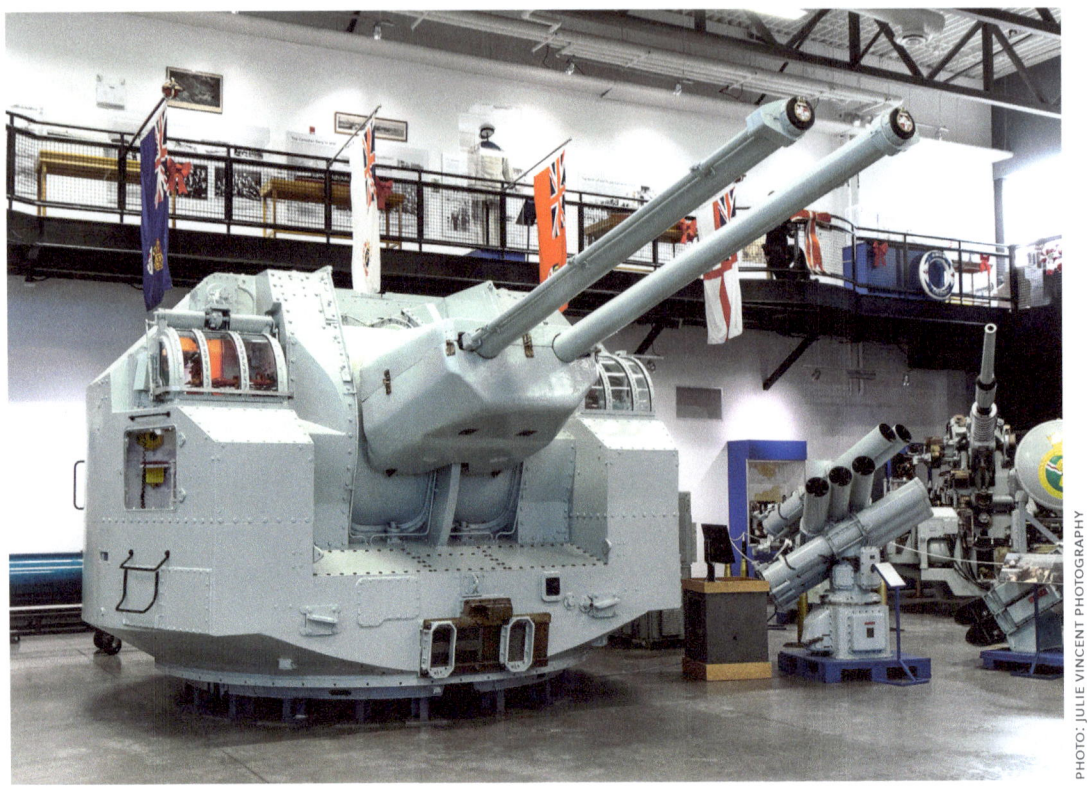

PHOTO: JULIE VINCENT PHOTOGRAPHY

(ABOVE)
3-inch 50 Naval gun at the Naval Museum of Alberta. Collection of the Naval Museum of Alberta.

(OPPOSITE)
Diorama in the Naval Museum of Alberta representing a mess deck on a Canadian corvette during the Second World War.

earliest naval contributions in the First World War, operations on the Pacific coast in the Second, the RCN's role at Dieppe and D-Day, the 1942 Battle of the St. Lawrence, massive contributions to north Atlantic convoy activities, and postwar operations, including the use of aircraft carriers and aircraft. Visitors could also avail themselves of the John Burgess Library and Ken McPherson Photographic Archives—named for preeminent Canadian naval historians—which, besides over 7,000 books, contained over 60,000 images, ship plans, and correspondence, one of the largest such collections in Canada. Since 2013, both the Burgess Library and

THE MESSDECK

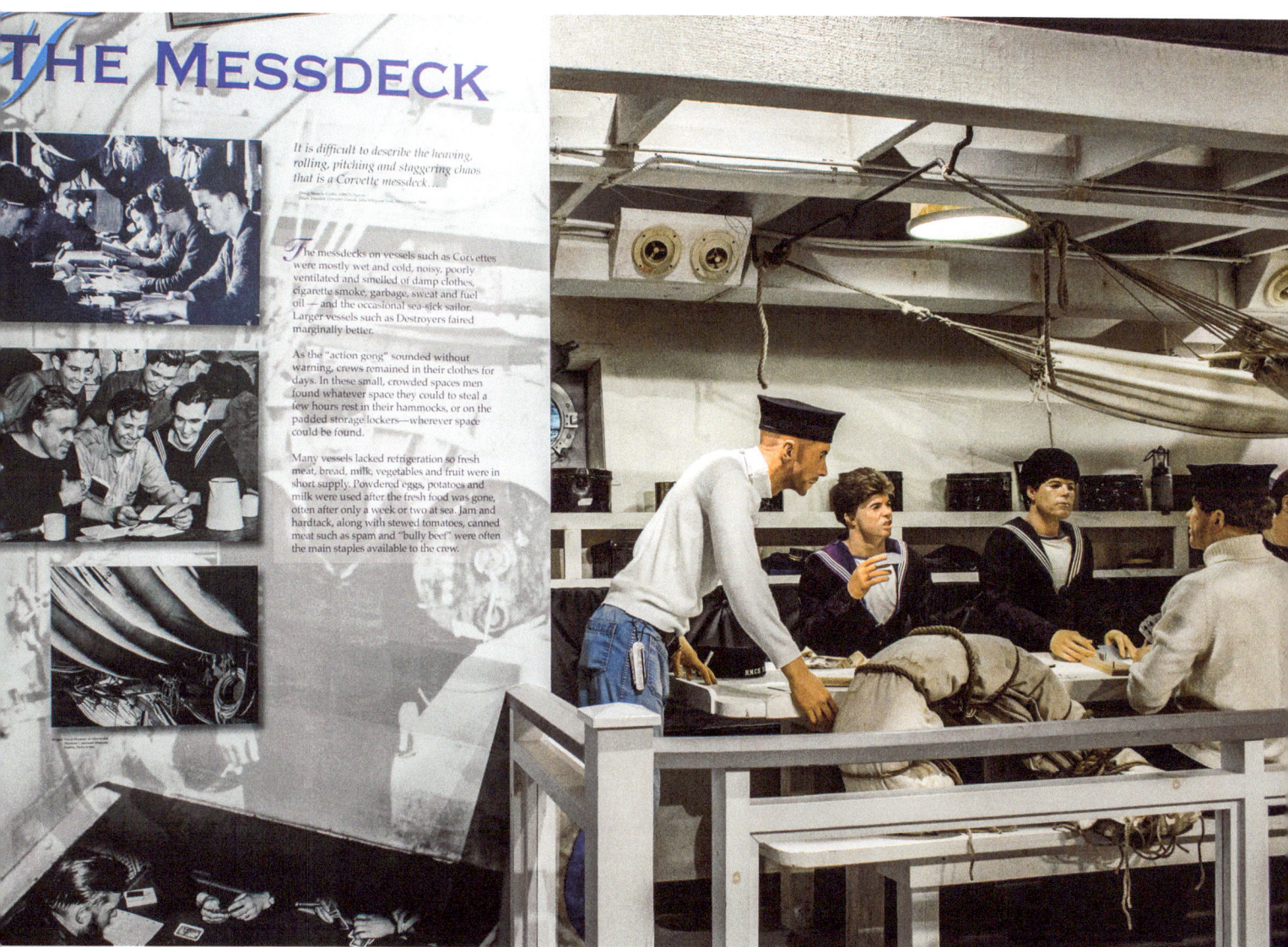

It is difficult to describe the heaving, rolling, pitching and staggering chaos that is a Corvette messdeck...

The messdecks on vessels such as Corvettes were mostly wet and cold, noisy, poorly ventilated and smelled of damp clothes, cigarette smoke, garbage, sweat and fuel oil — and the occasional sea-sick sailor. Larger vessels such as Destroyers faired marginally better.

As the "action gong" sounded without warning, crews remained in their clothes for days. In these small, crowded spaces men found whatever space they could to steal a few hours rest in their hammocks, or on the padded storage lockers—wherever space could be found.

Many vessels lacked refrigeration so fresh meat, bread, milk, vegetables and fruit were in short supply. Powdered eggs, potatoes and milk were used after the fresh food was gone, often after only a week or two at sea. Jam and hardtack, along with stewed tomatoes, canned meat such as spam and "bully beef" were often the main staples available to the crew.

Captain (N) Bill Wilson examines a naval anti-aircraft gun at the Naval Museum of Alberta.

McPherson photographic archives have been housed at The Military Museums in partnership with the University of Calgary.

Although dozens of volunteers and hundreds of donors worked to build this institution, one of the heroes of the project was the aforementioned Bill Wilson. Born in Winnipeg Bill had served on RCN corvettes and destroyers in the Second World War and had been present at D-Day. After the war, Canadian Pacific hired him. Driven by his love of the navy, his desire to care for his family, and his ambition of telling the story of the war and the navy to each new generation of youngsters, he devoted much of his spare time to building up the naval museum. At the same time he climbed steadily through the ranks of CP.

The collection at the naval museum grew rapidly. By the 1980s Second World War veterans began passing away in increasing numbers and their families were donating uniforms, medals, photographs, and documents. In the meantime, a search was initiated to locate guns, mortars, radar equipment, and other bits and pieces of Second World War and postwar ships that the RCN had relegated for scrap. Canadian Pacific was a very strong supporter of the military in the Second World War, through its many steam ships, trains, and shops, and influenced by Wilson were prepared to arrange the transport of naval artifacts that included massive items, such as a complete set of anti-aircraft guns and anti-submarine mortars.

In October 1988, on the 183rd anniversary of Admiral Nelson's victory at the Battle of Trafalgar, Lieutenant-Commander Frank Saies-Jones, the Society's first president, invited Her Honour, the Honourable Helen Huntley, Lieutenant-Governor of Alberta, to officially open Canada's newest naval museum. Under Frank Saies-Jones' direction as its first "curator," the museum subsequently became the country's largest naval museum. By the time the new museum opened, it was full of photographs, paintings, ship models, naval armament, and, of course, the three naval aircraft, now completely restored and painted. High above all the displays was a mock bridge replicated from a Second World War RCN destroyer complete with voice pipes, a SONAR and RADAR shack, signal flags, wheel, and compass.

The main gallery of the Naval Museum of Alberta from the mock bridge.

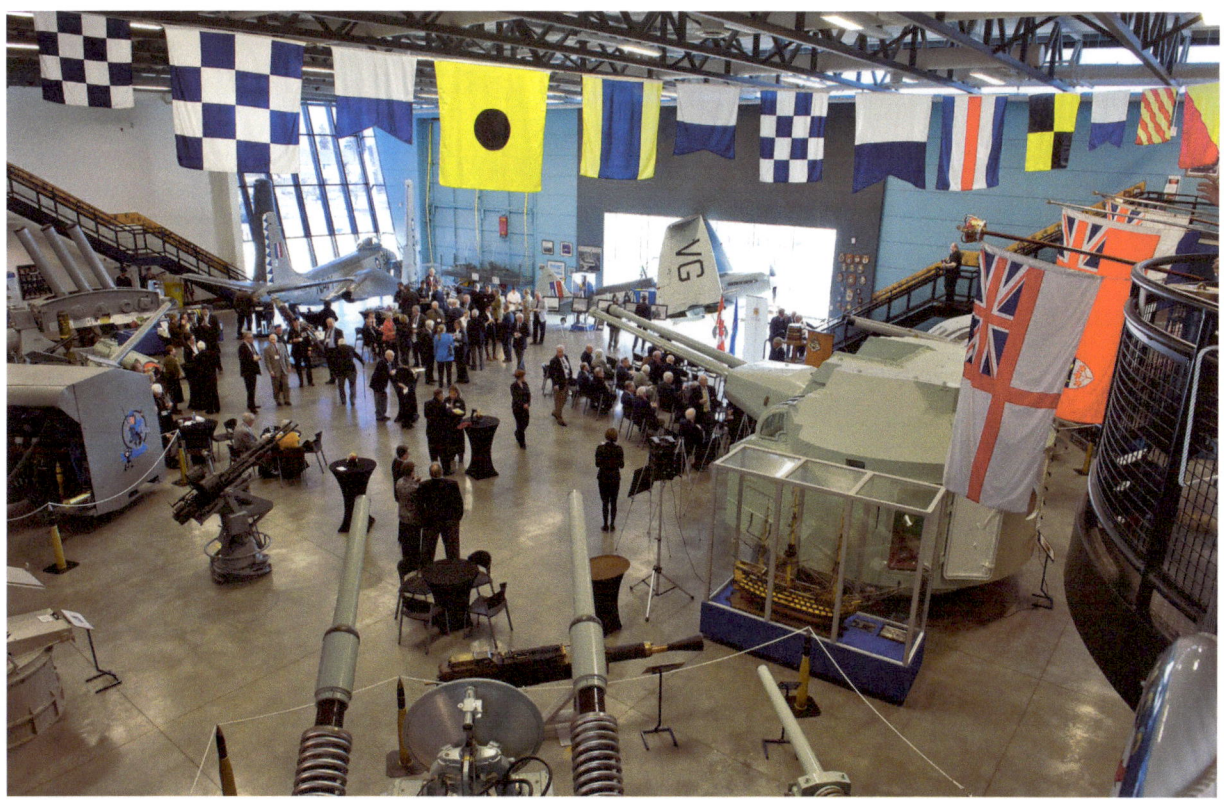

THE NAVAL MUSEUM—BEGINNINGS

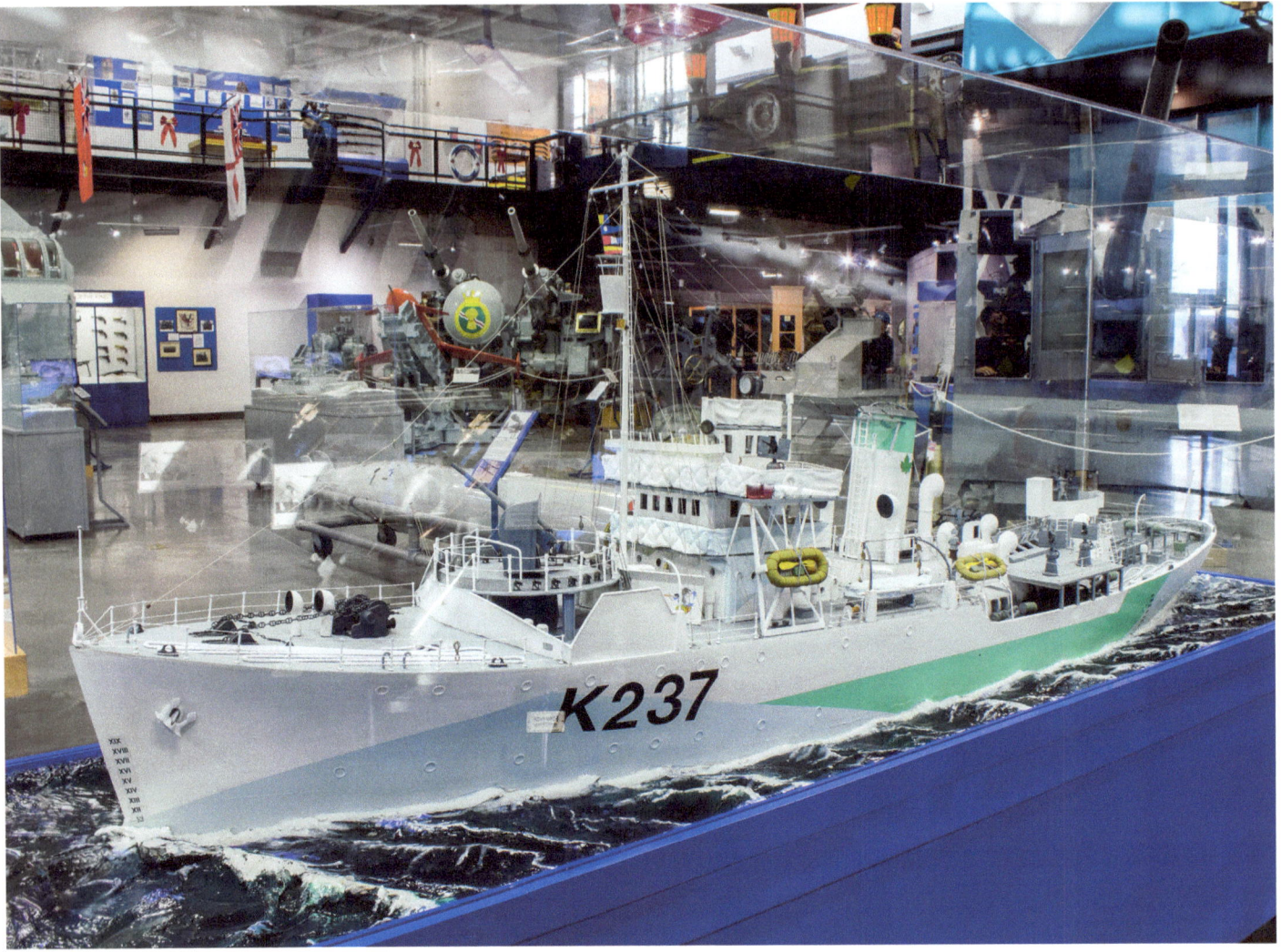

(ABOVE)
A model of an RCN revised Flower-Class corvette, the HMCS *Halifax*, as it would have sailed in the Battle of the Atlantic, in the naval exhibit.

(OPPOSITE)
A Banshee naval jet fighter as flown from the aircraft carrier HMCS *Bonaventure* in the naval museum.

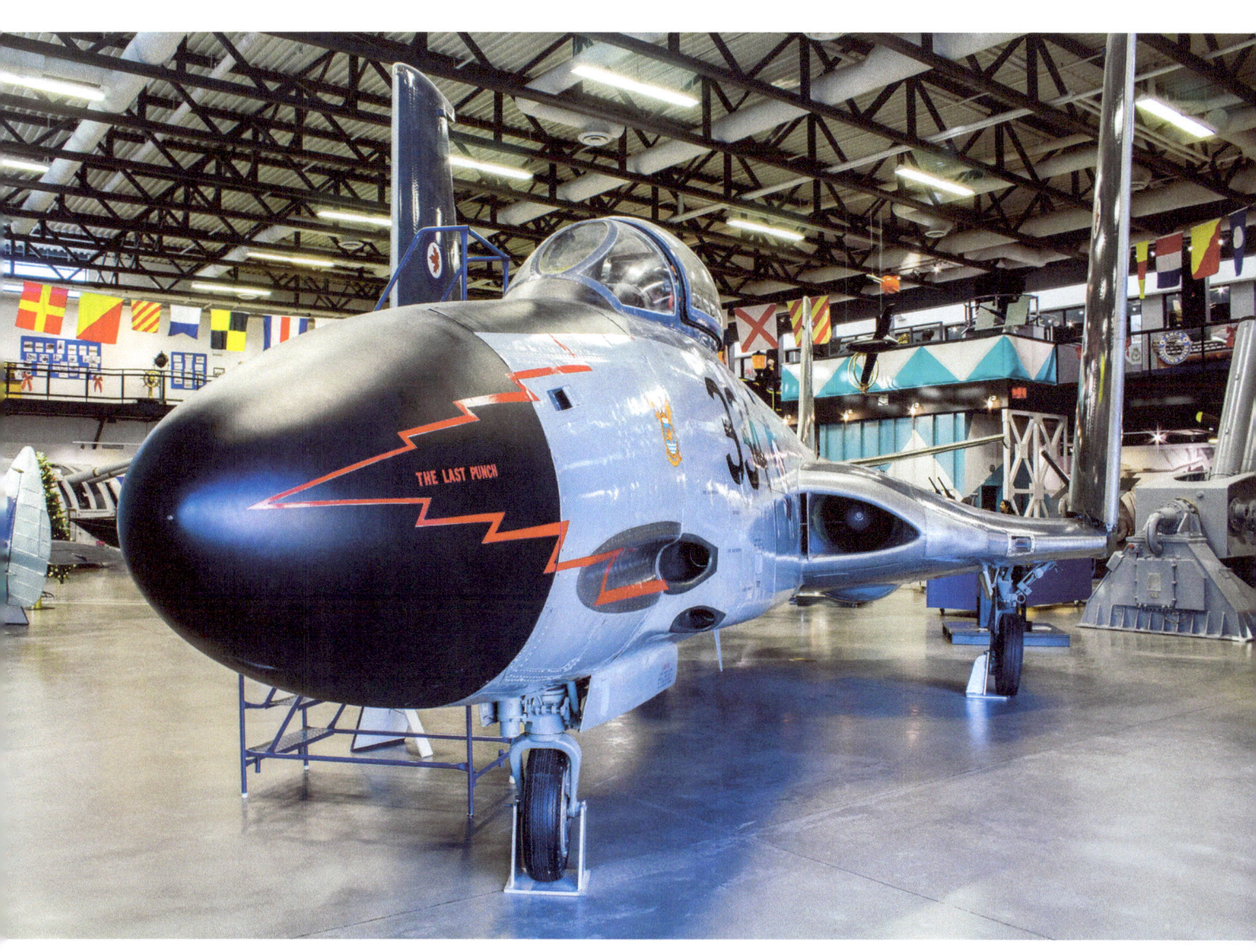

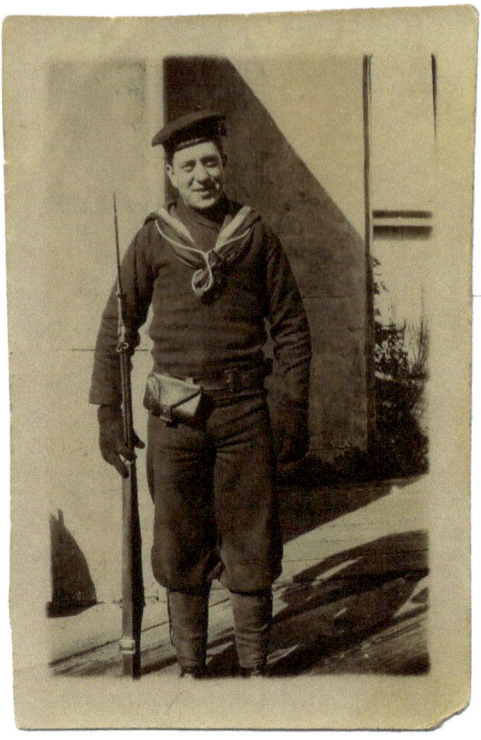

Bill Duce pictured in his winter uniform on gate duty. Date and place unknown. University of Calgary Archives, Naval Museum of Alberta Collection.

PETTY OFFICER WILLIAM DUCE

Royal Navy Canadian Volunteer Reserve (RNCVR), First World War

In October 1917, William (Bill) Duce answered his country's call to service in the Great War and volunteered for the Royal Navy Canadian Volunteer Reserve (RNCVR) at the Cardston, Alberta, post office. On 17 November of that year he left Lethbridge with a party of recruits and was posted to Rainbow Division on the West Coast where he qualified as a 1st Class Seaman.

He was later posted to the Atlantic Coast where he served in Niobe Division as Ship's Cook. Bill Duce ended the war as a petty officer on one of the small coastal vessels at Saint John, New Brunswick—the *St. Helena*. His war had involved minesweeping and fireboat service, and he escorted troops halfway into the Atlantic.

The Naval Museum of Alberta received his uniform as a donation from his son in 2014. Naval uniforms from the Great War are extremely rare, and the fact that not only is this one complete but we know who owned it—and have a picture of him—makes it one of the more special items at The Military Museums.

Bill Duce's uniform consists of a Class II duck tunic complete with blue naval tri-striped denim collar which is sewn onto the tunic. The tunic bears the Petty Officer rank (blue cotton on white) on the right upper sleeve, and blue piping on the cuffs and tunic bottom. The tunic is complete with the original lanyard and a black silk. The trousers are white summer duck RN trousers, five buttons, laced at the aft waistband. Interestingly, the trousers still have the remnants of the "seven seas" folds on the lower legs. The uniform includes a black peaked cap with a Petty Officer's cloth cap badge, and a white cloth weather cover. Collection of the Naval Museum of Alberta.

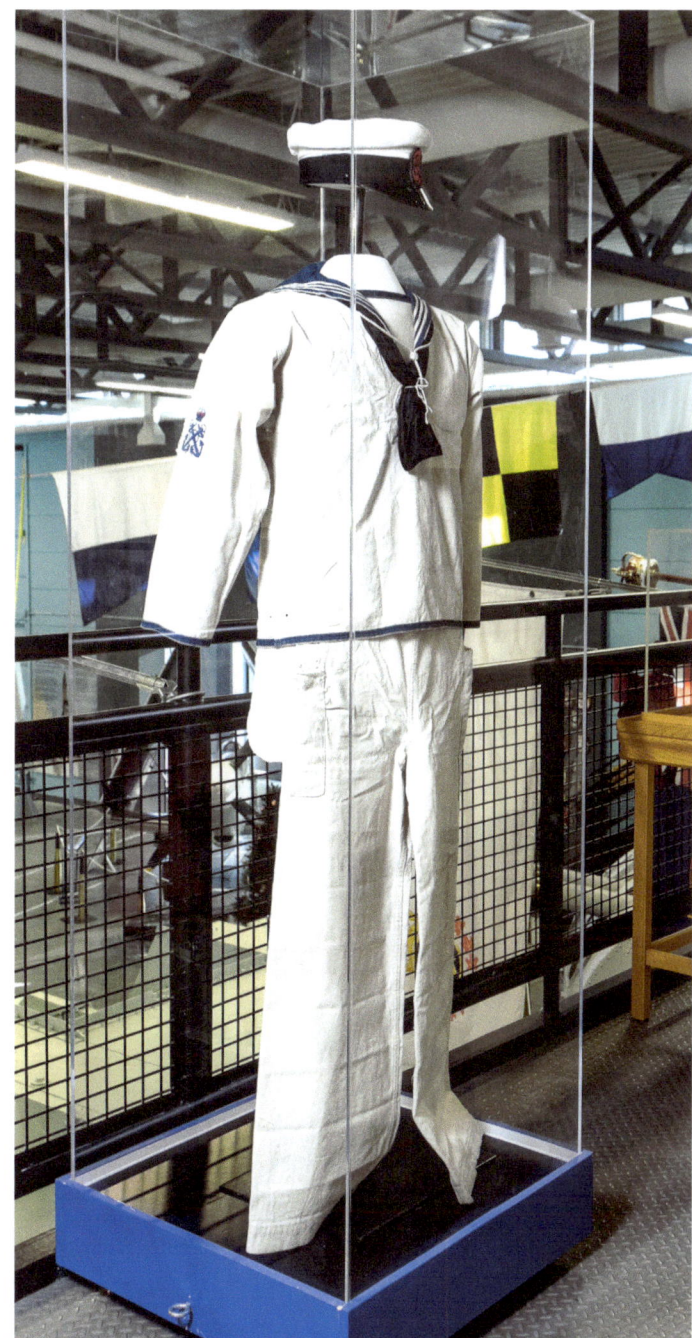

SECOND WORLD WAR NAVAL GUNS

4" (102 mm) QF Mark XVI on a twin Mark XIX Mounting on exhibit at the Naval Museum of Alberta. This gun was manufactured at the Canadian Pacific Munitions Department, Ogden Shops in Calgary.

Railway shops like this were a major part of Canada's war effort during the Second World War, since they were already set up to make heavy machinery. Collection of the Naval Museum of Alberta.

PHOTOS: JULIE VINCENT PHOTOGRAPHY

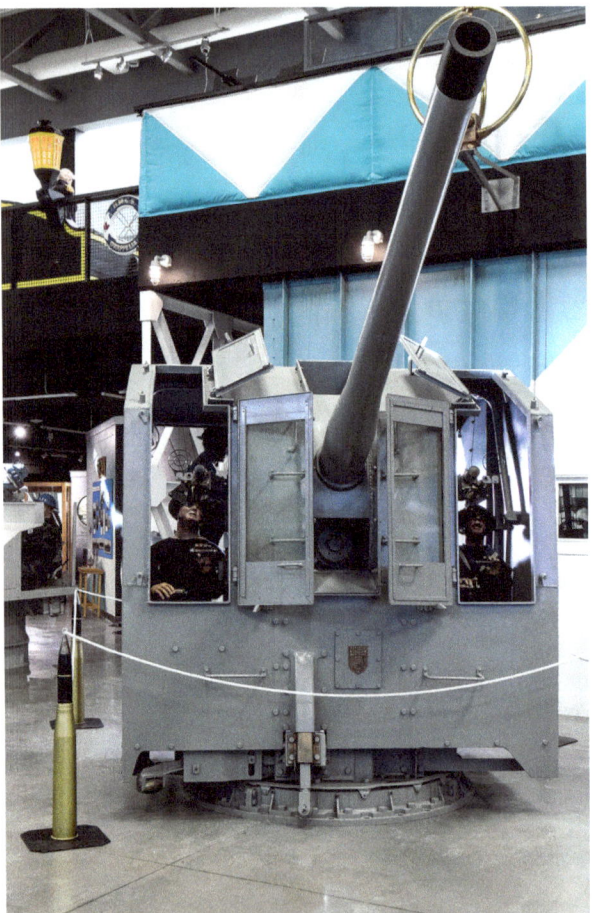
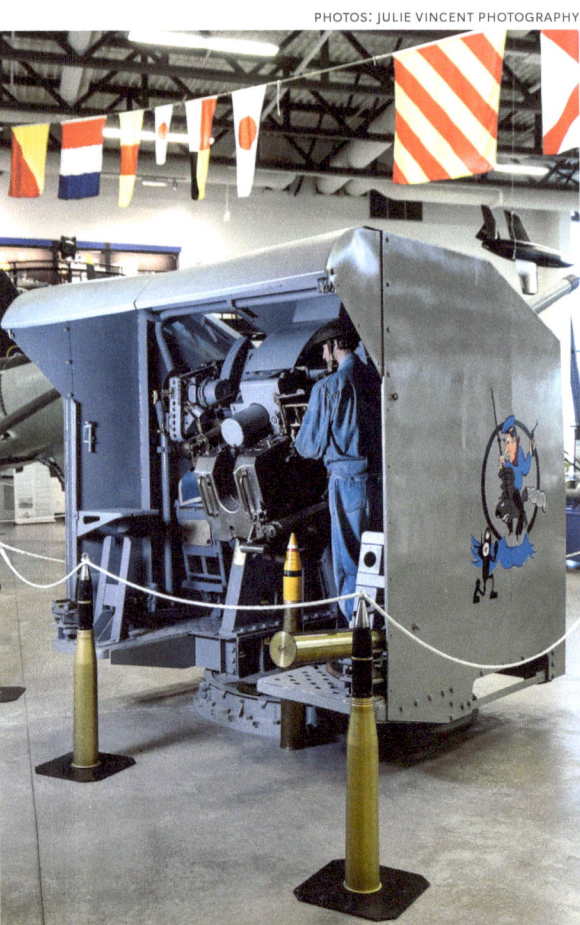

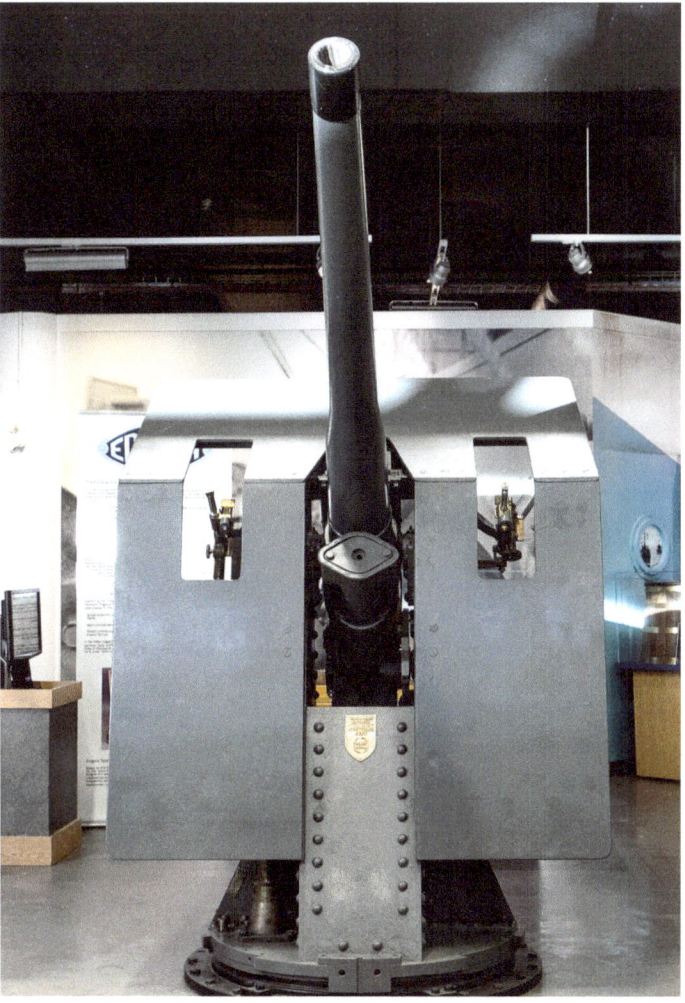

12-pounder, 40-calibre Quick Fire/Low Angle Mk V gun on a Mk IX Mounting. These guns were installed as the main armament on the forecastle of most Canadian Bangor Class minesweepers and fitted as secondary armament on many frigates. They were also installed on defensively equipped merchant ships (DEMS). This gun was manufactured at the Canadian Pacific Munitions Department, Ogden Shops in Calgary. Collection of the Naval Museum of Alberta.

PHOTOS: JULIE VINCENT PHOTOGRAPHY

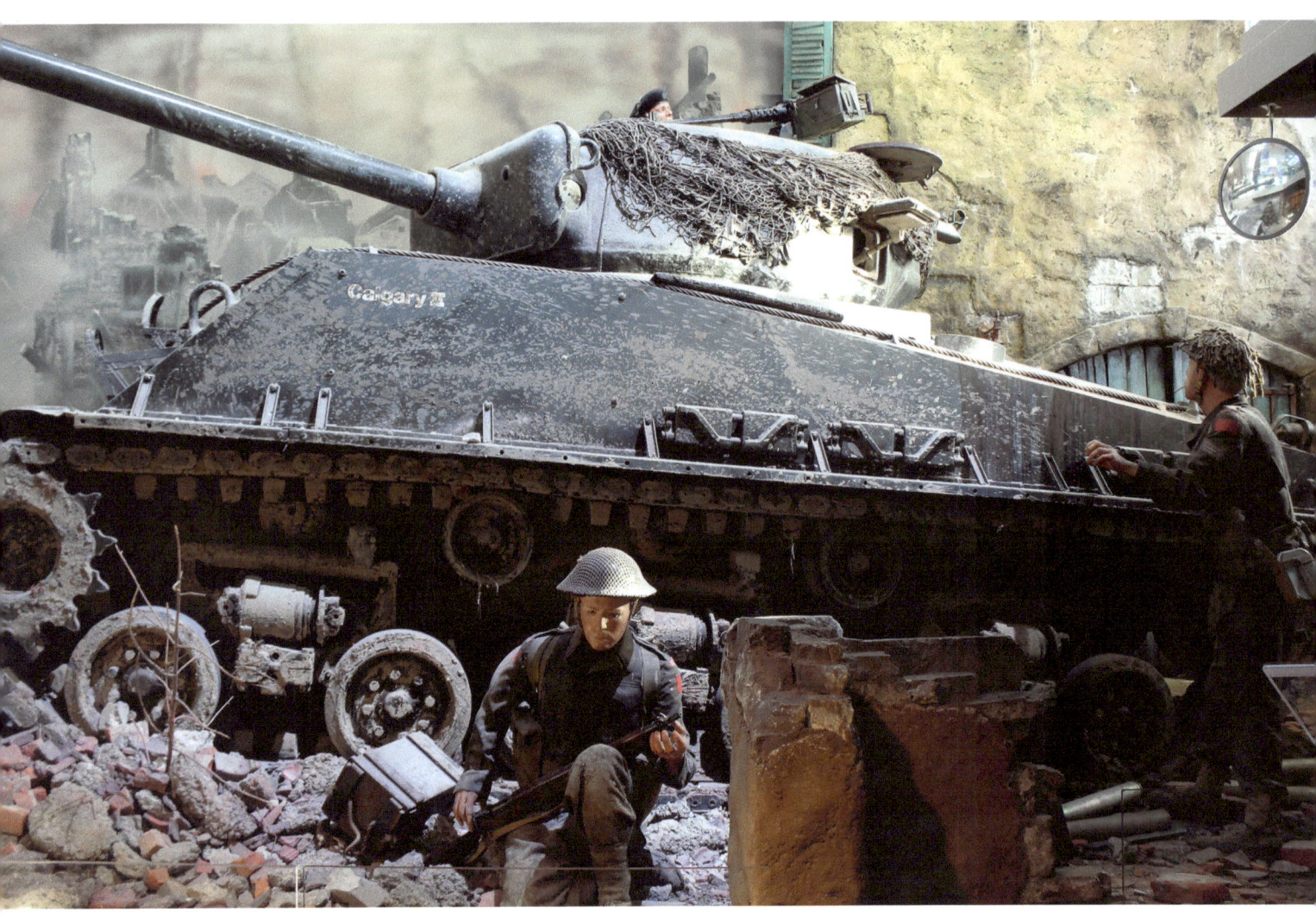

A diorama featuring cooperation between infantry and armoured units in the fall of 1944, as seen at the entrance to The Military Museums.

4

OPERATING THE MUSEUM OF THE REGIMENTS

With the completion of the Museum of the Regiments in September 1991, the old school building had been completely transformed. It made a striking appearance along Crowchild Trail. As visitors approached the main entrance, they encountered a number of military vehicles that included a Lynx reconnaissance vehicle, a five-ton Universal Carrier, a Centurion tank, and a 39-ton Churchill tank with a mounted flame thrower.

Inside the main atrium were exhibits on a lower floor showing scenes from the Second World War. One was a Sherman tank from the Strathcona's that required a special heavy duty crane to lower into position. On the main floor were five principal galleries. Reflecting the different size of the regimental collections, Princess Patricia's Canadian Light Infantry had the largest, followed by Lord Strathcona's Horse. Later, the Army Museum of Alberta gallery was added to display other aspects of regional military history, such as relating to Indigenous peoples, the 1885 rebellion, and the massive presence of the British Commonwealth Air Training Plan in the province. A small gallery for touring exhibits, or temporary ones organized by Museum staff, sponsored by Imperial Oil, took up the remainder of the space.

Within a couple of years of opening its doors, the museum was drawing some fifty thousand visitors annually. About two-thirds were Calgarians, 15 per cent from the rest of Alberta, 10 per cent from other parts of Canada, and the rest from the United States and other nations. It was also not long before tens of thousands of

(ABOVE)
Colonel Donald Ethell in his United Nations Association blazer. Ethell later became Lieutenant-Governor of the Province of Alberta.

(BELOW)
George Milne wearing regalia of the Honourable Guard at the museum.

school children were visiting annually for tours and lessons relating to the provincial curriculum.

Many Calgarians worked hard to create the original Museum of the Regiments, including by raising funds and collecting artifacts. Few were more involved than George Milne. Born in Toronto, George had established himself as a marketing genius by the time he moved to Calgary with his family in 1986 to take an executive position with Petro Canada. With the Calgary Winter Olympics coming in 1988, and Petro Canada a major sponsor of the event, George initiated the highly popular Petro Canada Olympic glasses hand-out and the Olympic Torch parade. He also became the Regimental secretary for the Calgary Highlanders after he retired from Petro Canada, working with Fred Mannix and others to come up with new and imaginative fundraising initiatives such as elaborate dinners organized for a Chinese general and the Maharajah of Jaipur. George also worked on several exhibits such as that covering the Highlanders' involvement in the 1944 Battle of the Walcheren Causeway, as part of the Battle of the Scheldt Estuary.

Until 2001, Milne spearheaded the museum's fundraising operations. Among his innovations was the creation of the Museum Honourable Guard, which was used to connect to prominent local people. Adopting a military theme, the Guard had its own colours, with jacket, vest, and trousers patterned after Calgary's 103rd Regiment. It established ranks—Members, Escort to the Colours, and Honourary Commander—linked to the level of money paid for a membership fee. Its numbers quickly reached some three hundred and included a number of Calgary's most notable people such as the Chief of Police, the president of the Chamber of Commerce, and industry leaders. Members received advance access to exhibits and invitations to social activities like international wine and cheese tastings or mess dinners. When the building was finished and paid for, fundraising by Milne and others went to support extensive educational programs.

The Museum also grew its profile by becoming the focal point for Remembrance Day ceremonies, taking over this role from the Southern Alberta Jubilee Auditorium. What started in 1993 with a few thousand spectators became, in the following decade, a gathering attracting ten thousand or more people, with official representation from the four regiments, provincial and municipal governments, police, fire fighters, cadet corps, Boy Scouts and Girl Guides, and military bands and choirs.

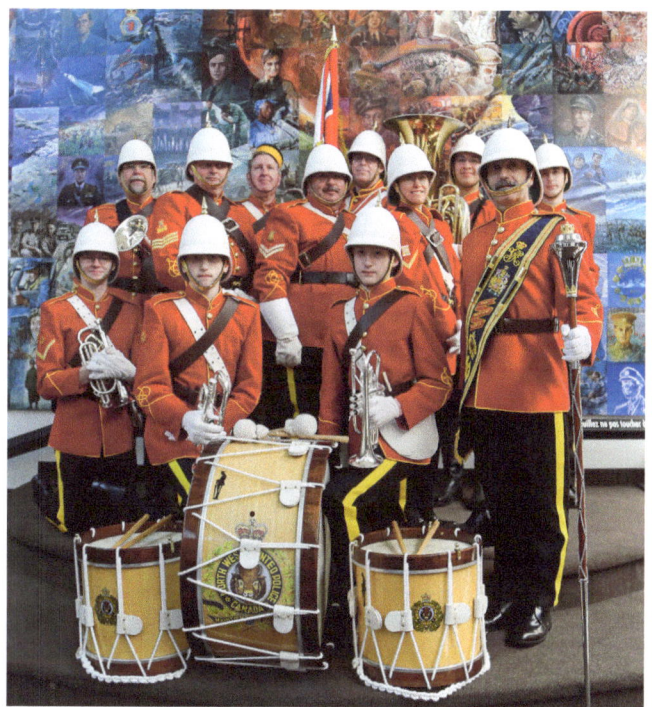

Among the museum's events, organized twice in the late 1990s, were outdoor concerts involving military bands, including the King's Own Calgary Regiment Band, and the Regimental Pipes and Drums of the Calgary Highlanders, as well as Highland dancers. Besides rousing music, antique cars were displayed, along with face-painting and clowns to entertain children. The museum also established a public lecture series covering topics of general interest such as the major battles in which Canadian soldiers fought in the First and Second World Wars. Another highly successful venture was organizing a version of the famous British television program, the Antiques Roadshow. With expert assessors from both the Museum of the Regiments and the Canadian War Museum, some two thousand people arrived with medals, diaries, photographs, paintings, and weapons, including a US cavalry sword from the 1860s, a Brown Bess Musket from the early 1800s, and a bayonet from a First World War Pritchard pistol.

(LEFT)
North-West Mounted Police Commemorative Association band standing in front of the *Mural of Honour* inside the Museum's main hall.

(RIGHT)
German brass bugle captured at Vimy Ridge on 9 April 1917 by PPCLI, No. 2 Company. A "Marguerite" cap badge and inscription have been added. Collection of PPCLI Museum and Archives.

CALGARY HIGHLANDERS MUSEUM & ARCHIVES

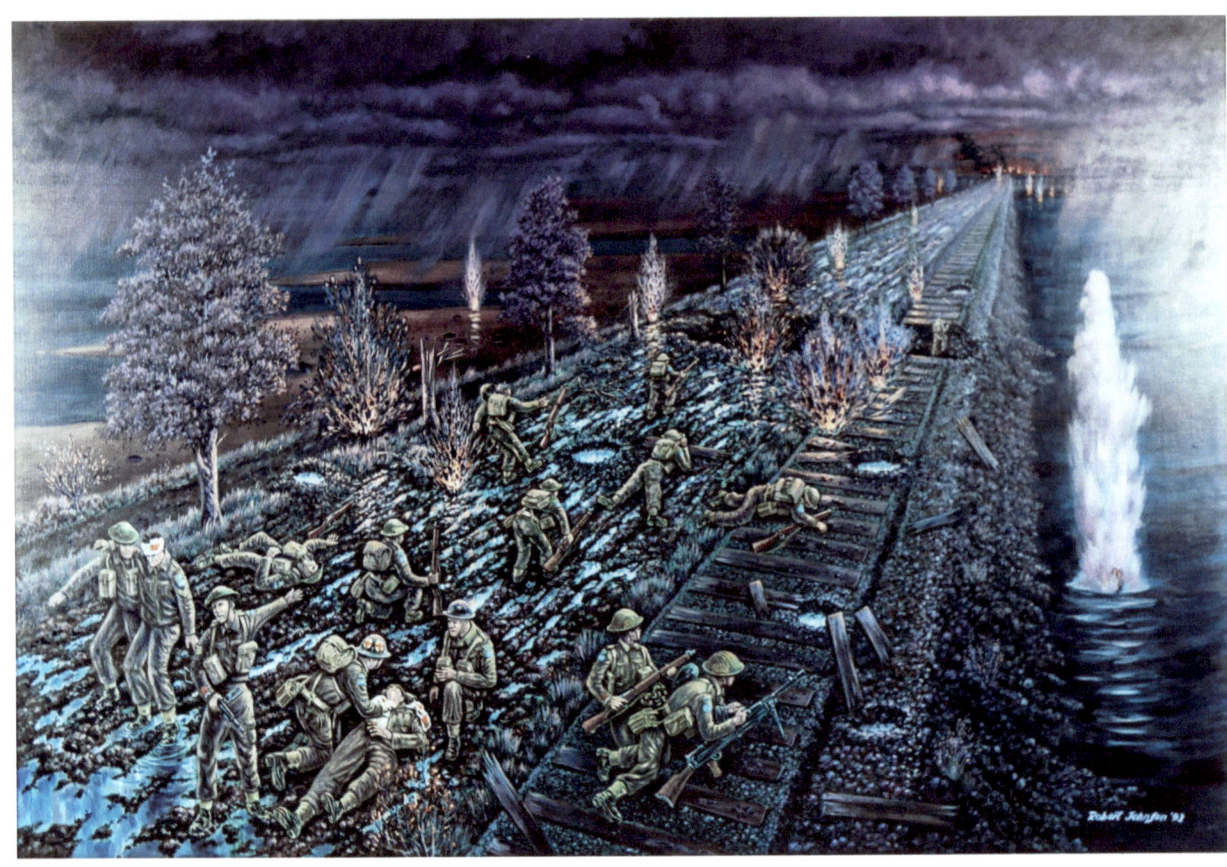

Calgary Highlanders advance through intense fire on the Walcheren Causeway, Scheldt Estuary, Holland, 31 October 1944. Robert Johnson, acrylic on board, 1993. Collection of the Calgary Highlanders Museum and Archives.

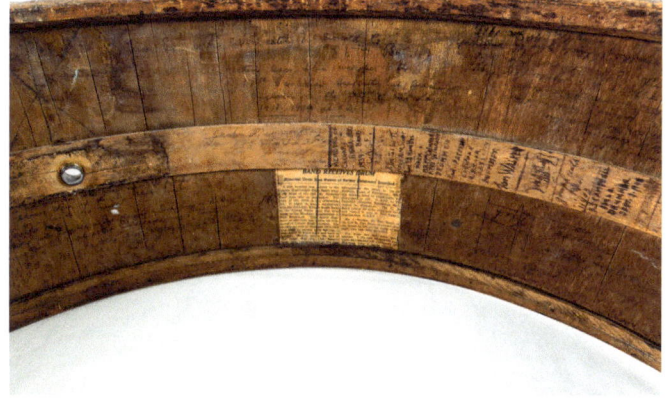
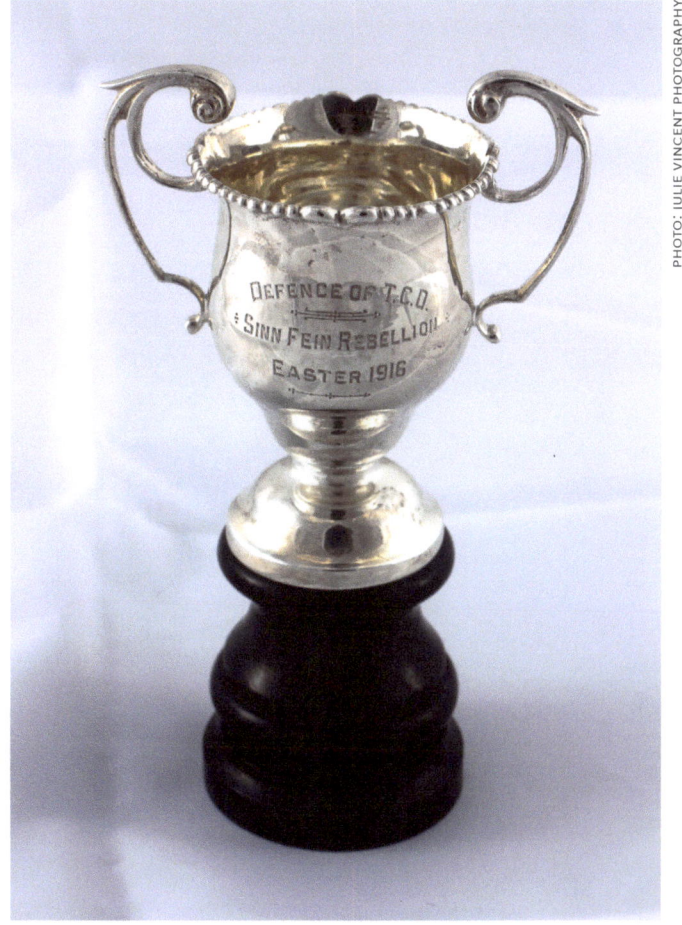

(ABOVE, LEFT AND RIGHT)
Wooden bass drum shell of the Calgary Highlanders pipes and drums, ca. 1941. Note the painted Battle Honours of the 10th Battalion, the Great War unit perpetuated by the Calgary Highlanders. The names of the wartime Calgary Highlanders pipers and drummers were written and are now preserved inside the bass drum shell. Collection of the Calgary Highlanders Museum and Archives.

(RIGHT)
Miniature silver presentation cup awarded to Bugler George Alfred Webb, of Calgary's 56th Battalion, for assistance in the defence of Trinity College, Dublin, Ireland, during the 1916 Sinn Fein Easter Rising. Collection of the Calgary Highlanders Museum and Archives.

GUNS IN THE MUSEUMS

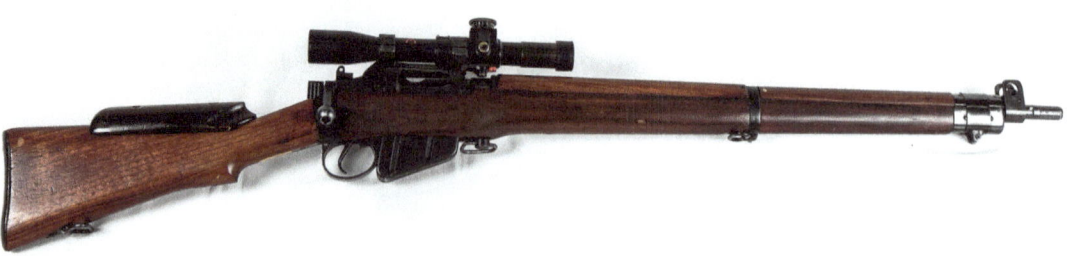

PHOTOS: JULIE VINCENT PHOTOGRAPHY

Lee-Enfield No. 4 Mk. I (T) sniper rifle in its original box, complete with No. 32 telescope and other tools. This was the standard sniper rifle used by Canadian snipers in the Second World War. Collection of the Army Museum of Alberta.

(ABOVE)
7.92-mm German Maxim machine gun captured by the 10th Battalion during the Battle of Hill 70, France, 15 August 1917. Weighing 55 lbs, the gun has a belt capacity of 250 rounds and fires at a rate of 400–500 rounds per minute. Collection of the Calgary Highlanders Museum and Archives.

(BELOW)
The Fallschirmjägergewehr 42 (FG-42) was specifically developed for German paratroopers during the Second World War. Its rate of fire is 900 rounds per minute. A 7.92 x 57 mm Mauser, it has a rotating bolt, a fixed bi-pod and an internal bayonet. It is much less common than the infantry version (MG-42). Collection of PPCLI Museum and Archives.

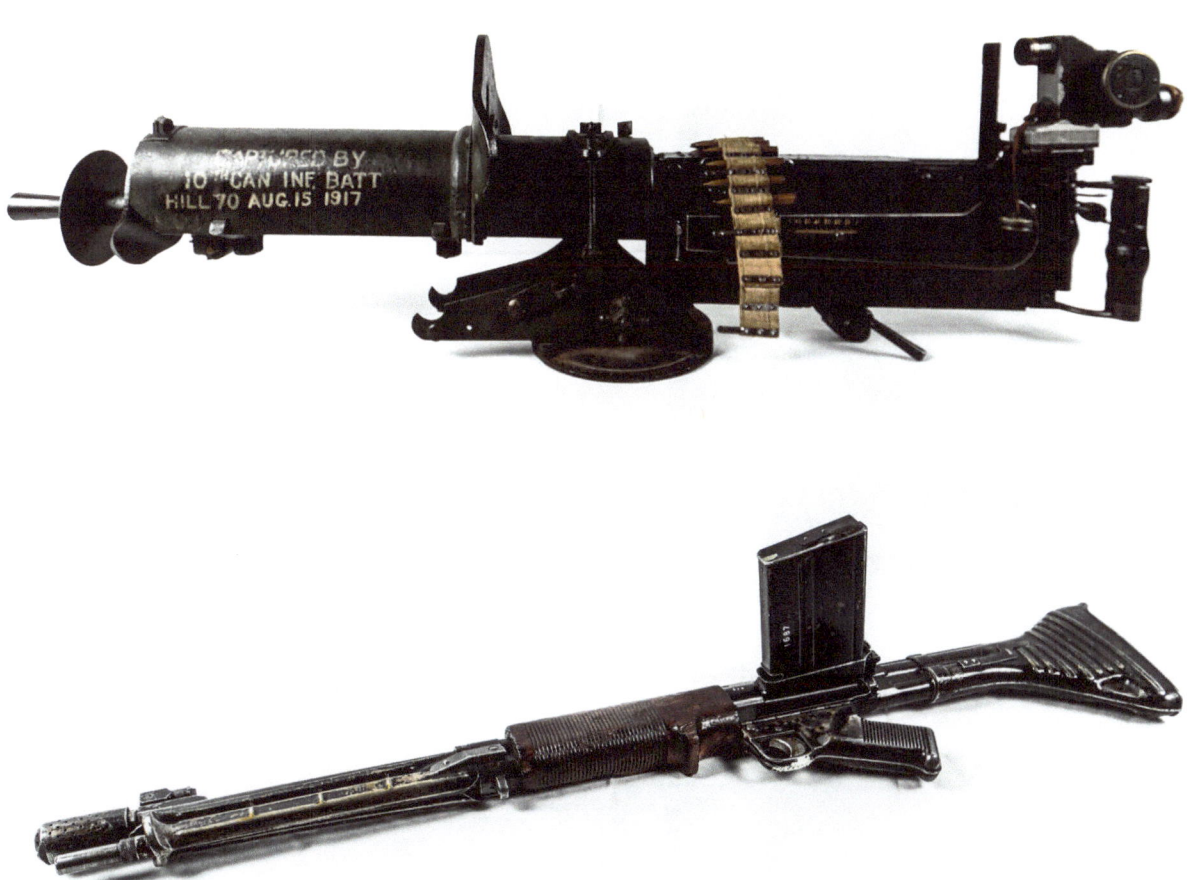

PHOTO: JULIE VINCENT PHOTOGRAPHY

THE AIR FORCE MUSEUM OF ALBERTA

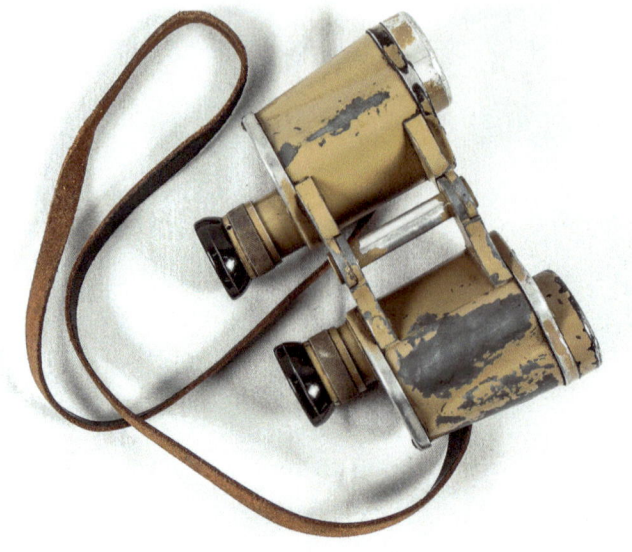

(ABOVE)
German 6 x 30 Dienstglas binoculars, ca. 1945. These binoculars were "liberated" from a German factory in 1945 by Flight Lieutenant William James Fowler. When lingering German soldiers opened fire on the group leaving the factory, they dropped another box of binoculars. Fowler only retained this pair, which were hung around his neck! Collection of the Air Force Museum of Alberta.

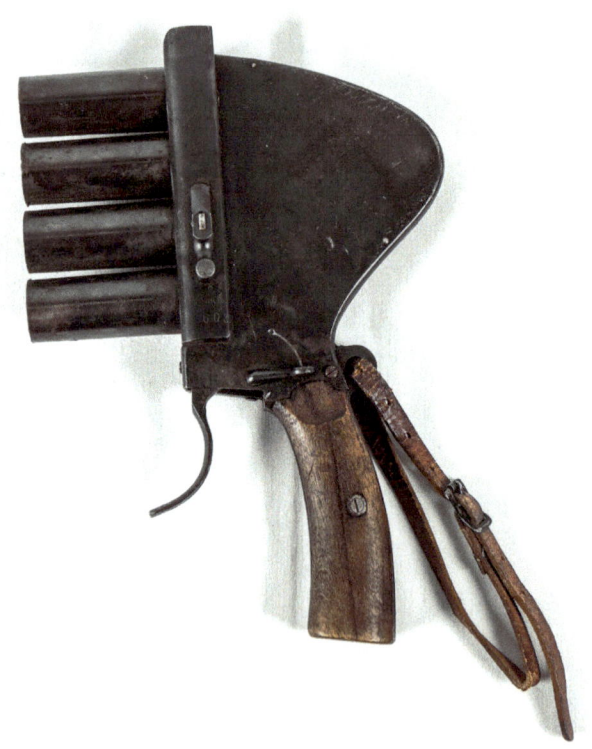

(BELOW)
Four-barrelled flare pistol, 1917. This extremely rare pistol was brought home by William Addison Henry as a souvenir. It was designed to illuminate large airfields without the need to reload. Over 2,500 were manufactured by seven different German companies, but only a few dozen survive to this day. Collection of the Air Force Museum of Alberta.

PHOTOS: JULIE VINCENT PHOTOGRAPHY

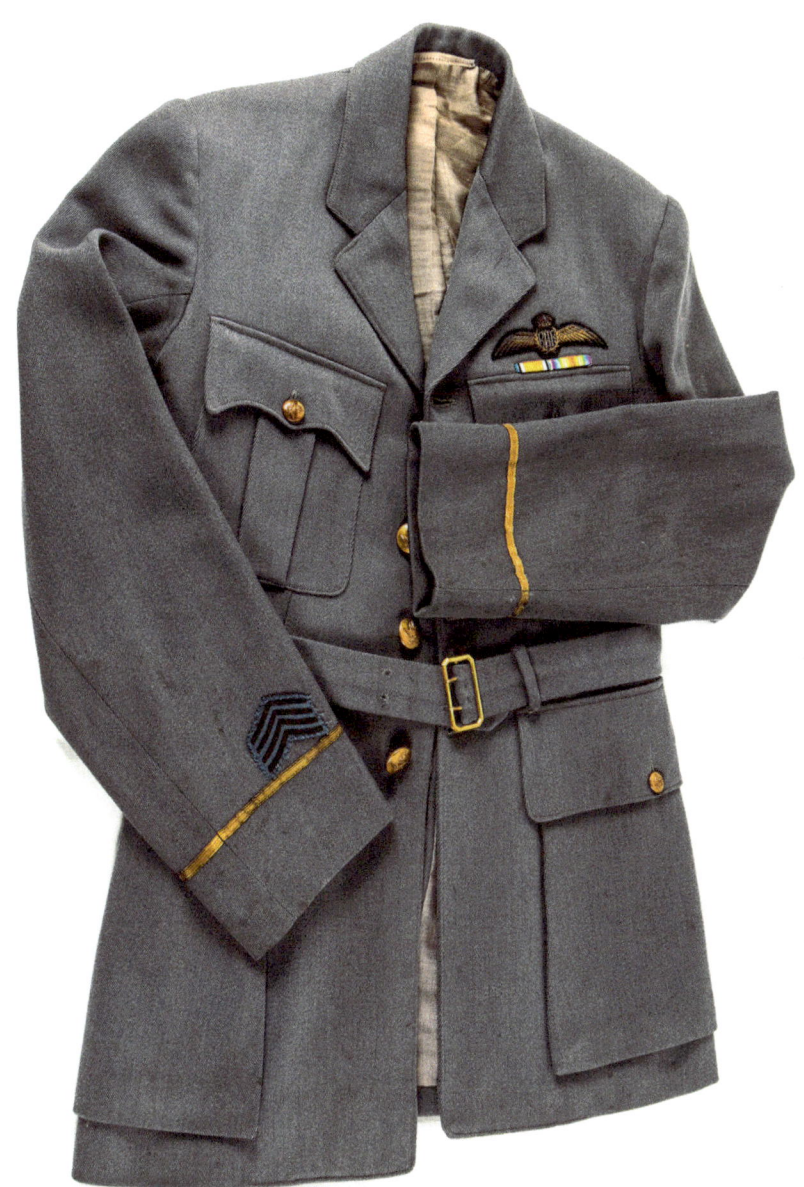

Royal Air Force Tunic, ca. 1918–1919. This tunic belonged to H.H. Gilbert, a Canadian pilot. After the formation of the Royal Air Force in 1918, new uniforms were needed. The signature blue fabric came from a surplus of blue twill originally intended for the Imperial Russian military. Collection of the Air Force Museum of Alberta.

PHOTO: JULIE VINCENT PHOTOGRAPHY

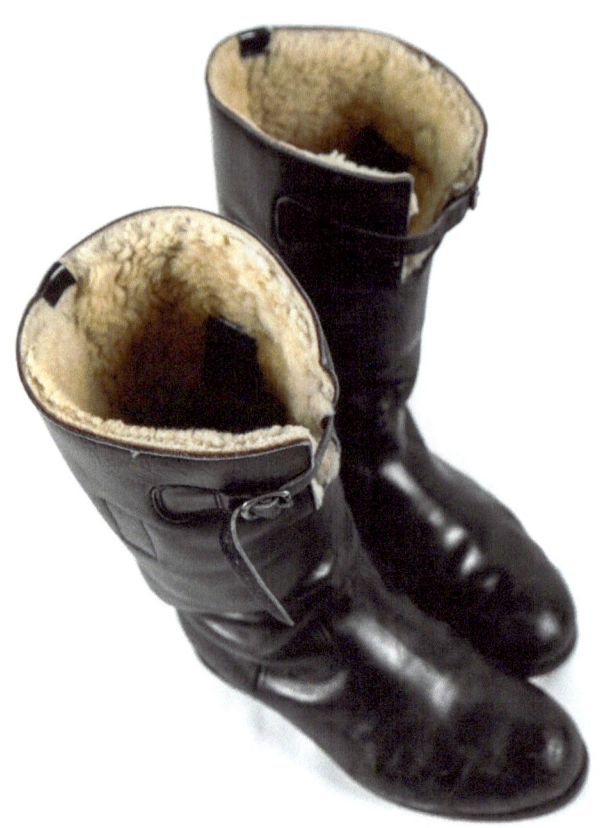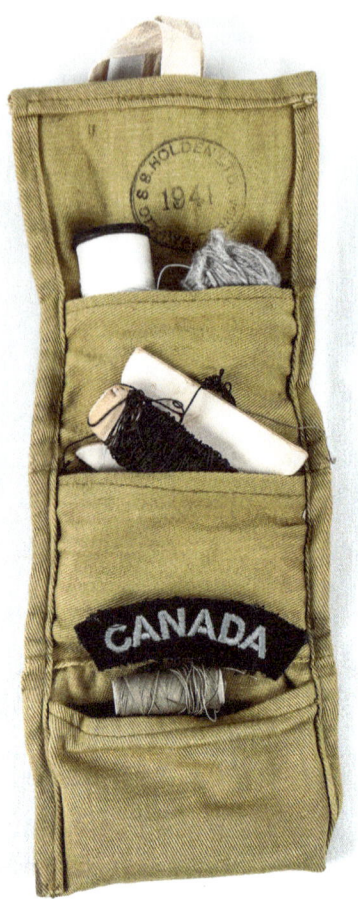

PHOTOS: JULIE VINCENT PHOTOGRAPHY

(LEFT)
'36 Pattern Flight Boots, RAF. These boots were worn by W.F. Young during his service with the RAF. They are a rare, early-war type. Collection of the Air Force Museum of Alberta.

(RIGHT)
This sewing kit belonged to Daryl 'Doc' Seaman from Calgary. He flew with RAF 500 Squadron in North Africa during the Second World War. Collection of the Air Force Museum of Alberta.

(RIGHT, ABOVE AND BELOW)
Royal Air Force Survival Kit, ca. 1939–45. This survival kit contains sunscreen, a button compass, a water purification sack and tablets, and Horlicks tablets, among other things. It was intended to help downed aircrew while awaiting rescue or trying to make their way back through enemy lines. There are few intact examples of these kits still in existence. Collection of the Air Force Museum of Alberta.

(BELOW)
Identity discs were issued to all servicemen and used in the event of death to identify the body. The green tag would remain with body while the red would be taken for official record purposes. This grouping belonged to Airman F.S. Reynolds. Collection of the Air Force Museum of Alberta.

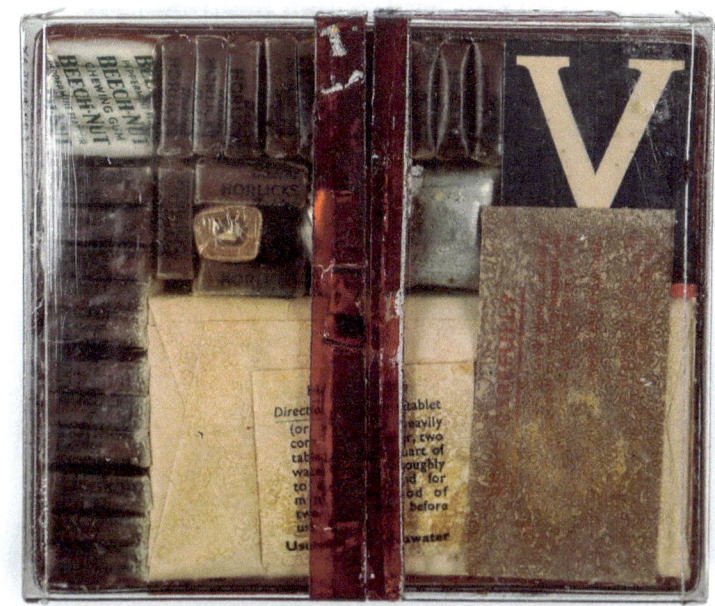

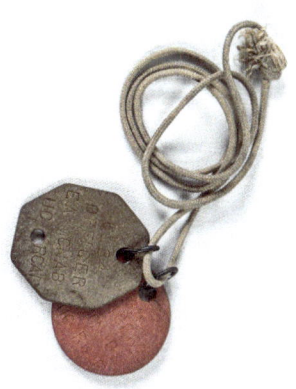

PHOTOS: JULIE VINCENT PHOTOGRAPHY

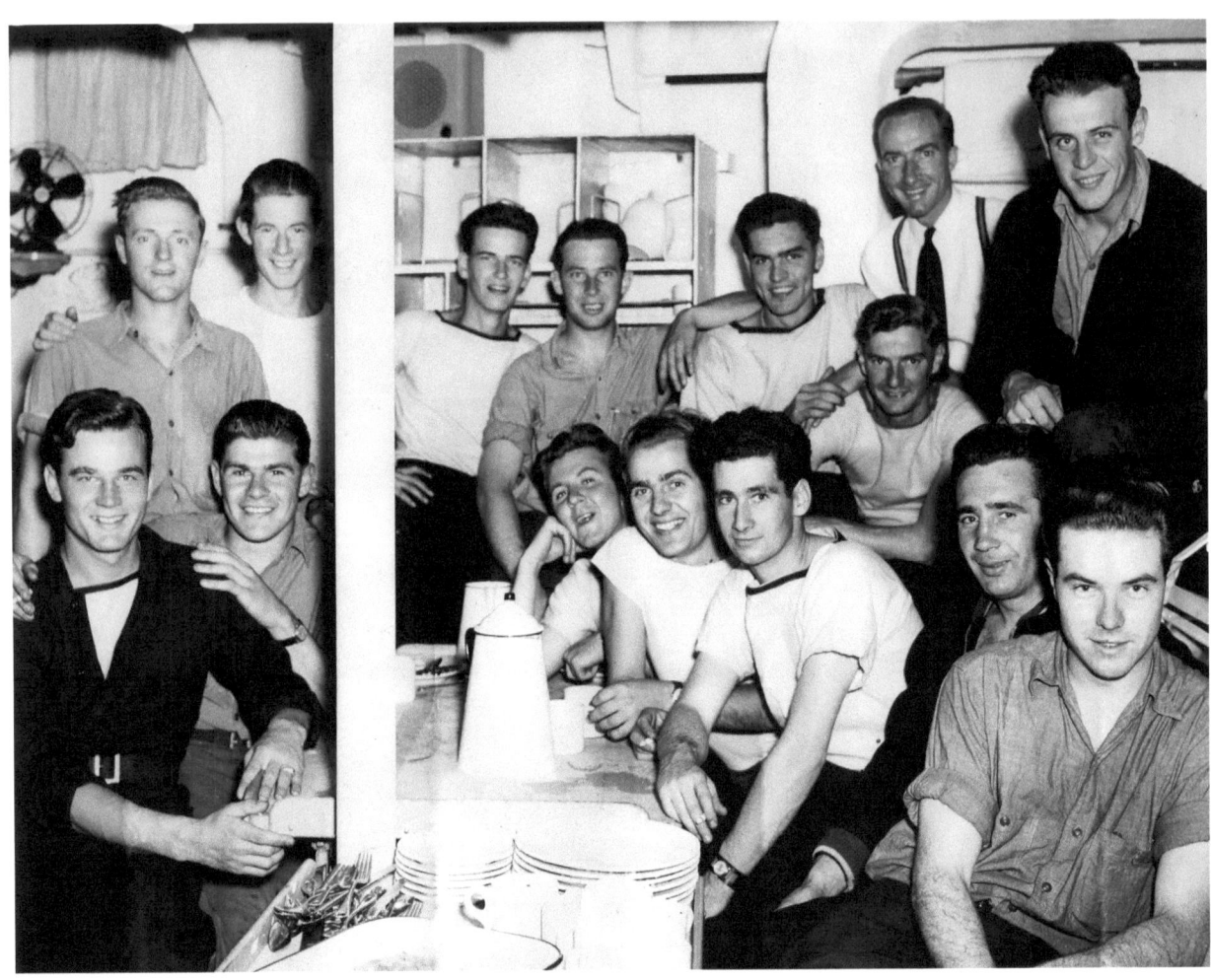

Crew members on the mess deck of HMCS *Winnipeg*, an Algerine-class minesweeper that served in the Royal Canadian Navy during the Second World War. Ken Macpherson photographic collection.

5

COMING TOGETHER

The success of the Museum of the Regiments and the constant demand to place more exhibits in it soon prompted many key figures to think about expanding the facility. One of the principal drivers was Honorary Colonel Fred Mannix. He also pushed for strategic alignment with the University of Calgary to create a major research library located at both the University and the Museum, an archives, and an art gallery in the original gym of the old school. He knew that many regimental libraries in the United Kingdom were being closed for lack of space and finance. He began by hiring former Calgary Highlander Jeffery Williams, author of the Governor General's prize winning biography *Byng of Vimy*, to search out some of these collections with a view to having them shipped to Calgary and housed in the Museum's library despite its shortage of space.

In 2000, Brigadier-General Bob Millar left his post as Deputy Commander of Land Forces Western Area to rejoin civilian life. Millar had served as Commanding Officer of the King's Own Calgary Regiment and, before that, as a tanker in Germany with the 8th Canadian Hussars (Princess Louise's), the Royal Canadian Dragoons, and Lord Strathcona's Horse (Royal Canadians). Now he went to work in the private sector in Calgary, but it was not long before the CMMS sought to recruit him to their organization. By this time the Calgary contingent had already worked out a handshake agreement with the Canadian War Museum in Ottawa to join the national campaign for the expansion of the War Museum there. Millar eventually became a key part of a three-way partnership between the Museum of the

Regiments, the Naval Museum of Alberta Society, and the Friends of the Canadian War Museum in Ottawa. In Calgary an anonymous donor had already come forth with an offer for a very large gift on the condition that the new museum contain an art gallery, primarily for Canadian war art housed as part of the Beaverbrook War Art collection in Ottawa, some of which could be loaned.

From this partnership between the Canadian War Museum and the museums in Calgary, the Sharing Our Military Heritage Foundation was born on 3 May 2001. Money collected in Alberta would be split equally between the campaigns to fund a new national museum and an expanded local museum. Once enough money was raised for the national facility—with Alberta's target being $1.5 million, based on its share of the national GDP, which it achieved—all proceeds raised in Alberta would stay in the province to support expansion of the Calgary facility. The Canadian War Museum was opened in Ottawa on 6 May 2005.

Funds were needed not only for enlarging but also for upgrading the Museum of the Regiments, as only half of its space had proper environmental controls to preserve the artifacts. The anonymous donor pushed for expansion of the library; through an earlier gift to the University of Calgary, he had secured the university's agreement to place a librarian at the Museum of the Regiments on a part-time basis to organize its collection and help plan for future growth. The University of Calgary was an eager partner from the start, not only for an expanded library but also for an art gallery, as it was noted that the Canadian War Museum was able to display only a small portion of its collection.

By 2001, amalgamation was being advanced by those running the Museum of the Regiments and the directors of the Naval Museum of Alberta Society. The Naval Museum needed more space, and its directors worried that the number of visitors to their facility seemed to have peaked at about five thousand per year, while the Museum of the Regiments was attracting about ten times that number. By 2003, the Naval Society made clear its intent to form a partnership with the Museum of the Regiments to establish a larger facility. Their plan was also to retain the existing site at Tecumseh for storage and to build items for display, such as models of navy ships.

The emerging broader plan was to create a new tri-service museum and, as such, to also include the Air Force. Alberta's part in the history of military aviation was substantial, but little known. The province had furnished comparatively large

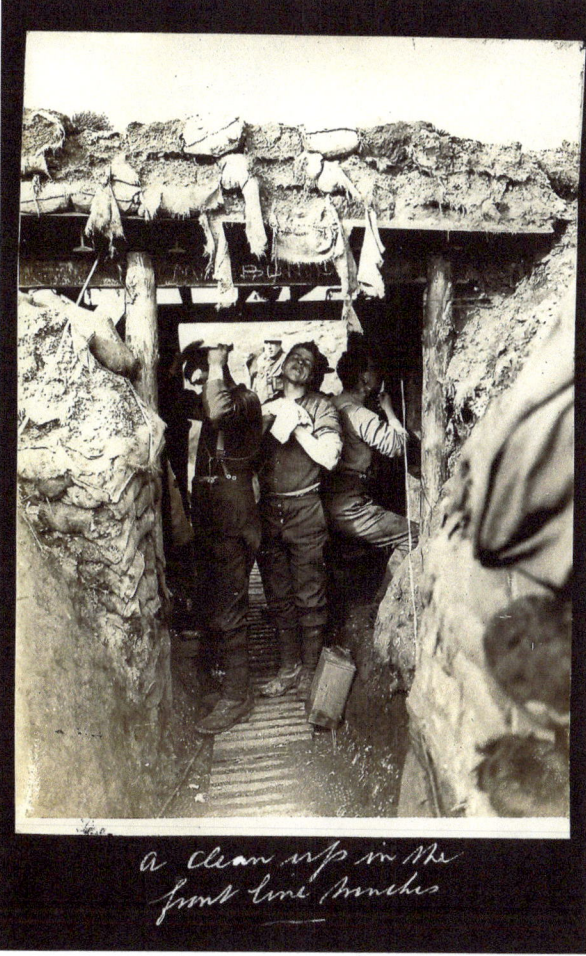

(LEFT)
The Listening Post was the trench journal of the 7th Canadian Infantry Battalion. This issue, from December 1915, marks the war's second Christmas in the field. Collection of The Military Museums Library and Archives.

(RIGHT)
"A clean up in the front line trenches." This photograph from Major-General Sir David Watson's albums likely shows members of the 46th Battalion in June 1917. Collection of The Military Museums Library and Archives.

PHOTO: JULIE VINCENT PHOTOGRAPHY

(ABOVE)
The Chicksands Collection forms the basis for The Military Museums Library and Archives' repository of rare books. The collection includes uncommon items like these Russian infantry drills from 1868. Collection of The Military Museums Library and Archives.

(OPPOSITE)
Objects excavated from the remains of Canol pipeline Pump Station #5. The Canol pipeline supplied petroleum for the Alaska Highway and the Northwest Staging Route. Collection of the Army Museum of Alberta.

numbers of recruits for the Royal Flying Corps in the First World War, including the air ace, Wilfrid R. "Wop" May. During the Second World War, Edmonton's Blatchford Field became the world's busiest airport: it helped supply those working on the construction of the Alaska Highway and Canol Pipeline, and served as the starting point for the Northwest Staging Route, a corridor that involved a series of airstrips in northern British Columbia and Alaska through which some seven thousand aircraft were transferred to the Soviet Union as part of the American Lend Lease program. Alberta was also home to twenty-three British Commonwealth Air Training Plan bases and schools, six of which were located in Calgary. More recently, the Cold Lake air base in the province's north served as a key NATO and NORAD location during the Cold War and as a pilot training centre for CF18s, including for United Nations missions in Bosnia, Haiti, and Iraq.

The Calgary-based Air Museum of Canada was founded in 1960, but consisted of a modest collection of former privately owned, and primarily civilian, aircraft. Disbanded in 1971, its aircraft were transferred to the municipal government and stored in the city's planetarium. Four years later, the Aero Space Museum Association of Calgary was established and soon after was registered as a non-profit charitable organization. In 1985, the Aero Space Museum of Calgary (now called The Hangar Flight Museum) opened in the former Bullock Helicopter Hangar located at the south end of the Calgary International Airport. It was a modest facility that sketched the general history of aviation in Canada. It contained several civilian and military aircraft, including a Second World War Lancaster bomber (not flyable) and a Canadian built Cold War CF-100 all-weather jet interceptor. But the Aero Space Museum insisted it was not a military facility and would not join a new tri-service museum. Thus the Air Force veterans negotiated space for themselves in the planned new facility. Don Smith, a well-known museum designer, worked with the veterans to produce a space that would tell the history of the RCAF from its beginnings to the post-Cold War era, with an emphasis on activities in Alberta.

The Air Force Museum built its artifact collection from the ground up, but even in its infancy, donors appeared with significant contributions.

PHOTO: JULIE VINCENT PHOTOGRAPHY

COMING TOGETHER

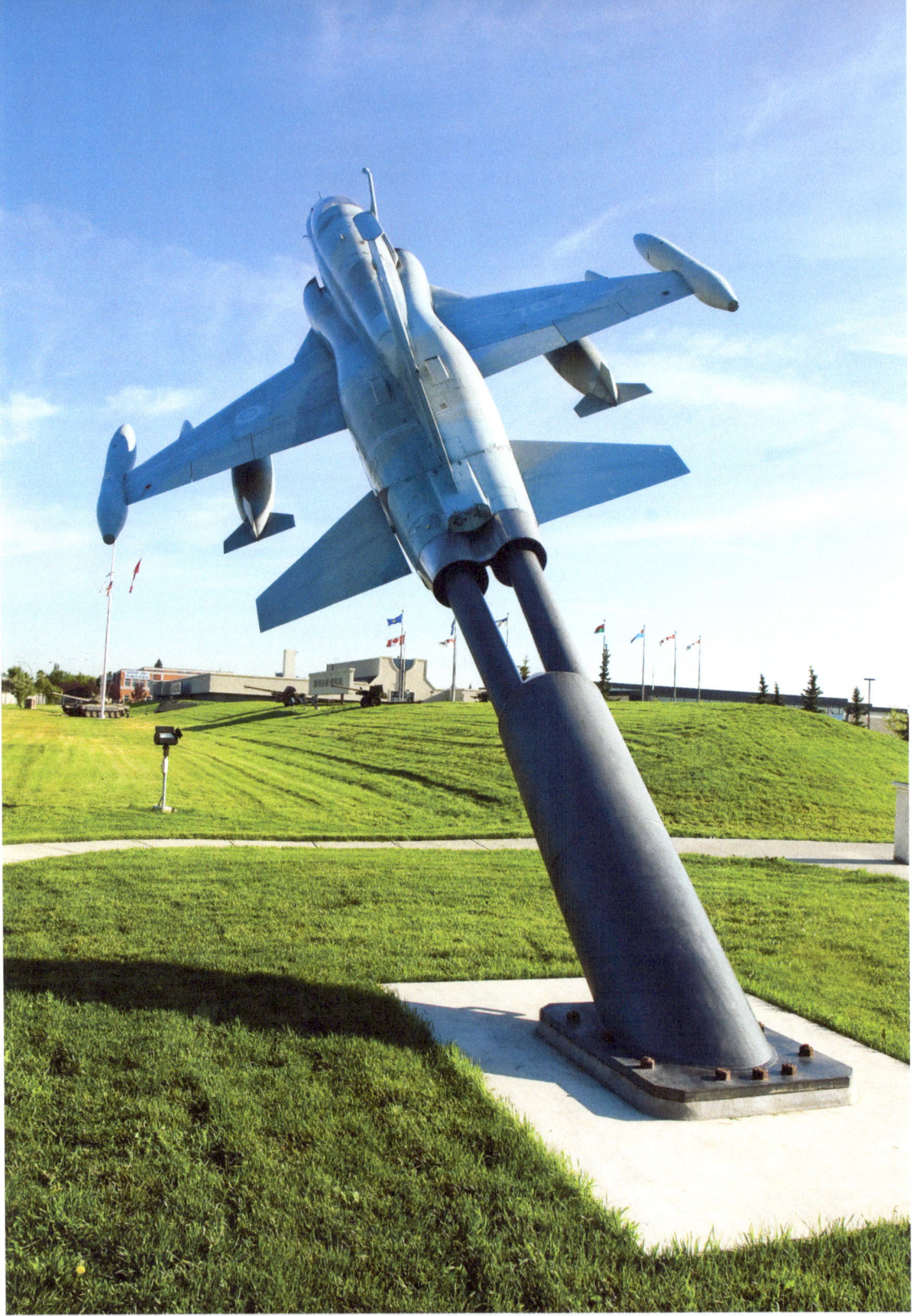

Joyce Lally, daughter of Conrad T. Lally, a pilot in the Royal Flying Corps and later mayor of Wainright, approached the Air Force Museum Society with her father's photograph albums, medals, and papers. Sydney Shulemson did the same with his own materials, including his flying clothing and personal papers. In Shulemson's case, he was a pioneer of air-to-ground rocketry as well as Canada's most highly decorated Jewish serviceman. The significance of both donations laid the foundations of the Air Force Museum's currently superb collection of Canadian military aviation artifacts. But since the Museum's initial holdings were limited, the development of the interior gallery relied much on images and storyboards to tell Canada's Air Force story. It also featured two immersive theatre experiences. The first theatre was based on the Nissen briefing huts used at air bases in England during the Second World War and features two custom films about No. 6 Group's role in Bomber Command. The second theatre was based on the interior of a Hercules aircraft, complete with salvaged Hercules webbing and instrument panels, and features films about Canada's Air Force today.

The first aircraft acquired was a CF-5 which rises from a plinth on the east side of Crowchild Trail. The jet was acquired in 2005 from the federal government's Crown Assets Corporation, and brought by truck in three sections to Calgary where it was pieced together and painted as it was when operational during the mid-1980s. It was mounted on two steel pipes extending from the aircraft's exhaust. The problem was that being fully exposed to Calgary winters and the grime thrown up from passing vehicles on Crowchild Trail, the aircraft and its plinth were in constant need of repainting and refurbishment.

Eventually the museum obtained three other Cold War aircraft: a Canadair Sabre, a CF-104, and a CF-18. Refurbished and repainted and with their engines removed, they were placed in flexible-walled structures outside the main building. Today, Calgary has a fairly large collection of former military aircraft in two locations, one at the airport in The Hangar Flight Museum and the other at The Military Museums.

By the end of the 1990s, the campaign to expand the museum was gaining steam. A survey of major Calgary businesses showed that some 30 per cent indicated they would consider donating to such an initiative. The aim was to double the display area, add significantly to the library and archives, construct an art gallery large enough to house major exhibitions, and provide an educational centre for

(OPPOSITE)
CF-5 116707 on podium in the south-west corner of the museum grounds.

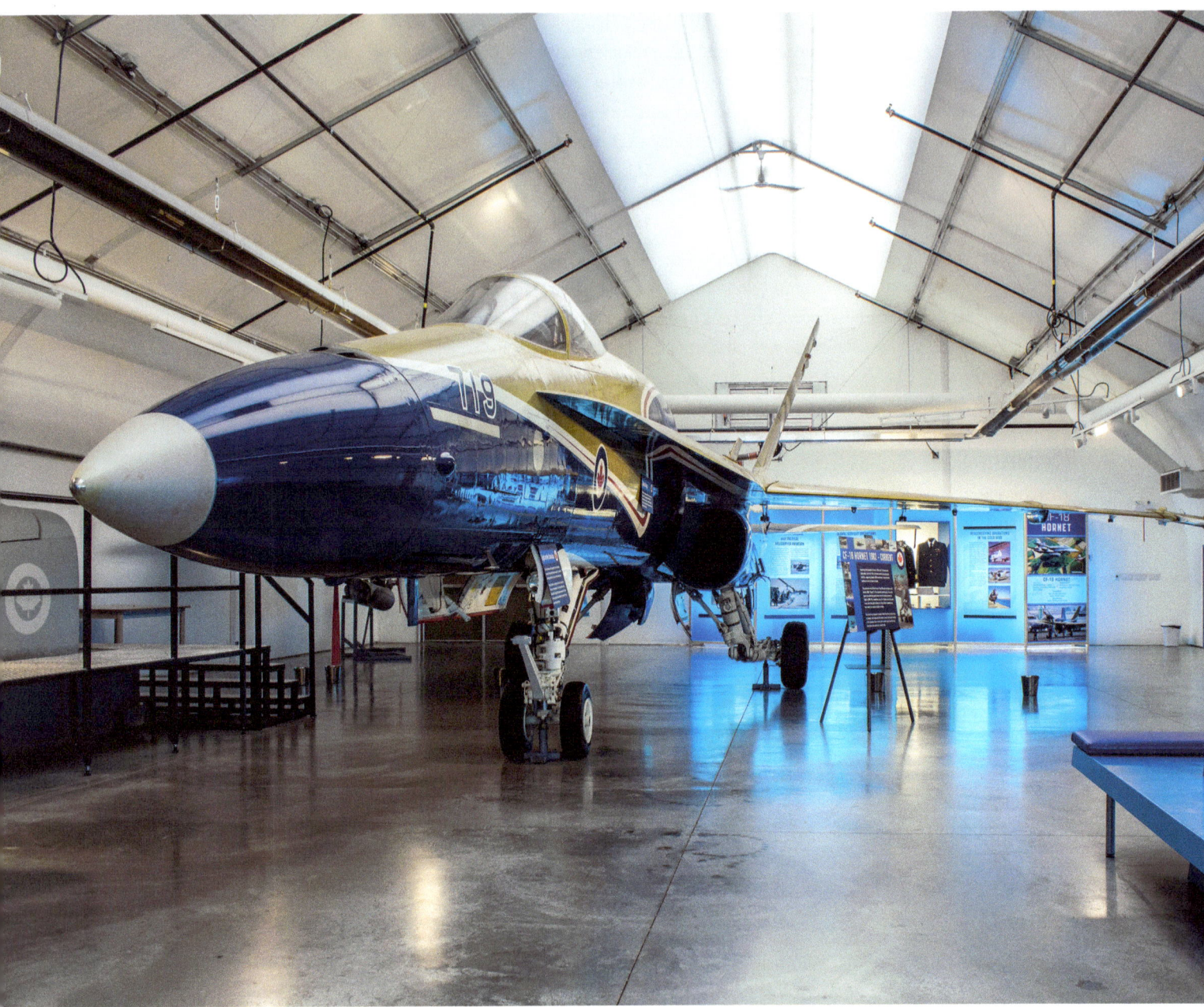

visiting school children where they could engage in hands-on interactive learning. Proponents stressed the importance of properly recognizing Alberta's military contributions, particularly in the two World Wars where the province's volunteers for military service was proportionately among the highest in Canada.

A larger and more high profile facility was also presented as helping to improve poor knowledge of history, especially about Canada's military past. A 2002 Environics survey showed that less than one-third of Canadian youth described the country's history as interesting, and according to an Ipsos Reid poll taken the same year, only about the same number of Canadians had any name recognition of Arthur Currie, widely considered among historians and military experts as the finest general the country ever produced. Yet, at the same time, the campaign to expand the museum benefitted from a resurgence of interest in military affairs, sparked and fuelled by the growing number of commemorations to mark key battles and events, starting with the fifty-year anniversaries of D-Day and VE Day in 1994 and 1995. Also, Canadian troops were making growing contributions to United Nations peacekeeping and peacemaking operations, such as in the Balkans where they courageously stood their ground in September 1993 against Croat forces seeking to attack Serb civilians and paramilitaries in the Medak Pocket. The 9/11 terrorist attack that facilitated Canada's extensive involvement in Afghanistan, starting December 2001 with Joint Task Force 2, added appreciation of the country's military forces and the need to properly catalogue and commemorate their histories.

Proponents predicted that a larger facility would increase museum attendance that remained flat throughout the 1990s. The federal government's decision in 1995 to close CFB Calgary and move its operations to CFB Edmonton sparked widespread concern that this would include the museum. Property used by the military was slated for transfer to the Canada Land Company to govern its sale for residential and commercial purposes. A petition signed by more than eighty-two hundred Calgarians organized by Jo Repp, a former member of the Canadian Women's Army Corps, demanded the museum stay at its current location. Municipal officials backed her campaign, especially with rumours that the Department of National Defence, as a cost-saving measure, was seeking to shed responsibility for the museum because it was drawing $560,000 annually from its budget. Soon, there came assurances from the federal government that the museum, including its financial support from National Defence, would remain protected. Ultimately,

(OPPOSITE)
The CF-18 Hornet on display in the eastern hangar of the Cold War Exhibit is the 2009 Demo Aircraft from airshows across the country. It is painted in the commemorative Canadian Centennial of Flight colours and lists the names of 100 influential Canadians in aviation around the fuselage.

the final closure of CFB Calgary in 2001 had a much different effect, bringing more residential housing to the area and, as such, a potentially larger local museum audience.

A major step forward occurred in 1999 with the establishment of a Military Library and Archives Advisory Board. With a $1 million gift from the Calgary-based Carthy Foundation, the CMMS and the University of Calgary established a partnership, also involving the University of Calgary's Centre for Military and Strategic Studies, nationally known for advancing graduate-level analysis in military, peace, and security issues. With new money for collections development and the hiring of a librarian, within a few years the library was reaching capacity with more than seventy-five hundred books and some five hundred metres of archival records. The museum also became part of a network of military libraries enabling it to borrow material from places that included West Point and the Imperial War Museum. Eventually, the University supplied the staff to run the library and designed a system by which all books in the Museum library were made available to students on the main campus via a continuous transit service and by listing museum titles in the main library computer catalogue.

In May 2002, representatives from the Sharing Our Military Heritage campaign approached several retired Calgary Air Force officers. They were asked to champion the transfer of the Aero Space Museum collection dealing with the history of air force operations into a tri-service facility. The result, a couple of months later, was the creation of the Air Force Museum Society of Alberta whose mission was to "tell the Air Force story, both in terms of the involvement of Canadians from earlier times in Britain's Flying Corps through to later developments with the Royal Canadian Air Force." In 2003, the provincial government officially recognized the Society, which also acquired from the federal government a registered charitable status to help it raise money and move into a new facility.

By the end of 2003, the Canadian War Museum, the Museum of the Regiments, and the Naval Museum of Alberta had raised some $3.3 million towards creating a new facility. The next year, there came an agreement in principle that both the Navy and Air Force museums would unite with the Museum of the Regiments. Architects and other consultants were hired to draw up a detailed plan, including how to best use expanded space, the logistics of moving collections to a new site, and setting a timeline for completion.

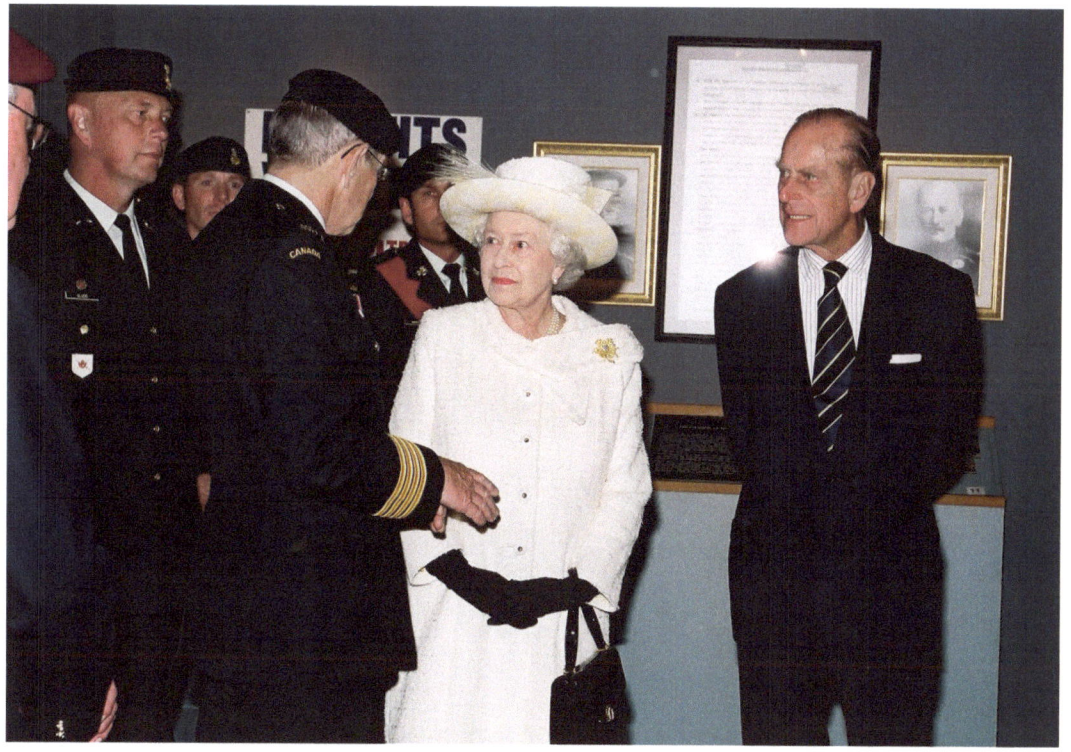

Her Majesty the Queen and Prince Philip visiting the Museum in 2005.

In 2005, Queen Elizabeth II again visited the museum, adding to the sense of anticipation that something big would soon happen. Among the large crowd greeting the Queen was Helen Kozicky, who had served with the Canadian Women's Army Corps in England in the Second World War. The Queen approached Kozicky and briefly spoke to her admiringly about the growth of the museum after Helen shared a photo showing the two of them meeting when the Queen opened the same facility fifteen years earlier. On 3 June 2006, the visit of another Royal, the Countess of Wessex, became the occasion to turn sod and lay the cornerstone of what was officially to be called The Military Museums. Brian Brake, who then spearheaded the Museum's fundraising efforts, and who had a twenty-seven-year

COMING TOGETHER

The Countess of Wessex, Sophie Rhys-Jones, present for the sod turning for the museum expansion in 2006, poses with veterans and museum supporters standing and seated around her. The woman in the red uniform in the front row is Helen Kozicky, a veteran of the Canadian Women's Army Corps.

military career, said "it has been a long and difficult road to get to where we are," but now he and the many others who had championed this project could take great satisfaction from the fact that "the military's role in the growth of Canada as a nation … [will] be captured and preserved for the next generation of Canadians."

Construction soon commenced even though funding had not yet reached its target. To build public support, excitement, and anticipation, and to underline the remarkable educational potential of an expanded museum, artifact displays

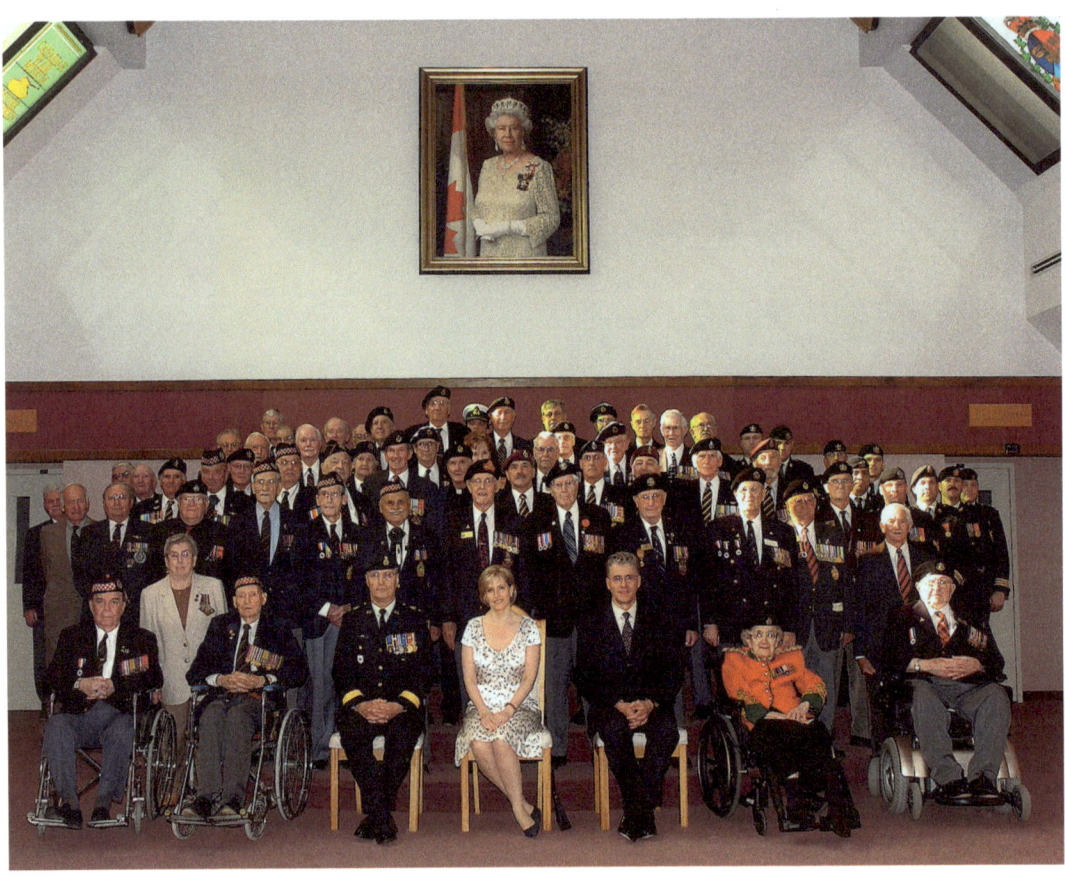

were established at places that included the Calgary Stampede, Spruce Meadows Equestrian Centre, trade shows, and at teacher conventions.

As with the creation of the Museum of the Regiments, governments ultimately provided the lion's share of the funding. Ottawa would contribute $9 million, the provincial government $7.6 million, and the municipal government just over half a million dollars. However, with an estimated price tag of $26 million, some $9 million had to be raised from other sources.

Several foundations and corporations, particularly major oil companies and banks, provided gifts of $50,000 or more. Individuals contributed over 30% of total funding in 2007. Casino and bingo nights raised some $200,000 annually. Significant money was also obtained through commemorative dinners, such as in May 2006 with Prime Minister Stephen Harper as the featured speaker.

One of the more successful fundraising initiatives involved the creation of a massive mural mosaic. Sponsored by the Bank of Montreal, this striking visual art display, placed in the museum's atrium, remains one of the first things visitors see when entering the building. The well-known Edmonton mural artist Louis Lavoie was hired to paint two hundred and forty one-square-foot panels. Pre-approved images cost $1,000 to sponsor; special requests relating to Alberta's military history ranged from $2,500 for a thematic topic to $4,000 for an individual portrait. Princess Patricia's Canadian Light Infantry paid $2,500 for a panel depicting the Battle of Kapyong, where its members fought in the Korean conflict, while the South Alberta Light Horse paid $4,000 to include a panel dedicated to PPCLI Captain Nicola Goddard, who, in 2006, became Canada's first female soldier killed in action in Afghanistan. The list of contributors was impressive and wide-ranging. It included the city's Sikh Businesspersons and Professional Club and the Calgary Motor Dealers Association that sponsored two $2,500 panels to "build a strong sense of freedom, responsibility and commitment in present and future generations." Viewed from a distance, the entire mural formed a large superimposed representation of a Second World War Canadian soldier, sailor, and airman.

The museum would ultimately double in size to one hundred and seven thousand square feet; only the Canadian War Museum in Ottawa is bigger. A striking new two-storey exhibit hall housed the air force and naval collections. The Alberta Gallery (which later became the Army Museum of Alberta), covering general military history involving Albertans, was enlarged to present artifacts from recent

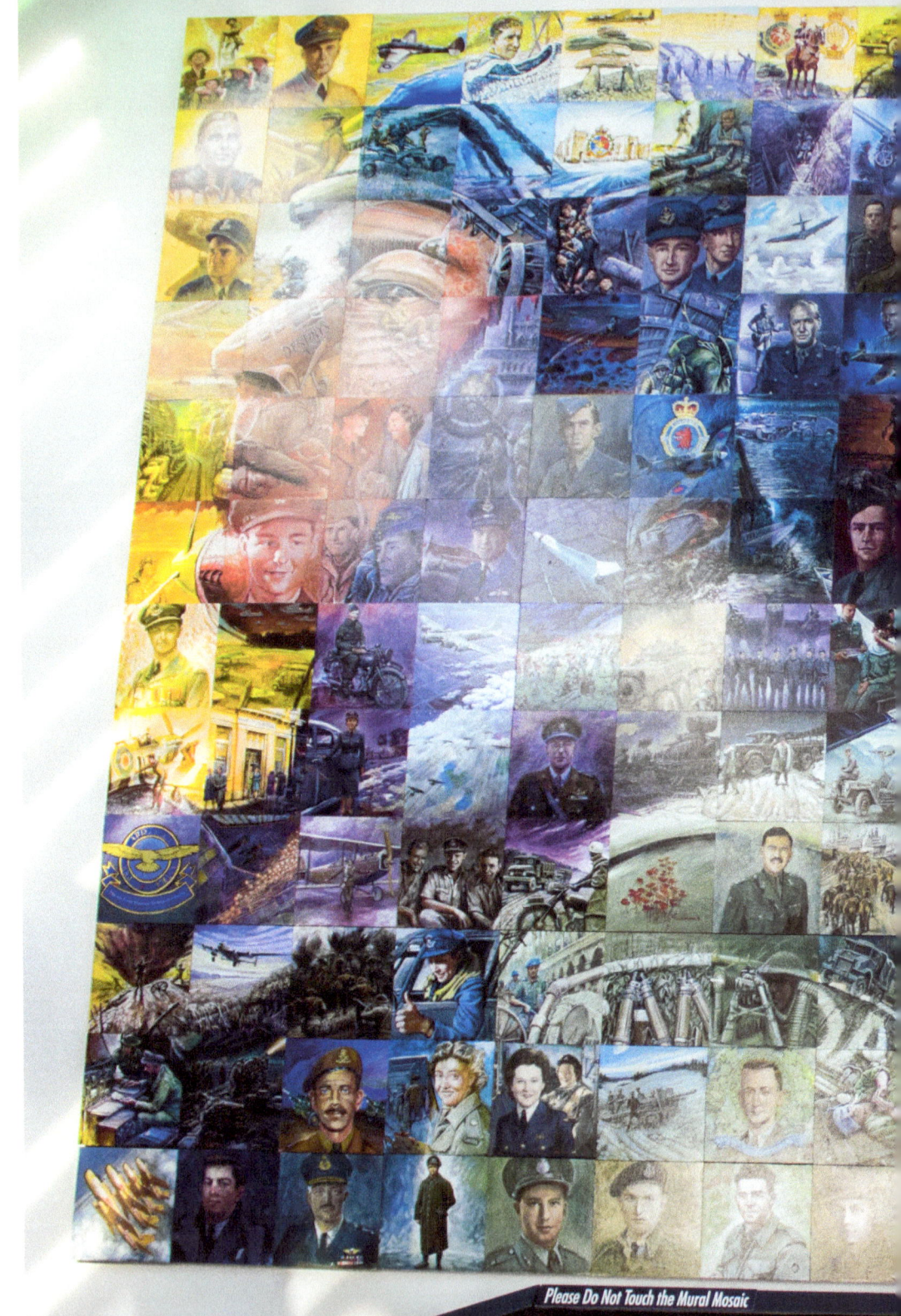

The *Mural of Honour* by Louis Lavoie on the northern side of the Queen Elizabeth II Atrium in the Museum.

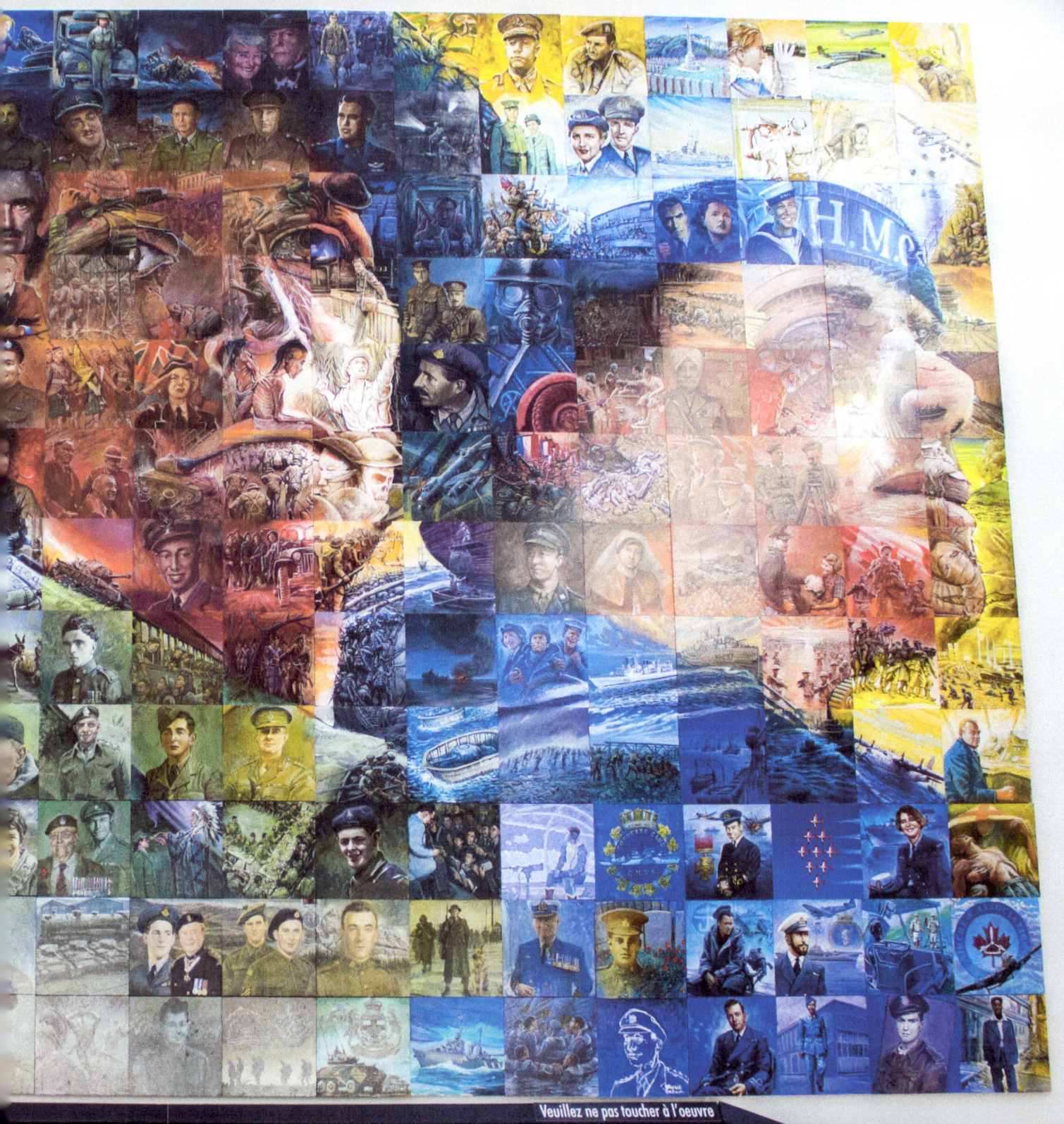
Veuillez ne pas toucher à l'œuvre

(OPPOSITE)
An overview of the main gallery at the Naval Museum of Alberta.

peacekeeping operations, particularly in Bosnia with respect to Canada's leadership in the removal of mines, and from its thirteen years of military participation in Afghanistan. The Founders' Gallery was inaugurated as a temporary gallery for art and heritage exhibits, a high-tech Discovery Centre was created—where visitors could engage in computer battle simulations—as was a multipurpose classroom, a larger library and archives, and more office and storage space. The remodelled museum became a hub for community events that could now take place in a grand, inspiring setting, namely in new space containing vintage military vehicles, large naval guns, and aircraft.

The CMMS managed the expansion's construction and financing along with Defence Construction Canada. Its goals were ambitious, aiming to get funding in place, shovels into the ground, artifacts set up, and doors open to the public by the end of 2007.

On 6 August 2007 the Naval Museum of Alberta lowered its Ensign at HMCS *Tecumseh* and closed its doors to the public. Cleaning and packing began in earnest, and by the end of September final arrangements were being made for the move. At the end of October its three naval aircraft were transported to their new home. However, delays resulted from material and labour shortages and extreme cold weather. Fabricating cabinets appropriate for the naval collection proved more challenging than predicted. These hiccups put back moves of large-bore naval mounting guns and an anti-aircraft gun until February 2008. Positioning the artifacts and developing exhibit storylines took until October. On 16 October 2008, the 20th anniversary of the opening of the original naval museum, the Honourable Norman Kwong, Lieutenant-Governor of Alberta, presided at the official opening of the new and magnificent naval exhibit consisting of large guns, aircraft, uniforms, weapons, ship models, and a periscope connecting two floors of artifact displays.

On 8 May 2009, the anniversary of VE Day, and a month before the official opening of The Military Museums, the Air Force display was completed. It was filled with photos, hundreds of well-built models of different aircraft flown by the RCAF, two small movie theatres, and reproduced nose cone art from Second World War bombers. Other unique features included a replica of a Nissen hut where visitors saw ghostly projections representing a bomber crew being briefed before a raid on Nazi Germany, and a mock-up of a C-130 cargo bay that transported supplies on UN peacekeeping and peacemaking operations.

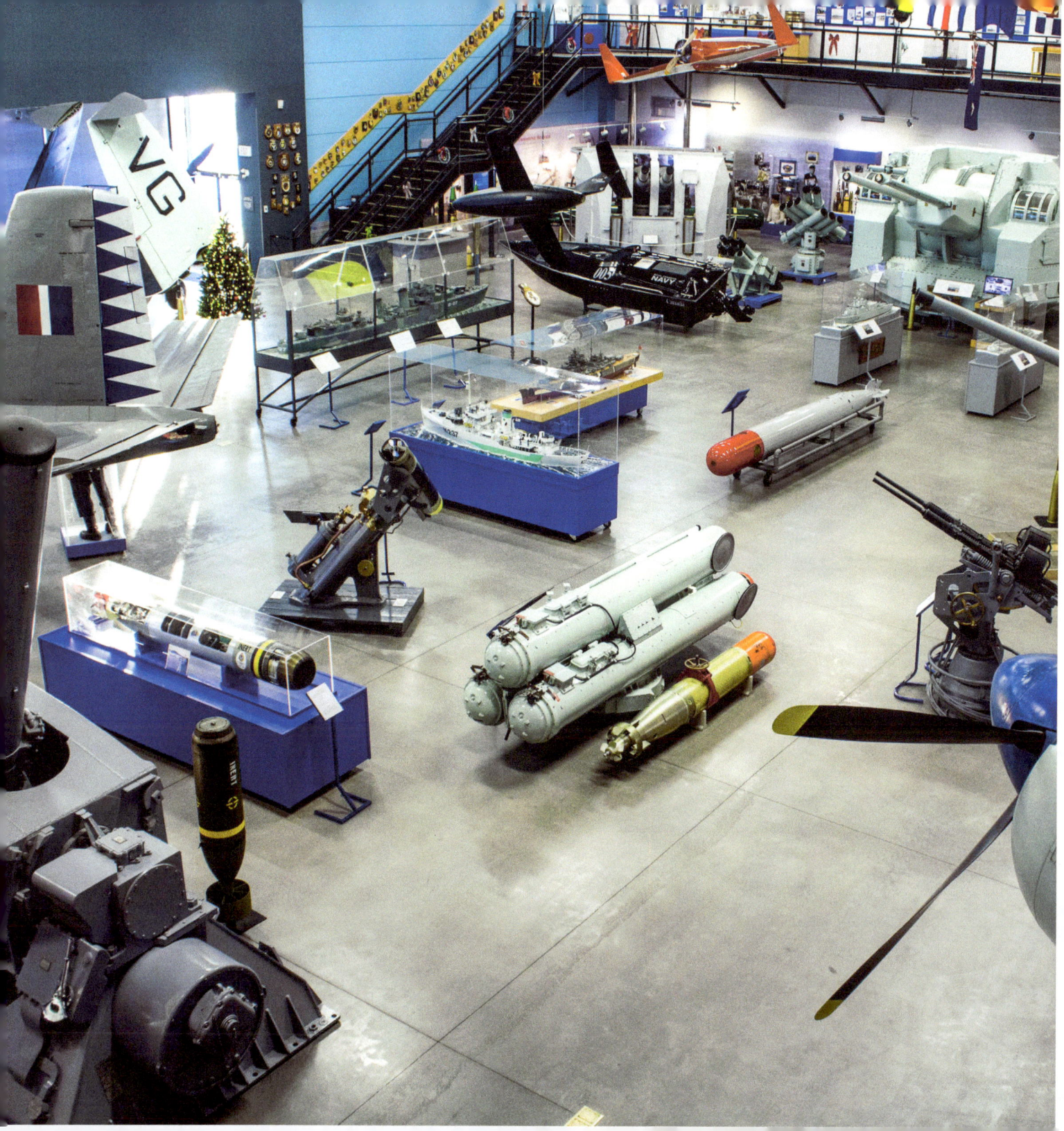

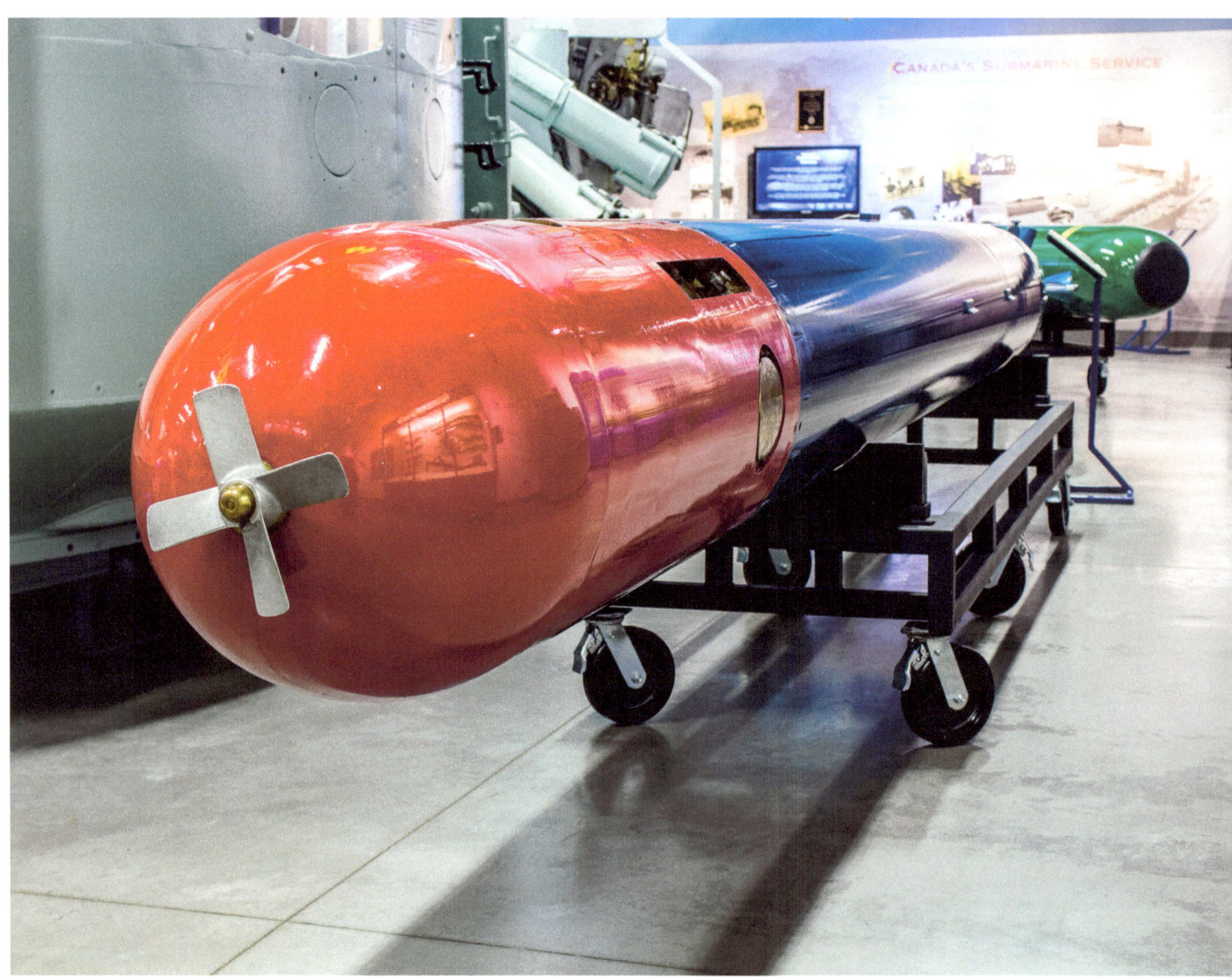

A Whitehead Torpedo on exhibit at the Naval Museum of Alberta.

The former W. A. Howard Library became The Military Museums Library and Archives, under the management of the University of Calgary through a partnership established in 2000, expanding over the years to hold more than 20,000 volumes. Also through the guidance of the University's Libraries and Cultural Resources, the old school's gymnasium became the Founders' Gallery for temporary art and history exhibitions. Reflecting this close relationship, including the university-funded art curator at the Founders' Gallery, the Vice Provost of Libraries and Cultural Resources was given authority over the library, archives, and gallery in 2009.

It took nearly three decades for those who tirelessly worked to establish a major military museum in Calgary to fully realize their dreams. It all came together on 6 June 2009 when the Countess of Wessex, who had announced the creation of the expanded facility three years earlier, returned to officially open the doors to the new tri-service facility. Upon entering, visitors encountered an enormous digital display detailing the wide array of individuals, organizations, and private sector sources whose generous funding made this possible.

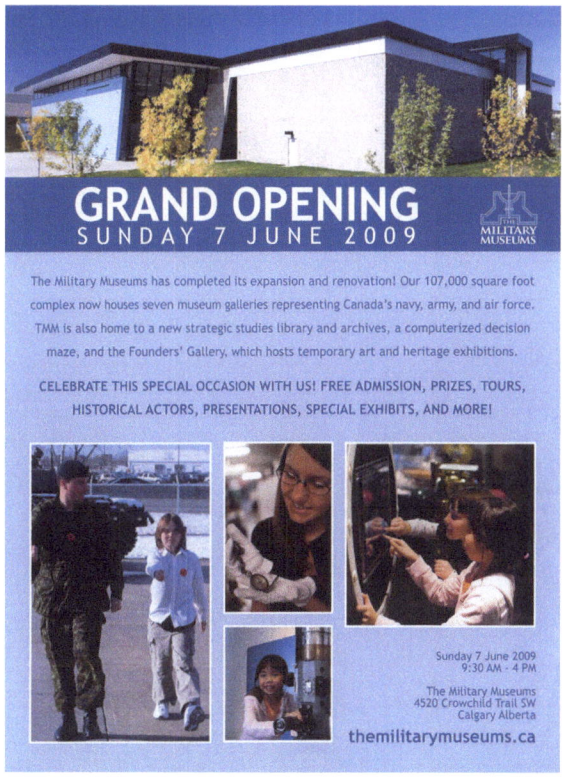

Poster advertising the grand opening of The Military Museums in June 2009.

BULLET-DAMAGED ARTIFACTS

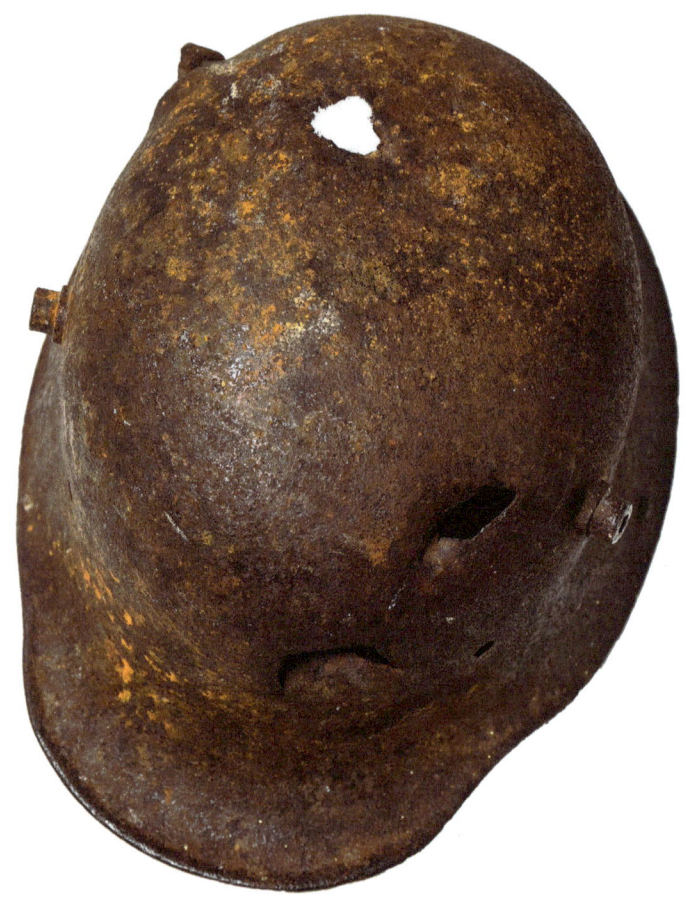

(ABOVE)
First World War German belt buckle taken as a battlefield souvenir by Canadian William McLaren. McLaren was wearing this when he was later shot (as seen by the bullet hole in it). He was wounded, but it saved his life. Ironically, the German inscription "Gott Mit Uns" translates to "God is with us."

(BELOW)
First World War German helmet excavated from the Vimy battlefield. Note the shrapnel holes in the helmet. This attests to the ferocity of the battle. Collection of the Army Museum of Alberta

PHOTOS: JULIE VINCENT PHOTOGRAPHY

(ABOVE)
Bullet hole in a message pad which belonged to Lieutenant-Colonel F.O.H. Eaton while serving with the Grenadier Guards during the Great War. Lieutenant-Colonel Eaton served in the Guards on several occasions when they were located on the right flank of the 10th Battalion. Collection of the Calgary Highlanders Museum and Archives.

(BELOW)
Corporal E.E. Daniels, a PPCLI Original, was wounded three times in the First World War. On 15 September 1916, he was hit by a sniper while going over the top; the bullet passed through his left arm and then glanced over this cigarette case in his trouser pocket. Collection of PPCLI Museum and Archives.

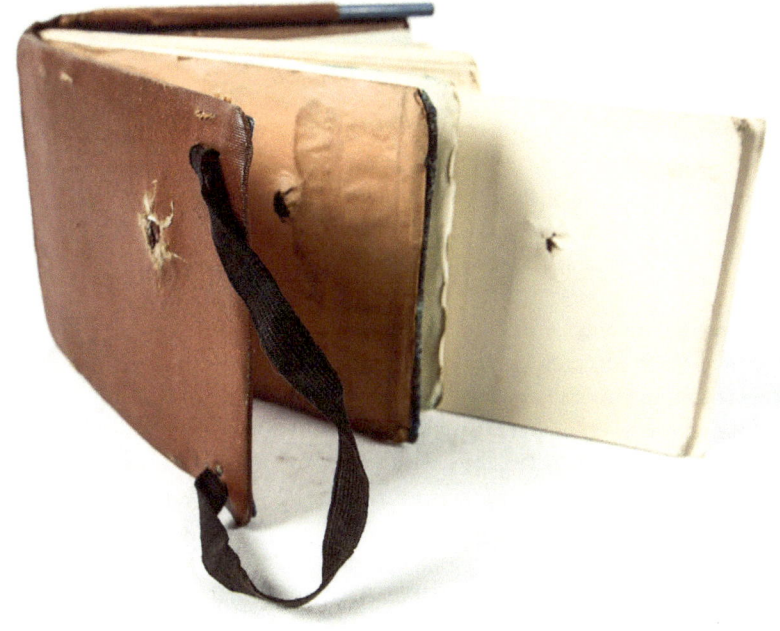

PHOTOS: JULIE VINCENT PHOTOGRAPHY

PRISONERS OF WAR

The Military Museums collectively has one of the largest collections of Second World War prisoner of war material in Canada. This is not surprising, considering that Alberta housed approximately 25,000 of the nearly 34,000 German prisoners of war held in Canada. There were two very large camps in Lethbridge (originally Ozada camp) and Medicine Hat, as well as smaller ones at Wainwright and in Kananaskis Country. Most of the prisoners were from the Afrika Corps, were captured during the Battle of Britain, or were submariners. Some were also civilian internees with ties to the Axis countries. They were treated well in the camps (so well that approximately 6,000 returned to settle in Canada after the war), but boredom was an ongoing problem. Many of them volunteered to work outside the camps in logging operations, construction, or agricultural work to stay occupied. Barrier Dam in Kananaskis Country was one of their building projects. One of the ways prisoners passed the time was by making crafts in various forms—textiles, woodwork, painting, and more. These are all represented in the collection, along with uniforms, camp equipment, cartoons, newsletters, oral histories and other material from both the prisoners and the guards. The Naval Museum of Alberta has a very important collection from the first prisoners held in Alberta. These were the crew of the German merchantman MS *Weser*, captured by Canada's HMCS *Prince Robert* in 1940 off the Pacific coast of Mexico. The collection includes the *Weser*'s flag and crest.

PHOTOS: JULIE VINCENT PHOTOGRAPHY

Shirt issued to German prisoners of war in Canada. The red dot was an aiming point for guards in the event that a prisoner tried to escape. These durable denim work shirts were made as a set with caps and trousers by the Great Western Garment Company in Edmonton. Collection of the Army Museum of Alberta.

(RIGHT)
The 'Kananaskis Record', essentially a humorous colouring book, was created by Otto Ellmaurer, a civilian internee at Prisoner of War Camp 130 in Kananaskis Country. Note the figure on the bed is wearing the POW uniform depicted on the facing page. The Military Museums Library and Archives, Kananaskis/Seebe POW collection.

(BELOW)
Folding dentist chair (*left*) and foot pump drill (*right*) used by Captain William Branch, a dentist who traveled around Alberta treating patients at the various prisoner of war camps. Both folded into a single suitcase for ease of transport. Collection of the Army Museum of Alberta.

PHOTOS: JULIE VINCENT PHOTOGRAPHY

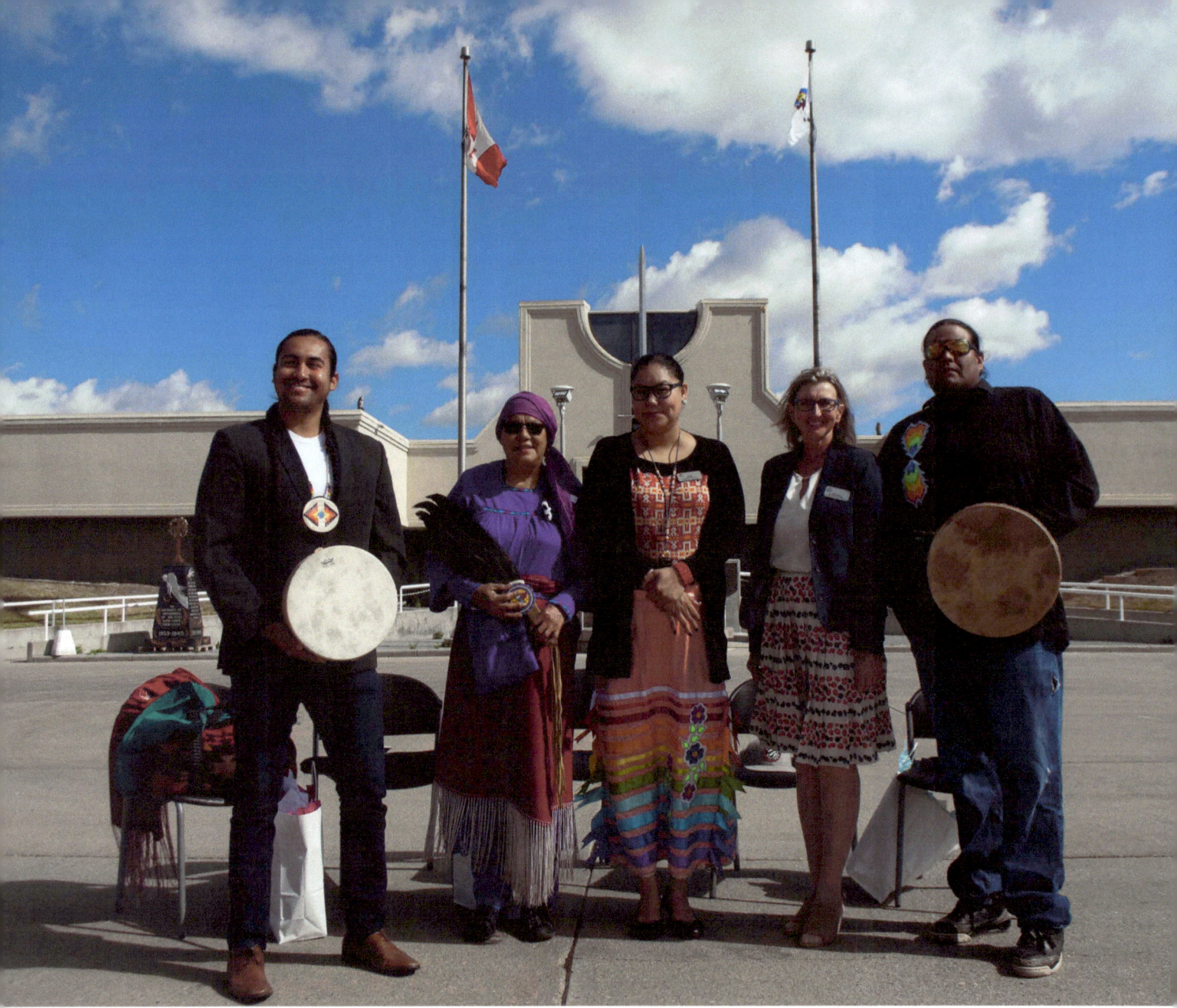

Representatives of the Tsuu T'ina Nation stand alongside Sheila Serup, executive director of The Military Museums Foundation, at a ceremony for National Indigenous Peoples Day in 2017.

6

CANADA'S MILITARY HISTORY ON DISPLAY

The complexity of Canada's, and more specifically Western Canada's, military experiences provided for engaging and distinctive exhibits at the newly renovated and expanded Museums. Key to advancing the museum's mandate was its more than two hundred and fifty volunteers, a number that had grown from just a handful when it first opened. Many were students, most commonly from Mount Royal College (or University after 2009) and the University of Calgary. Increasingly they were provided with specialized training enabling them to contribute in the library and archives, develop marketing materials, help with special events and fundraising, and give tours. Many volunteers were military veterans, such as Rose Wilkinson who joined the Canadian Women's Army Corps when it was created in 1941, and who enthralled visitors with stories about her job in Ottawa decoding secret messages. Other veterans provided stories of past battles or, with the passage of time, of peacekeeping operations and explanations on the operation of military equipment on display.

Museum volunteers received more comprehensive orientation and up-to-date handbooks describing and explaining the exhibits. With continuing management by Libraries and Cultural Resources of the University of Calgary, and assistance from the Centre for Military and Strategic Studies, the library and archives relocated to an expanded and more functional space to become a major resource

(ABOVE)
The Chicksands collection (part of which is seen here) consists of textual material gathered by military attachés assigned to British high commissions and consulates between 1650 and 1996. This remarkable collection of more than 50,000 books, government documents, treatises, pamphlets, atlases, manuals, and military orders is considered to be one of the most important acquisitions of military-related textual material in Canada.

(BELOW)
Fred Mannix reviews archival material in the W.A. Howard Library at The Military Museums. Mr. Mannix was instrumental in bringing the Chicksands collection to Calgary from Britain.

PHOTO: DAVE BROWN

for military researchers. Here, a major coup was the acquisition of the Chicksands Collection. Curated by the University of Calgary and housed at the Museums, the Chicksands Collection is now an integral part of Canada's largest military library.

The new Founders' Gallery—a four-thousand-square-foot space—opened with the museum expansion with the goal of contributing to Canadians' understanding of their military experience by displaying historic and contemporary works of art and related artifacts. After years of planning, the first exhibitions offered a stunning example of exhibitions to come: *Art in the Service of War: The Emergent Group of Seven*, organized by the University of Calgary curator Colleen Sharpe, displayed First World War art now part of the Beaverbrook Collection, originally commissioned on behalf of the Canadian government by artists that would form the Group of Seven; and *For You the War is Over: Second World War POW Experiences*, an exhibit of historical artifacts and archives created by The Military Museums in partnership with the Galt Museum & Archives in Lethbridge, Alberta. As the University of Calgary assumed full management of the Founders' Gallery in 2011, its mandate expanded to explore human conflict worldwide through projects by local, international, historic, and contemporary artists that challenge viewers' knowledge of and interaction with war. Founders' also hosts historical, artifact-based exhibits organized by The Military Museums that explore the rich and complex histories of Canada's military.

The advertisement for the two inaugural exhibits in the Founders' Gallery. Both included a unique blending of art and artifacts.

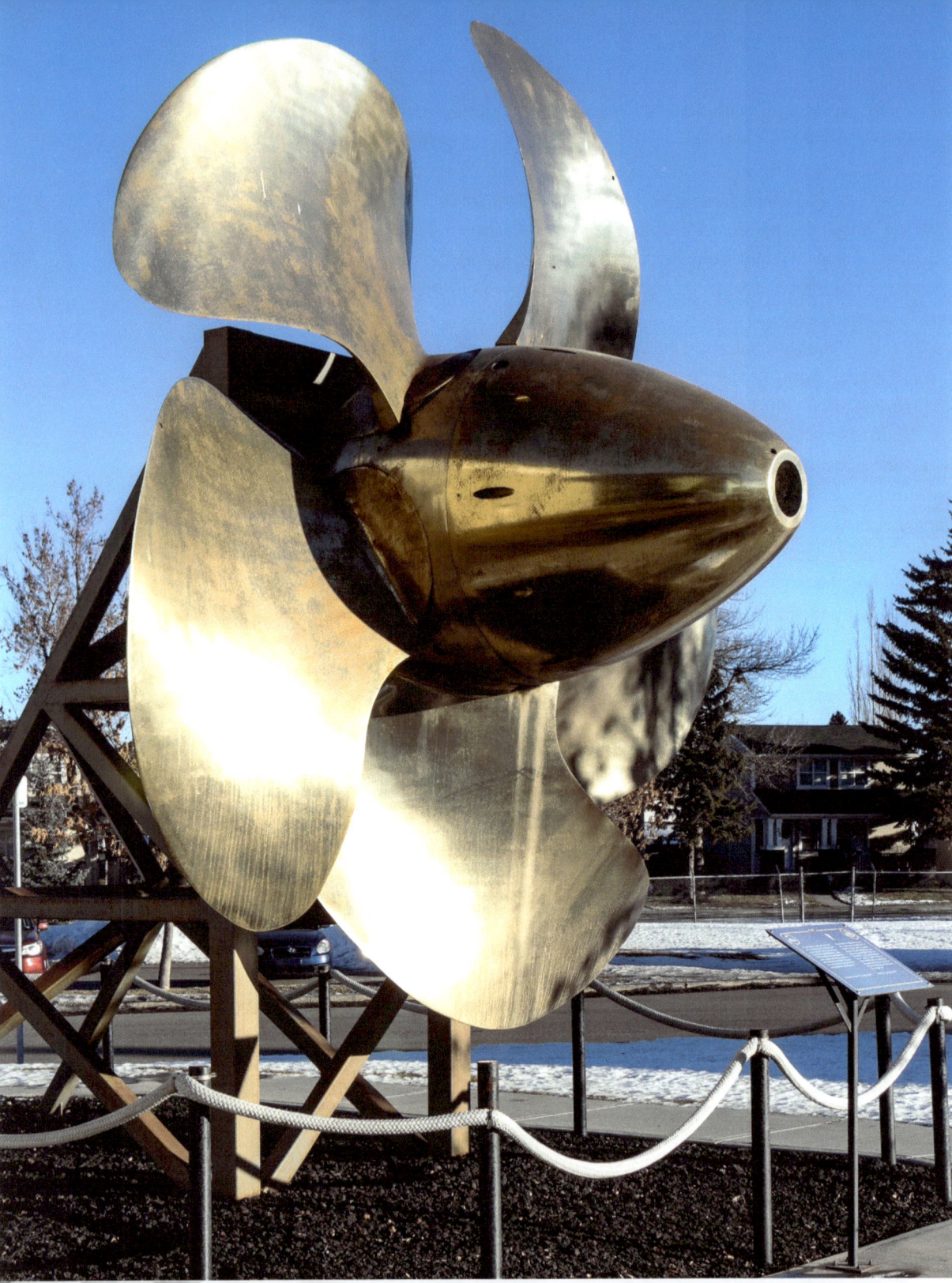

In addition to the two structures housing the three Cold War era fighter aircraft, the area surrounding the museum saw expanded displays of large military items such as tanks and armoured personnel carriers. Unveiled on 3 June 2012 and "dedicated to the men and women who served in the boiler and engine rooms of the warships of the Royal Canadian Navy during the 20th Century" was a giant propeller taken from HMCS *Huron,* a tribal class destroyer that operated from December 1972 to March 2005. Also added was a Taurus Armoured Recovery Vehicle used in Afghanistan and a Leopard 1C2 German-built battle tank that Canada's army began using in 1978 to replace aging Centurion tanks. Reflecting the recent War on Terror and to commemorate the twenty-four Canadians who perished in the 9/11 attacks on New York's World Trade Center, some two hundred people gathered at The Military Museums on the 10th anniversary of that horrific event to witness the dedication of a 1,270 kilogram piece of steel from one of the two destroyed Twin Towers that was placed on the lawn running along Crowchild Trail. Calgary was

(OPPOSITE)
Propeller from HMCS *Huron* outside the Museum.

(ABOVE)
One of the largest World Trade Center 9/11 remnants in Canada, this exterior wall column weighs 1,277 kg, is five metres long, and is part of a long-term vision for a Canadian 9/11 monument and public installation titled *Lookout for the Future*.

The Founders' Gallery exhibit *War Stories 1917* commemorated the battles of Vimy Ridge, Hill 70, and Passchendaele. It featured specific Canadian veterans who fought during the First World War and included indigenous art. A German 77mm field gun (at left) was one of the key objects shown.

among numerous communities that applied to the New York Port Authority that had stored many pieces and made them available as memorials to mark the ten-year anniversary. On that fateful day in 2001, a dozen planes carrying 2,160 passengers were diverted to Calgary whose airport was also honoured with a plaque from the US Consulate.

The museum continues to update and enrich its permanent exhibits. Added to its coverage of naval history were a large model of a D-Day landing craft and accounts from those who served with Canada's Merchant Marine. The Founders' Gallery continues to provide rich and diverse temporary exhibitions. The Fyke Collection of Afghan war rugs, many of them acquired by foreign soldiers and civil aid workers and displaying scenes such as the Soviet withdrawal from that country in 1989 and, later, the attacks on the World Trade Centre, were seen in *Unraveling the Yarns: War Rugs* (2010). Contemporary paintings by Calgary artist Bev Tosh showed the histories of Dutch War Brides in *Trees Heeft een Canadees*, alongside a history exhibit from The Military Museums *The Maple Leaf and the Tulip: The Liberation of Holland in the Second World War* (2015). Photographs by Leslie Reid in *Mapping a*

Cold War and archival photographs in *The Cold Before the War* (2016) worked together to explore the significance of the Cold War in Canada's North. In *Behind the Lines: Contemporary Syrian Art* (2017) showed paintings by Syrian artists, evoking the cataclysmic impact of the ongoing civil war in Syria.

Most recently, the 100th anniversary of Canada's capture of Vimy Ridge was commemorated in *War Stories 1917* (2017). Many important artifacts were borrowed from the Canadian War Museum and from England's Imperial War Museum, including Calgary Private John George Pattison's Victoria Cross and a Red Ensign flag flown by Canadians at Vimy. Reflecting the fact that Vimy marked the first time that Canada's four divisions joined forces in battle, this exhibit was also the first to have all galleries comprising The Military Museums contribute to a single exhibit that also included contemporary art contributions through the Founders' curator.

Many temporary exhibits hosted in the Founders' Gallery and organized by The Military Museums have focused on major military events, such as Canada's Second World War Campaign in Italy, its role in liberating the Netherlands, or participation in the Korean and Viet Nam wars. Areas of debate have been addressed—such as the August 1942 raid on Dieppe. Always, first hand accounts are highlighted and often captured as oral histories, and such exhibitions give The Military Museums opportunities to reach out to many and varied communities of people in Calgary.

Committed to presenting military history in its full scope, the museum covered the very different impact of events on various groups. This was evident in one of its first temporary exhibits entitled *Aboriginals in the Service of Peace*. Indigenous volunteerism and other examples of wartime patriotism, sacrifice, and loss were noted, but also fierce Indigenous opposition to conscription, discrimination experienced in the armed forces and in accessing veterans' programs, and confiscation of reserve land to

A rug produced in Afghanistan and displayed at the Museum showing war related themes.

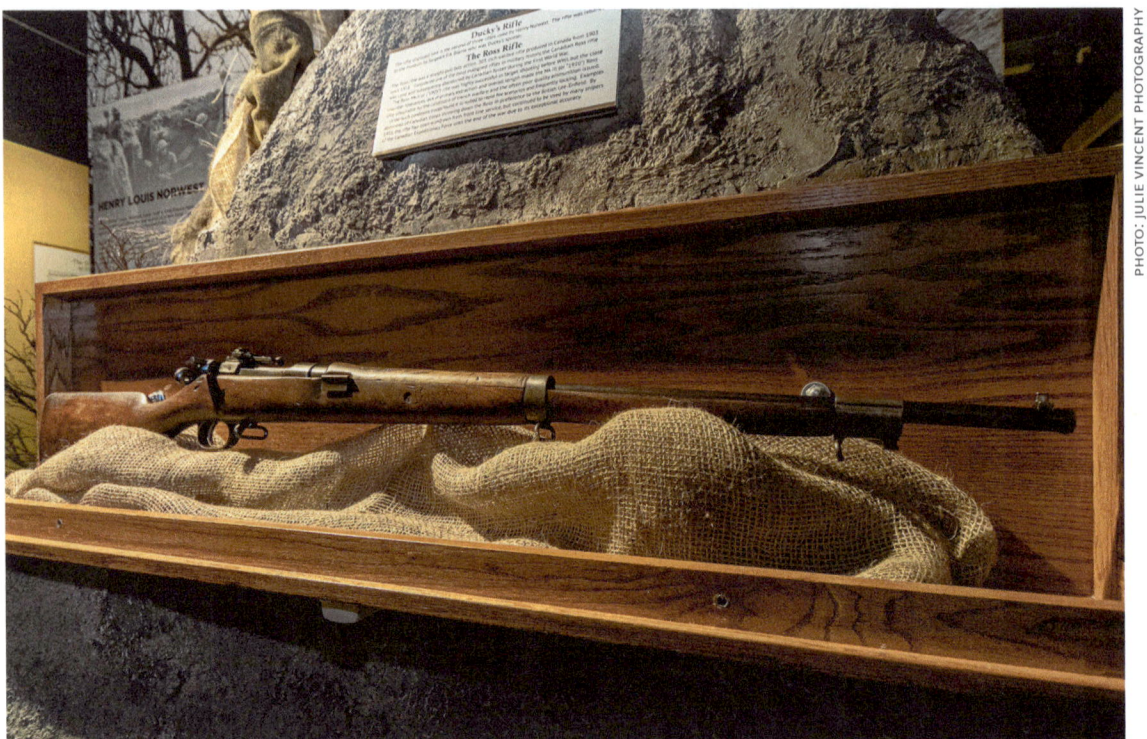

PHOTO: JULIE VINCENT PHOTOGRAPHY

Ross sniper rifle used by Henry "Ducky" Louis Norwest who was one of the most famous Canadian snipers in the First World War. He came from a Cree/French Métis family in Fort Saskatchewan and before the war worked as a farm hand and rodeo performer and served with the North-West Mounted Police. Collection of the King's Own Calgary Regiment (RCAC) Museum & Archives.

support military training. Several extraordinary individuals were highlighted, such as First World War sniper Henry Louis Norwest, a Métis, who had more than one hundred confirmed kills as a member of Calgary's 50th Battalion; Sergeant Tommy Prince of Manitoba's Brokenhead Ojibway Nation, a veteran of the Second World War and the Korean conflict, who received both the Military Medal and the American Silver Star; and Private Mary Greyeyes, who was the first Indigenous woman to join the Canadian Women's Army Corps in 1942. At the exhibit's opening ceremony, Indigenous television and singing star Tom Jackson was moved to comment: "All the people in these displays fought for our freedom, but sometimes they're forgotten because they're just our neighbors. But they cannot be forgotten. It is thanks to them we can all be neighbors and live side by side … in peace."

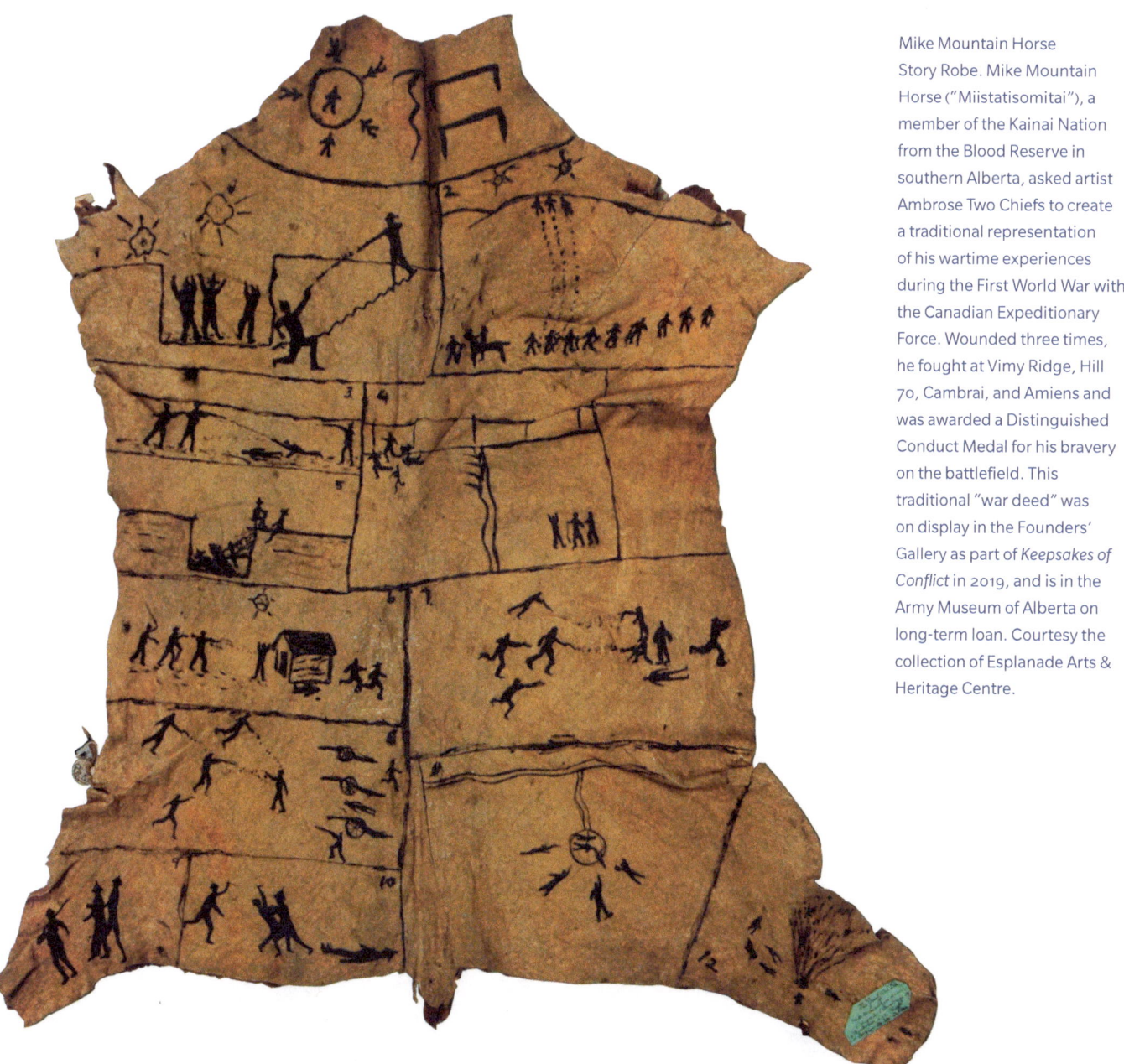

Mike Mountain Horse Story Robe. Mike Mountain Horse ("Miistatisomitai"), a member of the Kainai Nation from the Blood Reserve in southern Alberta, asked artist Ambrose Two Chiefs to create a traditional representation of his wartime experiences during the First World War with the Canadian Expeditionary Force. Wounded three times, he fought at Vimy Ridge, Hill 70, Cambrai, and Amiens and was awarded a Distinguished Conduct Medal for his bravery on the battlefield. This traditional "war deed" was on display in the Founders' Gallery as part of *Keepsakes of Conflict* in 2019, and is in the Army Museum of Alberta on long-term loan. Courtesy the collection of Esplanade Arts & Heritage Centre.

A diorama depicting the development of the Canadian Women's Army Corps in the Second World War as seen in the Army Museum of Alberta. The material for the display and the concept for the display were developed by the veterans of this unit themselves, and in particular by Rose Wilkinson.

Another early temporary exhibit examined the more than twenty-one thousand volunteers who served with the Canadian Women's Army Corps in the Second World War. Nearly three hundred people turned out for its opening, including forty-six former members of the Corps who travelled from across Canada to see an extensive collection of photographs, uniforms, and artifacts covering their many roles, not just administrative, but also in positions such as architectural engineer, mechanical draftsperson, and motor mechanic. Another early exhibit covered Japanese-Canadians' participation in the First World War. With accompanying text written in both Japanese and English, it told of a population that, though small and facing blatant racism in Canada, still made very substantial contributions to the war effort, including 228 who enlisted in Alberta, 54 of whom were killed in action.

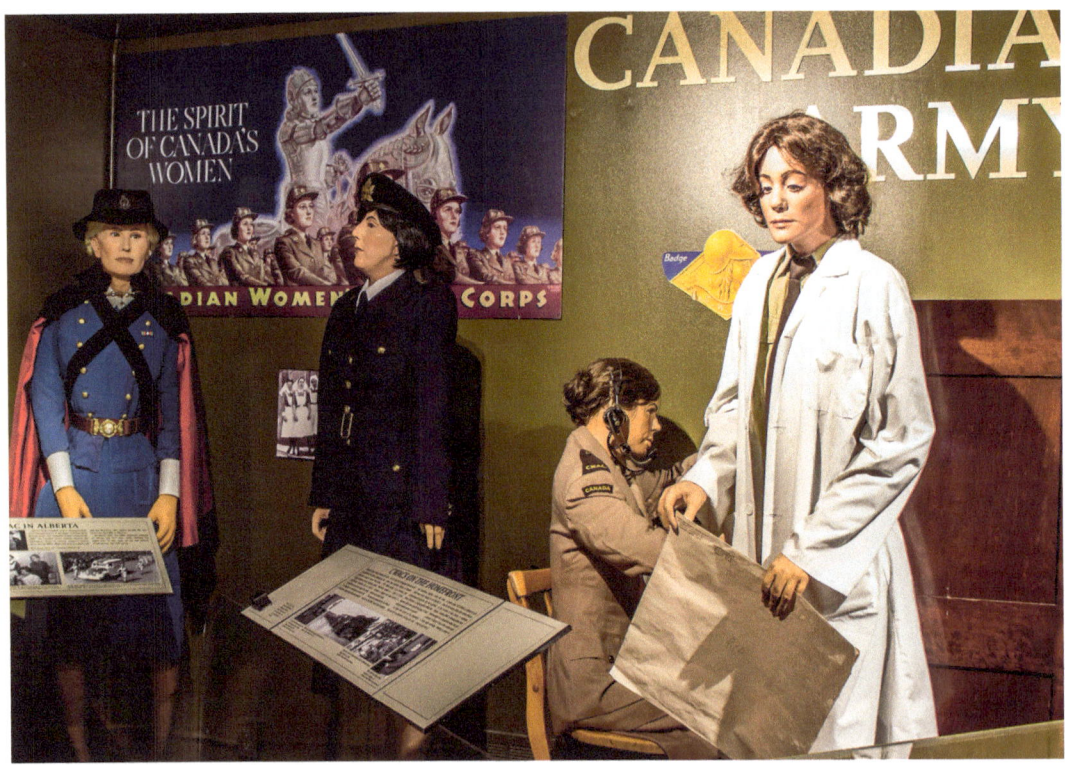

Veil and dress details, Lady Patricia Ramsay's wedding dress. Princess Patricia was Colonel-in-Chief of Princess Patricia's Canadian Light Infantry from 1919–1974. In 1919, the regiment was the Honour Guard for her wedding. It was stated that controlling the crowds of excited citizens resulted in the first time the regiment had their lines broken after four years of conflict. Her wedding dress now resides in the museum's collections, and is the only Royal wedding dress held outside of the United Kingdom. Photos: Ashley Fournier-Montalvo

PHOTO: JULIE VINCENT PHOTOGRAPHY

A Type K Enigma machine on exhibit at the Naval Museum of Alberta. Breaking this German coding machine's cipher shortened the Second World War in Europe. Collection of the Naval Museum of Alberta.

Seeking to broaden its coverage and appeal, with financial support from the India-Canada Association and the Canada Pakistan Association, the museum hosted an exhibit entitled *The Indian Army Side-by-Side with Canada's Sons and Daughters, 1914–1918, 1939–1945*. Launched with much fanfare, including the Regimental Pipes and Drums of the Calgary Highlanders, as well as Highland dancers, a sitar player, and performers of Indian dance, the opening ceremony also welcomed Maharaj Jai Singh and Omkar Nath Channan, representing the Calgary–Jaipur Development Foundation, who proudly noted that Jaipur and Calgary had been officially declared twin cities. With numerous artifacts loaned from London's Imperial War Museum, the exhibit detailed the roles served by the Indian army—comprised of Hindus, Sikhs, and Muslims, and Gurkhas—often side-by-side with Canadian

forces in France, Flanders, Gallipoli, Egypt, East Africa, Mesopotamia, and Palestine in the First World War, and in Sicily, Italy, and Hong Kong in the Second World War. Visitors learned of the critically important, and often overlooked, contributions India made in shaping the course of these global conflicts, for instance by raising 800,000 soldiers in the First World War and an incredible 2.5 million in the Second, all of whom were volunteers.

The museum borrowed extensively from other places to make its exhibits comprehensive and dynamic. An early example was its 2001 Boer War exhibit covering Canada's first official overseas military campaign that cost 224 deaths and 252 wounded from a total force of 7,368. Entitled *Good-bye Dolly Gray*, after a war-related song popularized in 1901 by Canadian tenor Harry Macdonough, the exhibit included twelve-pounder artillery and a maxim machine gun borrowed from the military museum in Shilo, Manitoba; medals and uniforms belonging to Lieutenant-Colonel John McCrae (author of *In Flanders Fields*) then held at the Royal Canadian Regiment's museum; and flags from the old Boer Republics, the Transvaal and the Orange Free State, as well as a Mauser rifle used by Boer guerilla forces, acquired through the Ottawa-based South African High Commission.

Soon after there followed a much different exhibit on *Public Relations in War*. Visitors were introduced to the increasing scope and sophistication of Canadian war reporting, and to journalists who became giants in the field, such as Peter Stursberg and Alberta's Matthew Halton who, in the Second World War, reported over CBC radio near the front lines during the Mediterranean and European land campaigns. Visitors learned about the extent of censorship, such as from instructions reporters received on what was permissible to disseminate, and were prompted to consider the propagandistic aspects of wartime reporting, in print, over radio, and through material supplied by the Canadian Army Film and Photo Unit (CAFPU). Formed in June 1941, its members captured compelling images from the invasions of Italy and Normandy. This often put them in grave danger: of its 220 members, six were killed and 18 were wounded. Most famously cameraman Bill Grant provided some of the first film footage of the D-Day landings. Along with images recorded from cameras affixed to the landing craft, the material was rushed back to the CAFPU's London headquarters where it was processed into the first news clips of this epic invasion. At the exhibit, visitors could also hear some thirty wartime radio broadcasts and view artifacts: these included a motorcycle used by

a Canadian Army dispatch rider and a model of a Creed teletype/No 33 wireless set correspondents used to send information.

In 2012, the Air Force Museum Society decided to address the comparative dearth of information about Canada's Air Force during the Cold War era in the form of a dedicated gallery space that would tell this story. After nearly four years of planning, research, writing, disappointments, and triumphs, the Ken and Roma Lett Cold War Exhibit opened on 25 September 2015. Contained in two structures south of the main Military Museums building, the highlights of this exhibit are three aircraft: a F-86 Sabre, a CF-104 Starfighter, and a CF-18 painted in the 2009 airshow demonstration colours representing Canada's centennial of flight. The F-86 and CF-104, sourced from private American collections, underwent extensive restoration before going on display, logging over 9,000 volunteer hours of labour.

Compared to their work on the First and Second World Wars, researching and writing a Cold War display proved a welcome challenge for the Air Force Museum Society team. The material had to be factual yet engaging but without the often-romantic flair seen in anecdotes from the First and Second World War to buoy it up.

Depiction of a nuclear fallout shelter in the Cold War exhibit.

PHOTO: JULIE VINCENT PHOTOGRAPHY

Dag Hammarskjold Medal awarded posthumously to one of nine Canadians killed on 9 August 1974 in the largest loss of life for Canadian peacekeepers. Collection of the Army Museum of Alberta.

It was challenging to create storyboards that would capture visitor imagination. That's where the three aircraft and the recreated fallout shelter stepped up, supported by the clean, light, minimalist design created by Terry Gunvordahl of Beyond Design Inc. and Irene Kerr of Exhibition Planning and Design. The storyboard panels are also supplemented by a dedicated cadre of volunteer guides, most of them Cold War veterans themselves.

Between 2017 and 2018, the Cold War Exhibit underwent some adjustment. Panels were relocated to improve visitor experience fluidity and a Memorial Wall was added, listing the names of all Canadian airmen and airwomen who lost their lives on duty during this period. The wall is supplemented by a large touch-screen monitor where information about these individuals can be researched, including unit association, aircraft involved, and cause and date of death. It is a space of which the Air Force Museum and its Society is very proud and is, perhaps, the only space of its kind in Canada.

Today, The Military Museums strives to be a vibrant hub for the Calgary community, centering on a wide variety of important issues related to war, peace, and security throughout the world.

FOUNDERS' GALLERY

The exhibition mandate of the Founders' Gallery is to "explore human conflict worldwide through projects by local, international, historic, and contemporary artists that challenge viewers' knowledge of and interaction with war." Through this, the exhibitions also create vital connections between the University of Calgary and The Military Museums, between the art community and the many communities of volunteers, veterans and members of the public, and between local, national and international audiences. Because it maintains high standards for all of its environmental conditions—from temperature and humidity, to lighting and a large and flexible exhibition space—the Founders' is able to create and present a wide range of thoughtful exhibitions, rich in content and drawing from major institutions such as the Canadian War Museum and the Imperial War Museum.

From its inception, the Founders' Gallery has presented a number of art exhibitions that explore the legacies of Canadian war artists: from the First World War paintings by artists that would form the Group of Seven (*Art in the Service of War: The Emergent Group of Seven*, 2009, organized by the Founders' Gallery) to *A Brush With War: Military Art from Korea to Afghanistan* (2012, organized and circulated by the Canadian War Museum), to *Witness: Canadian Art of the First World War* (2018, organized and circulated by the Canadian War Museum).

While Canada's war art program had its beginnings during the First World War, it remains a vibrant and important program, and many of contemporary artists who have served as official Canadian Forces Artists Program artists have exhibited at the Founders' Gallery, including Althea Thauberger, Leslie Reid, Dick Averns, and Gertrude Kearns.

Contemporary art provides a unique vantage point for viewers to consider the social and cultural impact of war and conflict, both at home in Canada and globally. *Diabolique* (curated by Amanda Cachia, 2011) was an early and significant grouping of 22 Canadian and international artists that demonstrated

Poster for one of the heritage exhibits in the Founders' Gallery. Many of the heritage exhibits have focused on increasing awareness of under-recognized groups of veterans. This exhibit focused on Korean War veterans, and was also one of several exhibits that have helped forge ties with diverse communities in Calgary—in this case the Korean community. Other exhibits have connected the museum with the Chinese, Dutch, Syrian, Sikh, and Vietnamese communities, among others.

(ABOVE)

Views of the exhibit *Tour of Duty: Canadians and the Vietnam War* in the Founders' Gallery in 2018. An estimated 40,000 Canadians served in Vietnam in the US military, but had very little recognition prior to this exhibit. The museum has become a major repository for artifacts and oral histories about Canadians in the Vietnam War as a result.

(RIGHT)

Monty Coles, a Canadian Vietnam veteran who served in the US Marine Corps. Coles was one of almost 30 local Vietnam veterans awarded a special service pin at a 2019 ceremony at the museum, as seen here. His artifacts and oral history were included in the Vietnam exhibit.

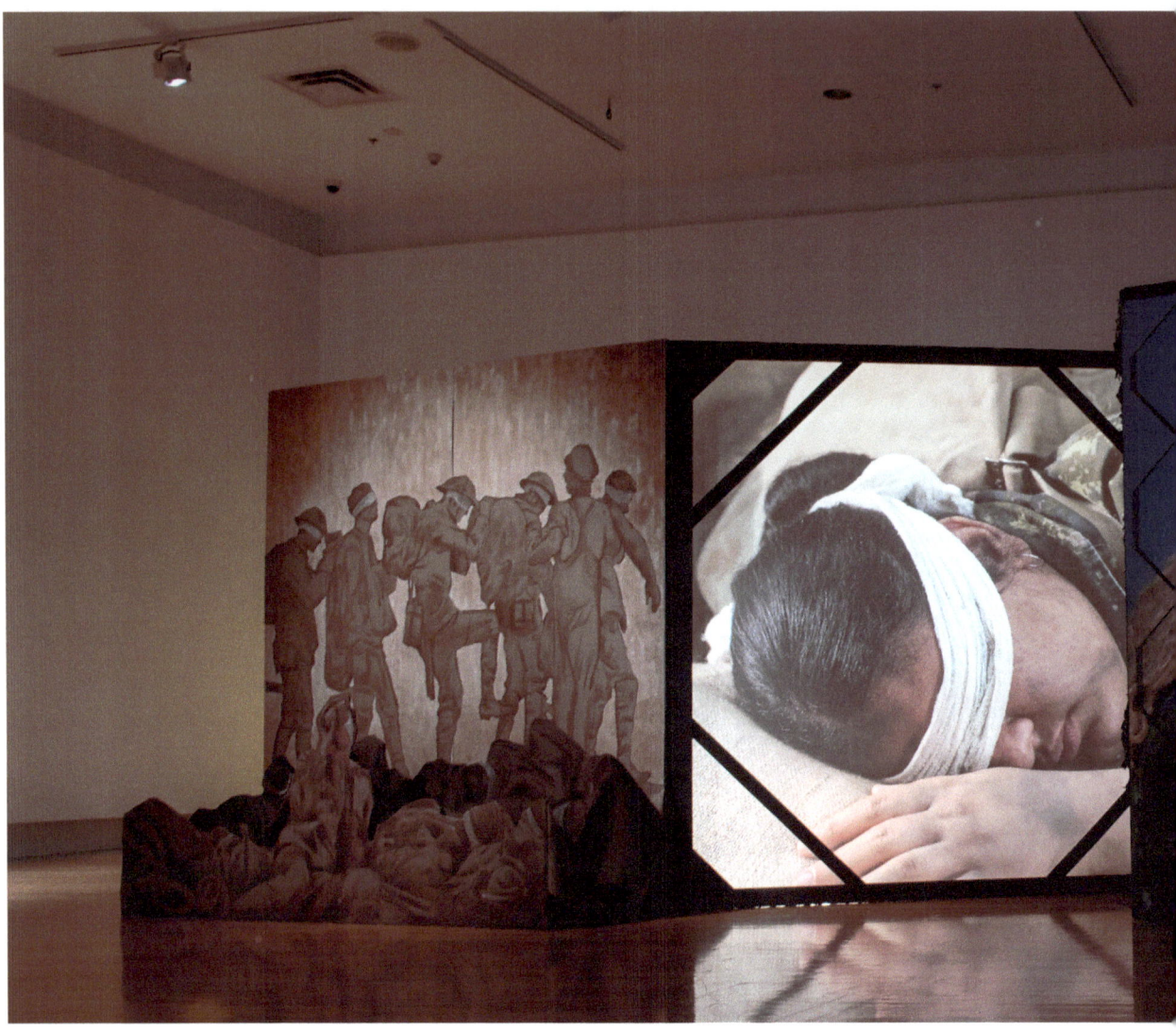

Shown in the summer of 2019, *gassed, redux* was an exhibition by Canadian artist Adad Hanna that employed live performance, photography and video in creating a *tableaux vivant* of John Singer Sargent's massive painting *Gassed*, in the collection of the British War Museum.

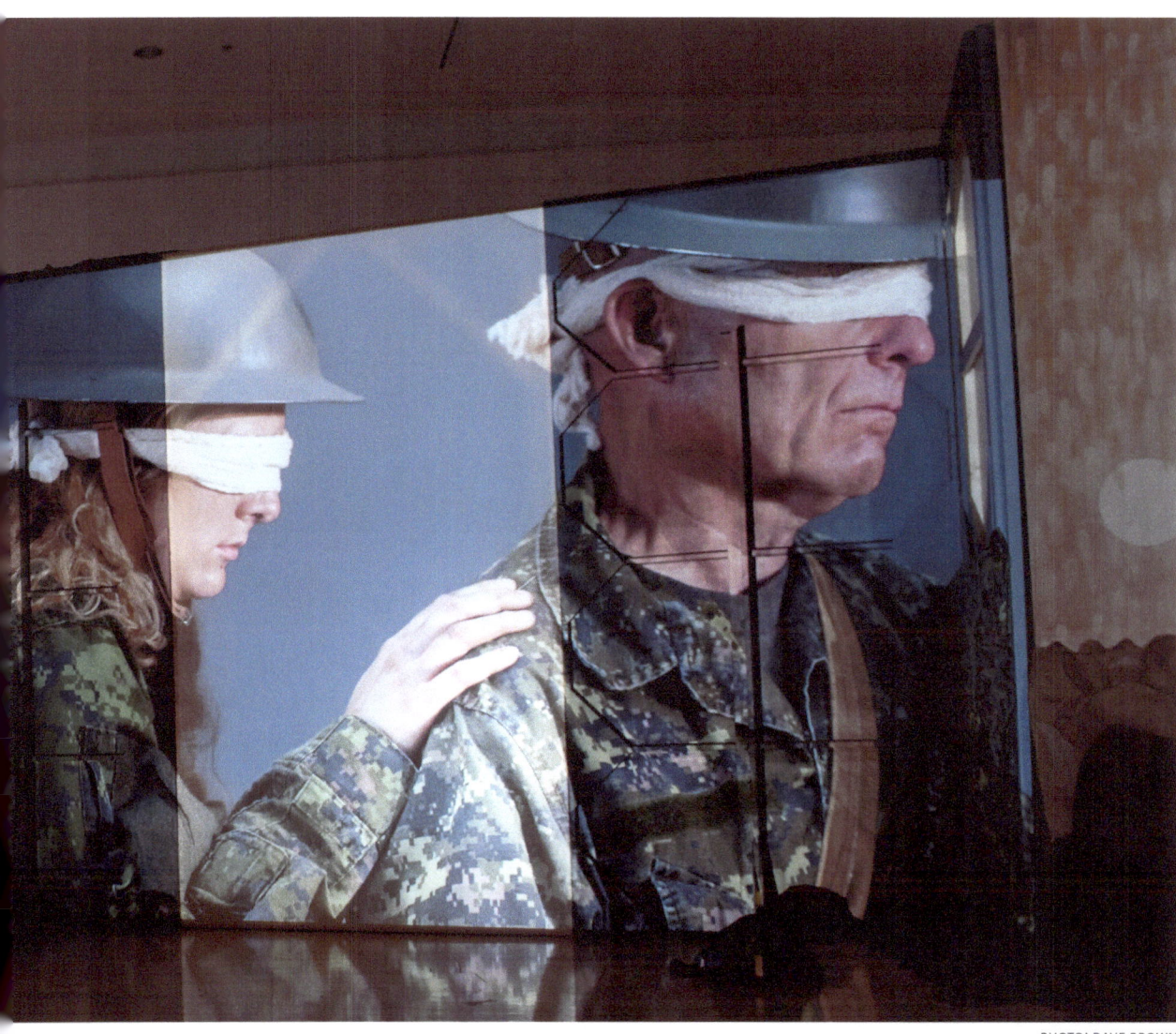

PHOTO: DAVE BROWN

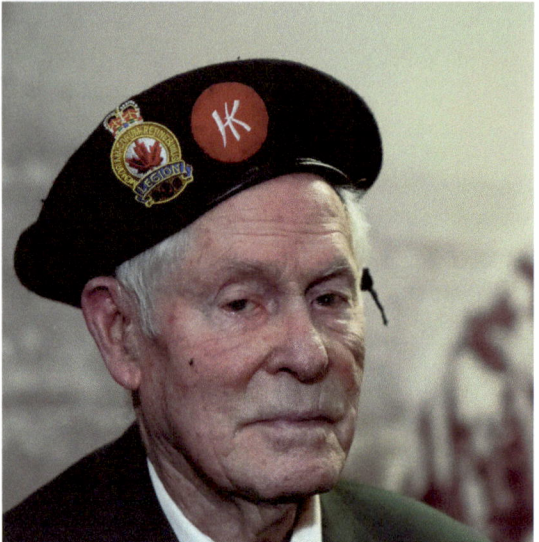

(LEFT)
Poster for two exhibits in the Founders' Gallery. There has often been a pairing of related art and heritage exhibits in the gallery, which has proven very successful, and in this case provided complementary narratives. *Ring of Fire* was another exhibit that increased awareness of under-recognized veterans.

(ABOVE)
Ralph MacLean, one of the veterans featured in the exhibit *Ring of Fire: Canadians in the Pacific in the Second World War*. MacLean was taken prisoner by the Japanese in Hong Kong in 1941. His grandson Mark Sakamoto wrote a book about MacLean, entitled *Forgiveness*, that won an award.

the diverse media artists now work with – from traditional painting and sculpture but also photography, video, installation and multi-media pieces.

The Founders' Gallery also hosts exhibitions that directly explore Canada's military history through artifacts and archives, typically as organized by curators within The Military Museums. A stunning example of the rich collections within The Military Museums was the 2019 exhibition *Keepsakes of Conflict: Trench Art and Other Canadian War-related Craft*. Curated by Heather Smith and circulated by the Moose Jaw Museum and Art Gallery, *Keepsakes of Conflict* brought together many important pieces from the regimental museums in an exhibition that toured Canada.

Whether through artifacts, historical art or contemporary art, the Founders' Gallery is a proud contributor to the rich legacies held within The Military Museums.

Beverley Tosh's fascinating exhibition *Trees Heeft een Canadees* (Teresa Has a Canadian) shared stories of Dutch-Canadian war brides through painting, letters, photographs, film and artifacts.

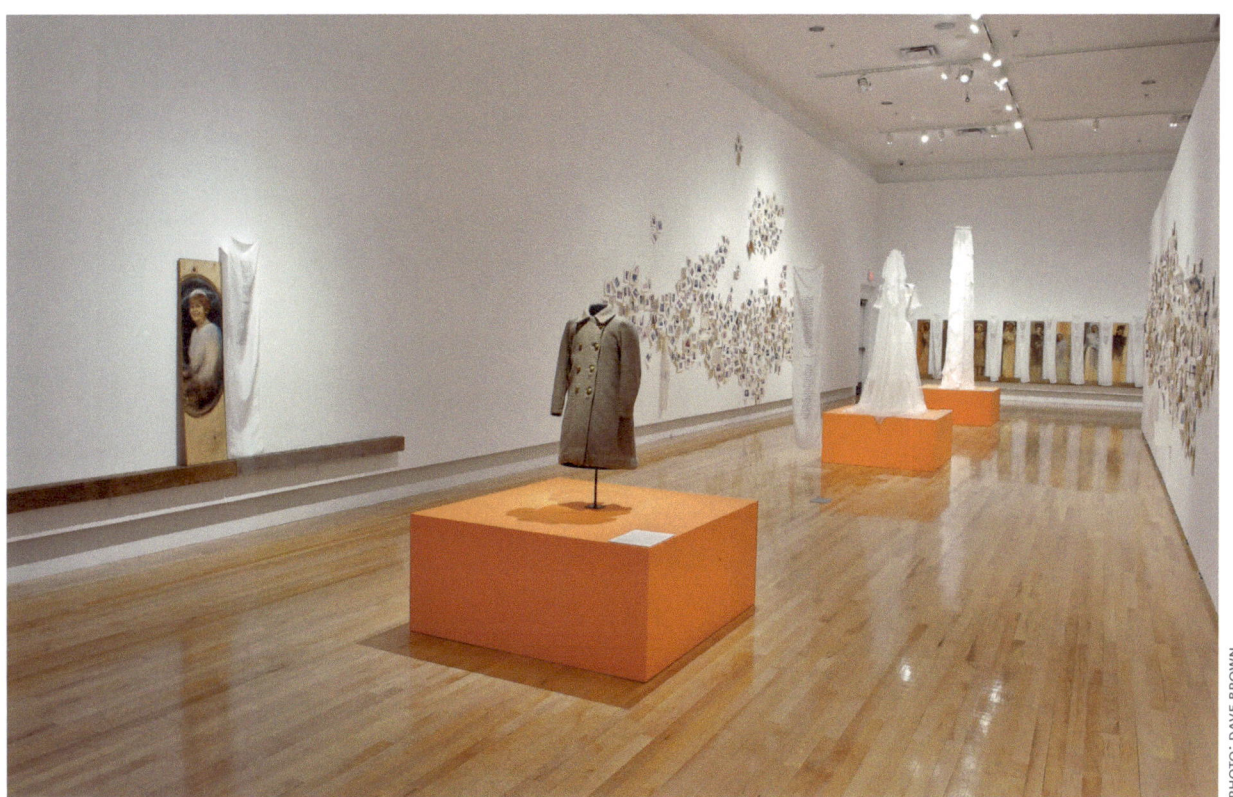

PHOTO: DAVE BROWN

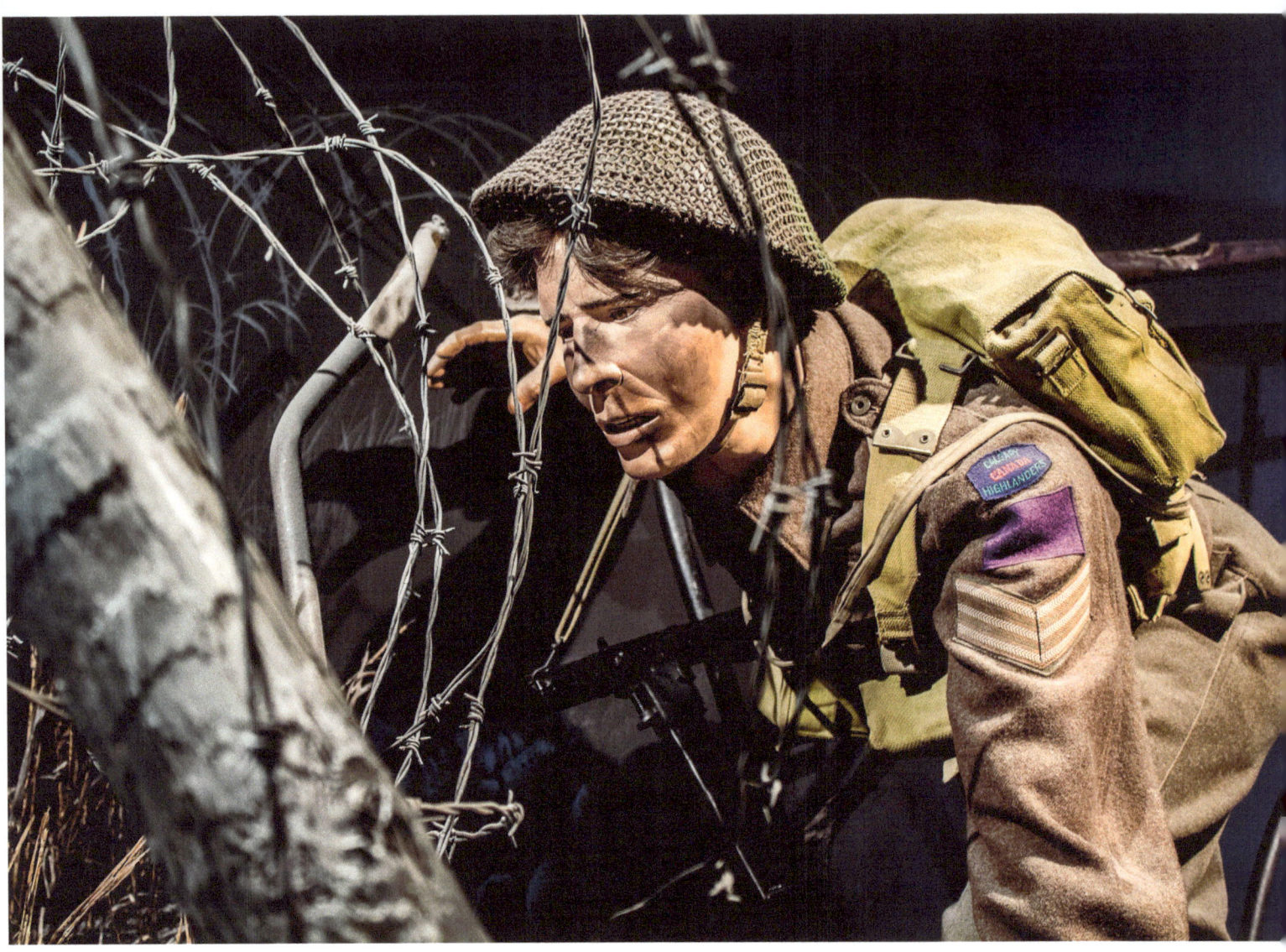

Detail of a diorama depicting events on the night of 22 September 1944, when Sergeant Clarence Crockett led a Calgary Highlander patrol across a ruined lock gate at the Albert Canal in Belgium. His patrol successfully established a foothold on the far bank allowing the battalion to cross the canal. For his actions in this operation, Sergeant Crockett was awarded the Distinguished Conduct Medal for bravery.

7

REMEMBER, PRESERVE, EDUCATE

Within a little more than a generation, Calgary had developed a major museum primarily to showcase both its own and Alberta's rich military past. Its exhibits drew from local and worldwide sources to explain the multi-faceted impact of war. What was once an abandoned middle school had become a major tourist destination, heritage and cultural site, and research centre.

Central to the museum's mission is educating young people. Its founders sought to establish this as a basis for reputational excellence. In educating the young, the CMMS identified three major goals: to understand that war affects everyone; that it is a devastating human experience; and that the conflicts Canada participated in profoundly shaped its formation.

Museum educators vigorously pursue connections with schools and post-secondary institutions. This includes establishing curriculum-based museum programing, educational summer camps and sleepovers, organizing battlefield study tours, creating research projects, and bringing mobile displays into schools. By 2010, museum personnel reached some ninety thousand young people, ranging from kindergarten to Grade 12, providing lesson plans accompanying loaned artifacts.

The museum seeks to collaborate with teacher associations and also to attract teachers as volunteers. The museum's Education Committee ties its programing around different exhibits to specific themes and outcomes of the official school curriculum. This has typically related to the social studies component that, depending

Artifact handling program in progress. This program helps the students to understand how meaningful these items are.

on the grade level, focused on topics such as citizenship, global communities, democracy, understanding nationalism, and understanding ideologies.

Innovative and flexible thinking was often evident in this process. An exhibit on peacekeeping with a major component covering "landmines and landmine technology" was linked not only to "Canada and the world," which was part of both Grade 5 and Grade 10 social studies curricular objectives, but also to "technological change and its impact," which was aimed at Grade 9 learning expectations and dealt in this case with the horrid toll landmines exacted on civilian populations. High school students were prompted to consider the concept of "sovereignty" in the context of Canada's leadership in producing the 1997 Mine Ban Treaty (that is, the Convention on the Prohibition of the Use, Stockpiling, Production and Transfer of Anti-Personnel Mines and on their Destruction) signed by 122 countries, but excluding the United States, Russia, and China.

This led to exploring the extent to which nations should be able to intervene in the affairs of others, even to protect their civilian populations. Encouraged also to organize a debate around the issue of using landmines, students were given arguments on both sides, such as their use by the United States in the demilitarized

zone in Korea to keep the southern half of that long-divided country secure, without the need to commit massive numbers of troops.

University of Calgary Education students prepare many of the lesson plans. Depending on the age group, this could involve trying on uniforms or handling artifacts, teaching mathematics through exploring artillery sound-ranging techniques, or learning how to decode cipher messages.

Before visiting the museum, teachers are sent packages to prepare children with basic knowledge and to familiarize themselves with key content. For instance, with respect to peacekeeping, the teacher's kit included a list of all United Nations military operations in which Canadian forces had participated. Potential class activities have also been included, such as crossword and word-find puzzles linked to key themes and terms, possible essay topics and test questions, and suggestions for class initiatives such as writing to Canadian soldiers serving abroad. So inspired were students from Calgary's St. Ambrose Elementary School that they raised $800 to send educational supplies to Afghan children, an amount local businesses matched.

When preparing their presentations, educators take care to present a balanced account. While avoiding the glorification of past battles, lessons discuss circumstances where it is essential to put young men, and more recently women as well, in harm's way. Youth are told that the decades of peace we have enjoyed have sometimes been dearly bought by the sacrifices of Canada's sons and daughters in 1914–1918 and 1939–1945, and up to the present day.

Wider societal considerations of what leads to, and the mixed consequences of, armed conflict are examined. In covering the 1885 North-West Rebellion, lesson plans asked students to consider how they would feel as a soldier trying to quash Riel's uprising; whether Riel's trial was fair; and if they could better appreciate Riel's position in light of contemporary western Canadian, and especially Alberta, alienation from Central Canada, such as over national energy policy. In covering Canada's involvement in the Boer War, loyalty to Britain and commitment to protecting the rights of Anglo Uitlanders were noted, but also Britain's economic interests in the region (namely its intent to control gold and diamond mining

Students get to see firsthand many of the items that are referenced in their programs.

REMEMBER, PRESERVE, EDUCATE

One of the unique aspects of the education programs is the involvement of veterans, such as Rose Wilkinson here (a Second World War veteran of the Canadian Women's Army Corps). This creates opportunities for intergenerational engagement and is very meaningful for veterans from the Second World War up to Afghanistan.

operations), its mistreatment of Africans, its use of scorched earth tactics and introduction of concentration camps, and the divisions the war brought to Canada, particularly between French and English Canadians.

Addressing the internment of Ukrainians in Canada during the First World War and the forced evacuation of Japanese Canadians in the Second, school lessons not only detailed the mistreatment of these ethnic minorities, but also asked students to consider whether certain wartime security considerations justified the widespread infringement of civil rights. In lessons on the First World War, students were prompted to assess the roles economics, ideology, nationalism, racism, and human blunders played in causing the conflict.

Detailed programing was established around Remembrance Day for which the museum received the 2001 Museums Alberta Award of Merit. The museum customarily received some three-quarters of its annual school visits between mid-October and the end of November. Lessons for those in Grades 1 to 3 dealt with "The Meaning of Remembrance," which included making a wreath; those in Grades 4 to 6 focused on the poem *In Flanders Fields*, both its themes and the emotions it sought to evoke; Grades 7 to 9 looked at how Canada's wartime contributions created strong and enduring ties with the Netherlands; and those in high school examined the topic of "coming to the aid of friends and allies in times of conflict," which led to discussion of Canada's more recent military roles, particularly in Afghanistan.

Many different types of items are used to engage youth, such as comic books produced in the Second World War, which help them better identify propaganda. To get students more personally involved in understanding the work Canada's military was doing as peacekeepers, they were shown and given the opportunity to make an Izzy Doll, named for Combat Engineer Master Corporal Mark "Izzy" Isfeld who, before he was killed in Croatia in 1994, became known for giving away "pocket sized simple knitted dolls his Mom had sent over that were made to look a little like a UN peacekeeper." Isfeld believed the children he encountered overseas had little to play with and that giving away these dolls built trust and positive relations with the civilian population.

The museum not only attracts thousands to its facility but also connects more broadly through outreach. Starting in the early 1990s, its EduBus, which was actually a donated semi-trailer, began transporting mobile displays. The number of schoolchildren it reached over its first five years climbed annually from thirty-four

thousand to fifty thousand. Given space limitations, particular themes were chosen: one tour in 2003 presented *A Soldier's Life* (1900 compared to 2003) in elementary schools, and for those in high school *Canadians as United Nations Peacekeepers* or *Mine Awareness*. The principal of Calgary's St. Patrick School said that students were "thrilled to experience something on-site that they normally wouldn't have access to."

The museum plays host to Boy Scout troops, Girl Guide companies, and Cadet Corps through specialized programing, exhibit tours, and night patrol games. It established camps for summer and other school breaks where children aged six to twelve learn about the exhibits and practise military drill, handle equipment such as a surgeon's kit, and try on and learn about different parts of a military uniform. Camouflage face painting, tasting hard tack that soldiers in the World Wars ate while in action, and practising military hand signals are common activities at birthday parties and sleepovers arranged at the museum.

University students have been hired as "Living History Players," writing and performing short plays relating to temporary museum exhibits, such as a performance created around a display on the 1885 North-West Rebellion depicting life in Calgary at the time.

Cub Scouts examining documents pertaining to Canadian war dead.

REMEMBER, PRESERVE, EDUCATE

The annual Summer Skirmish is the largest outdoor event at The Military Museums, other than Remembrance Day.

Starting in the mid-1990s, the museum organized periodic contests for high school youth, requiring them to submit an essay or poster explaining the significance of a particular military event for Canada. Typically, a half-dozen winners were sent on an all-expenses paid tour of battlefield sites, at places that included Flanders, Vimy Ridge, Normandy, the Netherlands, and Italy. These were called "Heavy Metal Tours."

Hosting both local and international scholars, the museum's lecture series covered an increasingly eclectic array of topics spanning from the story of the Enigma code busters, to the relationship between music and war, to the use of social

media in modern military situations. People were invited to evening events where they learned board and card games popular during the World Wars. In 2017, the museum hosted a showcase of "geek culture icons," from Star Wars, Star Trek, and Halo, connecting itself to battles fought in the sci-fi universe. The museum also hosts an annual Summer Skirmish on its grounds that involves live re-enactments of Viking raids, medieval duels, gladiatorial combat displays, musketry and cannonades. Militaria and antique shows came to the new facility, as did conventions—even for comic books—thus bringing the museum to the attention of otherwise unlikely visitors.

Members of the 78th Fraser Highlanders (an 18th-century re-enactment group) shooting muzzle-loading rifles outside the museum.

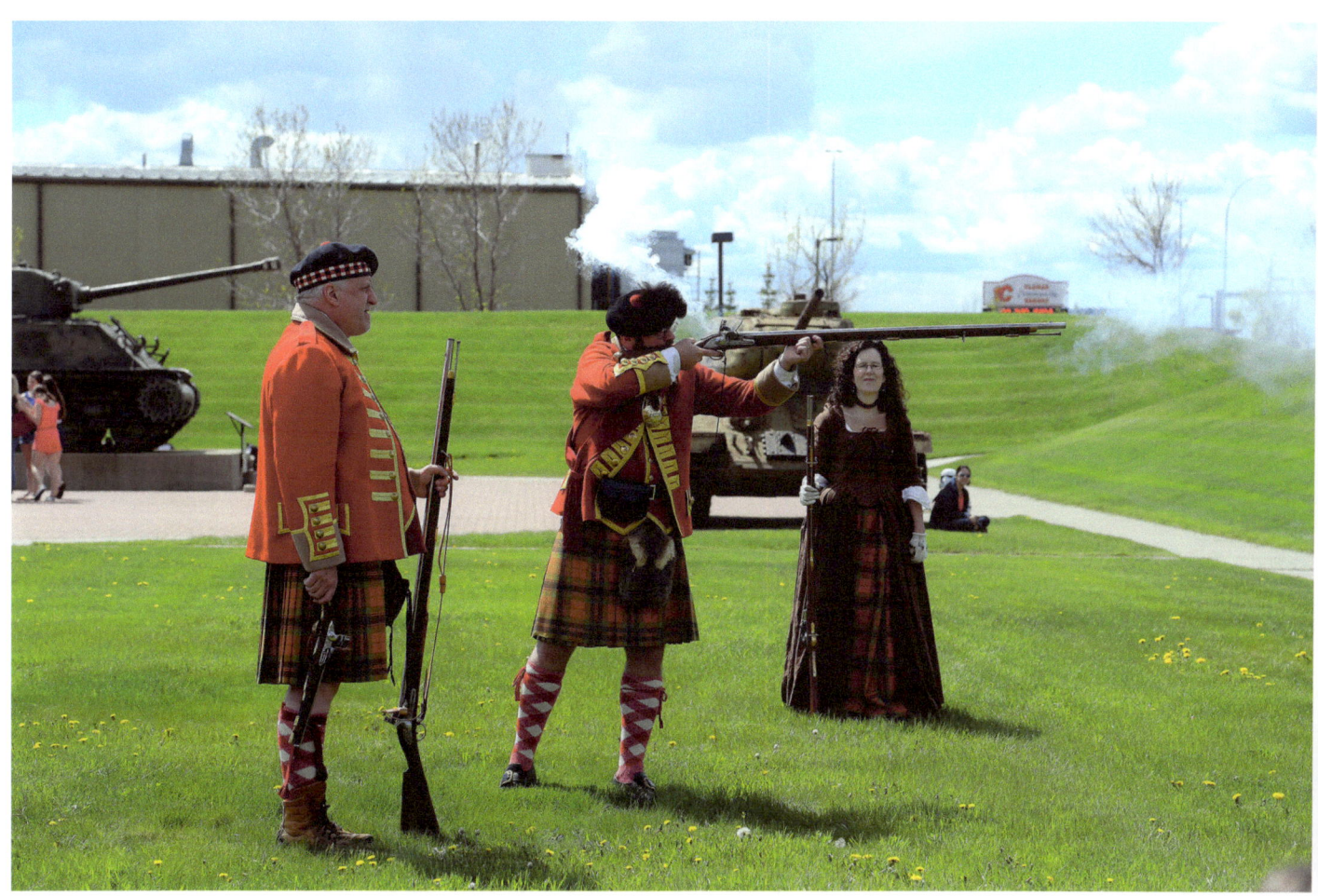

AFGHANISTAN

Canada's overseas commitments in Afghanistan lasted longer than the Second World War and Korean War combined, from 2001–14. Over 40,000 Canadians served, and 158 were killed. All three services (Army, Navy, and Air Force) were represented.

(RIGHT)
Memorial plaque honouring Corporal Nathan Hornberg, killed in Afghanistan.

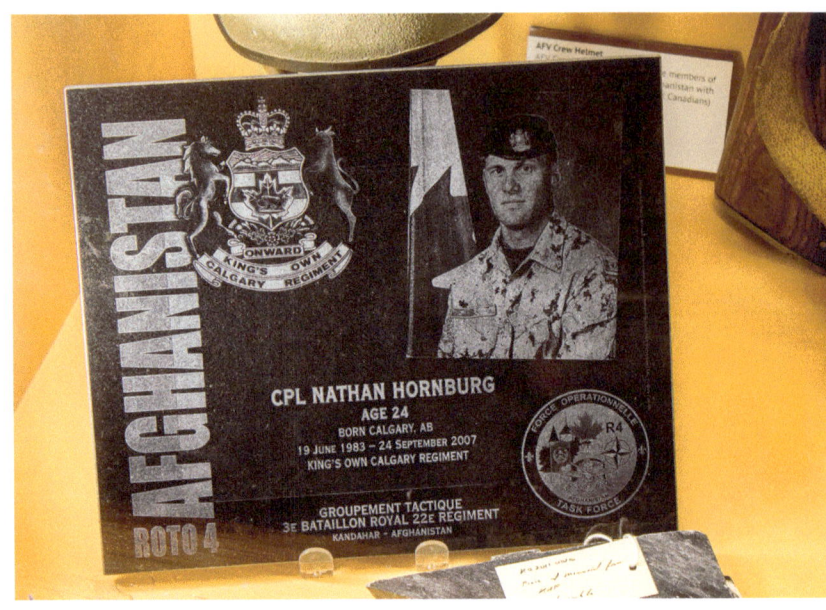

PHOTO: JULIE VINCENT PHOTOGRAPHY

Canadian Forces' Unit Commendation Award presented to the Calgary Highlanders in 2015 for their outstanding contribution to the Canadian mission to Afghanistan from 2001 to 2011. The award is composed of a scroll and a medallion. A pennant is also awarded, which the unit can fly for one year from the date of award. Collection of the Calgary Highlanders Museum.

(BELOW)
Voting ballot for the first democratic election in Afghanistan following the toppling of the Taliban government. The election of 2004 was an important milestone in the development of the new Afghanistan but was a challenge in a population with high levels of illiteracy. The solution was a ballot that included a name, portrait, and symbol for each candidate. Collection of The King's Own Calgary Regiment (RCAC) Regimental Museum & Archives.

PHOTO: JULIE VINCENT PHOTOGRAPHY

This smock belonged to Corporal (Ret'd) Rob Furlong of the 3rd Battalion, Princess Patricia's Canadian Light Infantry. During Operation Anaconda in Afghanistan in 2002, while using the McMillan Tac-50 sniper rifle, Furlong achieved the longest sniper kill in history, killing a Taliban insurgent at 2,430 m (2,657 yd). He held this record until 2009.

Today, The Military Museums houses a vast collection representing Canada's three service branches. It serves as Calgary's main gathering point on Remembrance Day; it contributes immensely to Alberta's education curriculum; and it creates a bridge to build understanding between veterans and museum visitors from all ages and walks of life.

The museum's story speaks to the power of community organization and mobilization. Government did not conceive its creation. The concept, strategy, and fundraising for this facility were led by people with deep roots in the military and the community. They and their legions of supporters shared an unshakeable determination to consolidate and showcase invaluable regimental collections housed in small, often dingy, places scattered across Calgary, where deterioration and permanent loss threatened to occur.

Today's museum attracts visitors from across Canada and internationally. It is a place where children and youth learn about the profound ways in which war shaped experiences, including long after the shooting stopped.

The Military Museums is a source of municipal and provincial pride, and is the largest such facility the Department of National Defence runs. Its prominent presence along Crowchild Trail, announced with planes, tanks, and armoured vehicles on its grounds, boldly asserts that the ways in which the military and the experiences of war impacted and shaped Calgary's past, as well as that of the broader region, will not be lost to future generations. True to its purpose, The Military Museums has fulfilled its mission to Remember, Preserve, and Educate.

www.ingramcontent.com/pod-product-compliance
Lightning Source LLC
Chambersburg PA
CBHW041547220426
43665CB00003B/57